Dilli's
RED FORT

Published by
NIYOGI BOOKS
(A unit of Niyogi Offset Pvt. Ltd.)

D-78, Okhla Industrial Area, Phase-I
New Delhi 110 020, India
Tel.: 91-11-26816301,26813350/51/52
Fax: 91-11-26810483, 26813830
e-mail: niyogioffset@bol.net.in
www.niyogibooks.com

Design: Write Media

ISBN: 978-81-89738-27-3

Year of Publication: 2007

Printed at: Niyogi Offset Pvt. Ltd., New Delhi, India

Dilli's
RED FORT
by the Yamuna

N.L. Batra

NIYOGI BOOKS

Contents

Preface

On 28 June 2007, the Red Fort was declared a World Heritage Site. *Dilli's Red Fort: by the Yamuna* aims to inform, stimulate and, above all, open the reader's eyes to the wonder that is the Red Fort, and to bring together words and pictures on this monument more closely than ever before. Although the edifices are described in the text, the intention here is to make the subject more illustrative and update the accounts and events associated with this marvellous Fort. We have striven to cover the entire span of its history, right from its evolution and inheritance till the present day, describing various aspects of the events associated with it, from the Mughal period to the days of independent India. The aim has been to keep the focus on the historical and architectural features of this great monument. The issues, day-to-day events and the conditions that prevailed during the reigns of the different rulers are elaborated here in order to throw light on the political, social and economic aspects such as trade, religious fervour, hobbies and sports.

The chapters have been arranged in such a way that the readers can either start at the beginning in the conventional manner or enter the book at any point, as each chapter is more or less self-contained, though it connects with the others to form a coherent whole. The broad development of events unfolds in narrative spreads which usually begin with the historical background and then cover a particular period, including the events associated with the freedom struggle of India.

Dilli's Red Fort: by the Yamuna is indeed a storehouse of information regarding architectural details, various constructional aspects, factors propelling deterioration, vandalism, decay, conservation, maintenance, preservation and the restoration work carried out by the Archaeological Survey of India.

This book is also for those interested in a detailed study of the Red Fort and curious to know about the structures that have disappeared, their original location and the steps taken to safeguard the ones that exist today.

Dilli's Red Fort: by the Yamuna provides insight into the work of those who are using their expertise to preserve the remains. The bibliography provided will help the serious reader.

In the selection of material for this book, an attempt has been made to obtain, as far as possible, contemporary sketches and drawings. In a few cases, where contemporary material was just not available or was unsuitable for reproduction, modern techniques have been used to enhance the images.

This journey into the past, into the glorious days that reflect a rich heritage and present the Red Fort as it truly was, has been an enriching experience for the team at Niyogi Books.

Standing silently on the banks of the River Yamuna in Delhi, this citadel is indeed where history was made.

—*Bikash D. Niyogi*
New Delhi
August 2007

PART I

A SilentWitness

1
Making History

The day was special, as was the occasion. It was the 24th Rabi II of A.H. 1058 (A.D.1648)—the inauguration of the majestic Red Fort, a citadel that to this day stands proud in the city of Delhi. There was much fanfare as Emperor Shah Jahan, along with a grand retinue, entered through the Khizri Gate facing the River Yamuna. Prince Dara Shikoh scattered gold and silver coins over his father's head as he walked up to the gates. The palaces were decorated; the courtyards covered with rich carpets and colourful hangings while deep red Kashmir shawls covered each seat. There was opulence everywhere.

Over 200 years later, in 1857, when India's First War of Independence broke out, the sepoys from the mutinying regiments at Meerut arrived in Delhi and clamoured for admittance to the Red Fort. Captain Douglas of the Palace Guard wished to go down and speak to them, but was dissuaded by Emperor Bahadur Shah II. Fierce battles and bloodshed followed.

The famous Indian National Army trial in 1945; independent India's first Prime Minister Jawaharlal Nehru's dramatic speech and the hoisting of the national flag—they all took place at the Red Fort.

This citadel symbolised the seat of power for the Mughal rulers as well as the British Empire in India. The British occupied the Red Fort till August 1947, after which the Indian Army took it over as a military garrison. In December 2003, the Army handed it over to the Ministry of Tourism and Culture to facilitate work to restore the Fort to its former glory. For, it is here that the kings lived and the knights fought valiantly. Here is where history was made, time and again.

Indeed, this magnificent monument in red sandstone, a symbol of free India, where the nation's signature song, *Vande Mataram*, has been invoked several times, bears testimony to another era, another world.

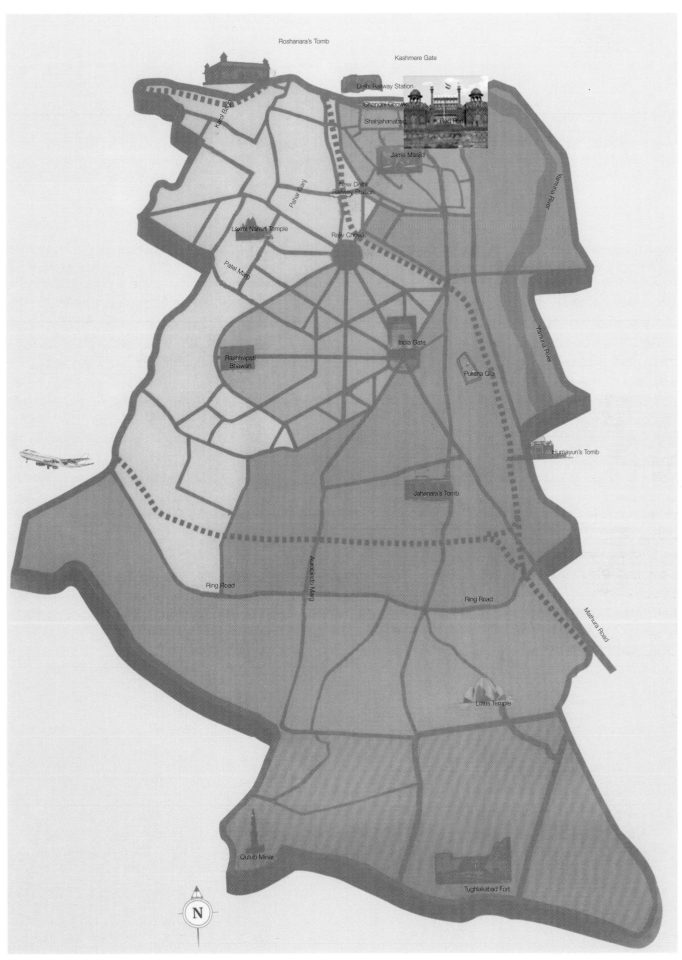

A map of Delhi showing the location of the Red Fort.

2
Delhi Beckons

Shah Jahan, earlier known as Prince Khurram, son of Emperor Jahangir, ascended the throne on 24 January 1628. He assumed the title of Abu-i-Muzzafar Shihabu-d-Din Muhammad Shibqiran-i-Sani (the Second Lord of Happy Conjunction) Shah Jahan Badshah Ghazi (the King and Champion of Faith). After a reign of eleven years in Agra, his seat of government, Shah Jahan decided to shift his capital to Delhi. In 1635, just before setting out on a Deccan expedition, Shah Jahan is said to have summoned Makramat Khan, the *Meri-i-Imarat* (Supervisor of Buildings), and ordered the construction of an entire new city to his taste. The intent was to immortalise his name to the north of Agra.

The reasons for shifting the capital were many. Agra became distasteful to the emperor after the burial of the beloved wife of his youth, Mumtaz Mahal (Elect of the Palace), took place there (even though she died in Burhanpur, Madhya Pradesh, in June 1631, during the long and painful birth of her youngest daughter). Other reasons included a desire to spend money on the gratification of a passion for exceptional splendour and to escape the excessive heat which held in its grip Agra or Akbarabad during summer. The rugged ravines throughout the city, a shortage of space in Agra Fort and the narrow streets for troops, elephants and the retinue of the emperor and his *umarahs* (lords) to pass through also propelled the emperor to take this decision.

Delhi beckoned and the emperor responded. Shah Jahan arrived here to build some more magnificent edifices, including the mighty Red Fort.

The city of Delhi before 1857.

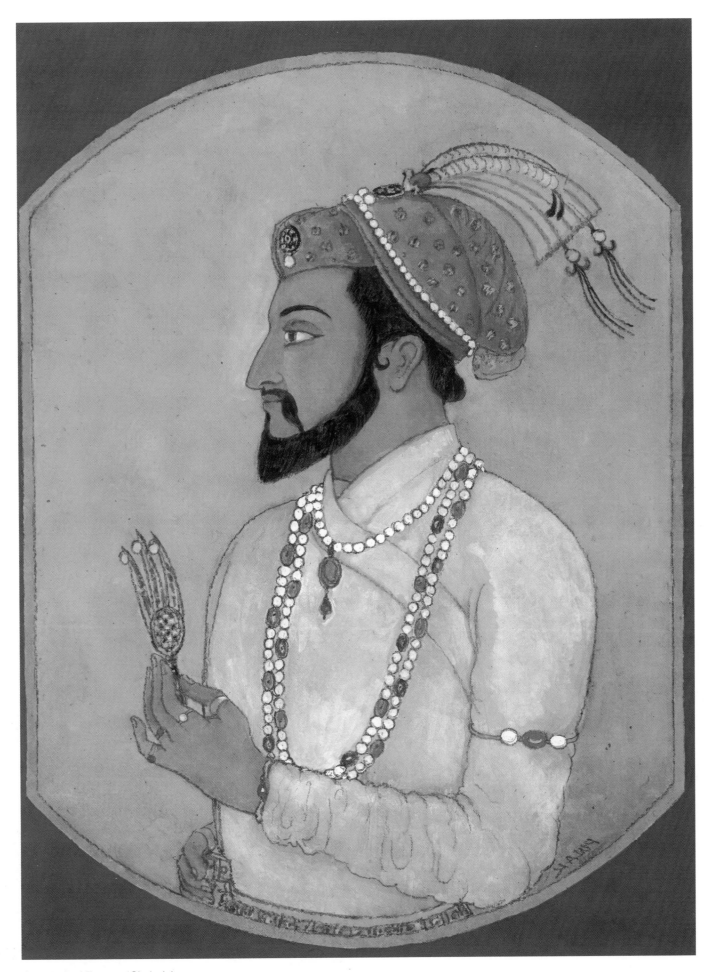

A portrait of Emperor Shah Jahan.

3

The Citadel is Born

After intense consultations and lengthy deliberations with astrologers, ministers, nobles and others, a site on the mainland, on the western bank of the River Yamuna was selected for the citadel, popularly known as the Red Fort. Having initiated the construction of the city wall of Shahjahanabad, Shah Jahan laid its foundation on the 12th Dhilhijjah or Dhul-Hijja A.H. 1048 (A.D. 1638). Sir Sayyaid Ahmad Khan, the author of *Asar-us-Sanadid* states that some old papers—a virtual horoscope of the Fort—fell into his hands, according to which the date of the foundation of the Fort was recorded as Friday night, the ninth Muharram of the year A.H. 1049 (12 May, A.D. 1639).

It took nine years, three months and a few days to complete this historic fort. It cost 100 lakhs of rupees. The Red Fort was built under the able supervision of Makramat Khan. Others associated with the building of the Fort were Ghairat Khan, the then Governor of Delhi; Izzat Khan, who later became the Governor of Sind;

Ali Vardi Khan, also appointed to a governorship, and two master builders, Hamid (whose name is still commemorated by the Kucha Ustad Hamid near the Jama Masjid) and Ahmad. Makramat Khan asked the emperor, who was then in Kabul, to come and see it and on the 24th Rabi II of A.H. 1058 (A.D. 1648), Shah Jahan entered the Fort through the gate facing the River Yamuna. This first entry of Emperor Shah Jahan to the Fort was marked with great fanfare. He held his first court in the Diwan-e-Am. The roofs, walls and *aiwans* (colonnades) of the Diwan-e-Am were hung with velvet and silk from China and Khata (Chinese Turkistan). It is said that the buildings became the envy of the art galleries of China.

A beautiful canopy—a huge covering especially prepared for the occasion in the royal factory at Ahmedabad, measuring around 64 by 41 metres and costing about a lakh of rupees, was supported by silver columns and surrounded by a silver railing. The Diwan-e-Am was enclosed by a golden railing, while the throne was provided with a special canopy, fringed with pearls and supported by golden pillars, wreathed with bands of studded gems. In keeping with the grandeur of the occasion, the emperor distributed lavish gifts to commemorate the day that saw the birth of the Red Fort. The Begum Sahiba received one lakh rupees and Prince Dara was presented a special robe of honour, jewelled weapons, an increase from the rank of 10,000 to 20,000 horses, a caparisoned elephant and two lakh rupees.

The princes, Sulaiman Shikoh and Sipihr Shikoh, received daily allowances of 500 rupees and 300 rupees respectively in addition to their original pay. The Prime Minister (*Wazir*), Sa'dullah Khan, got a robe of honour and a *nadri* with the rank of 7,000 horses. Makramat Khan received the rank of *Panj Hazari*.

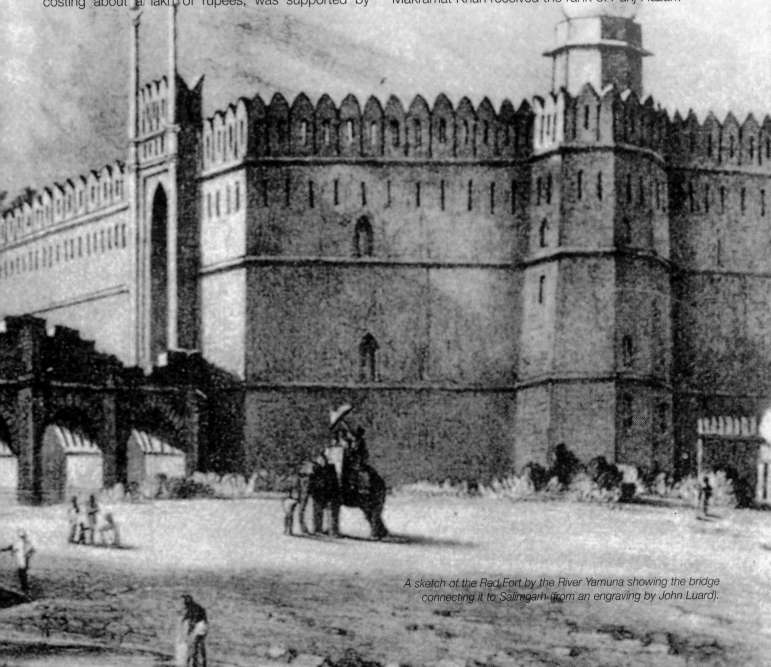

A sketch of the Red Fort by the River Yamuna showing the bridge connecting it to Salimgarh (from an engraving by John Luard).

4
Troubled Times

Emperor Shah Jahan, the grand Mughal architect of many splendid monuments, was not destined to enjoy his creations for long. His last days were dotted with intrigues and mishaps, sorrow and tragedy. Confined to a room in a tower facing the Taj Mahal, he died a broken man in January 1666. Sadly, the art that had developed under him found no encouragement from his son and successor, Aurangzeb, who was an iconoclast. With his zeal for religion and thirst for limitless dominion, he dealt a fatal blow to his empire. Aurangzeb's insistence on keeping all the reins in his own hands resulted in his never having the time to do justice to them. The finances of the empire were in utter disorder. In 1705, Aurangzeb was so ill as to inspire the worst misgivings among his retinue. His eldest son was held captive while his third son was in exile. He had imprisoned another son for seven years. Only the youngest, Kam-Baksh, was given some regard by the emperor.

It was on Friday, 4 March 1707, after a reign of almost five decades that Emperor Aurangzeb breathed his last. The empire started to disintegrate. An inevitable struggle for the throne followed his death. Bahadur Shah I overpowered his brothers and took over what was left of the empire. After Bahadur Shah I died in Lahore, his sons had to go through a civil war in order to establish succession. Other races ravaged the empire; the Marathas advanced to the very gate of the Red Fort and the Afghans seized Kandahar. Of such little importance were the successors of Aurangzeb, in death as in life, that not one has a mausoleum to mark his grave and it is not known for certain where some of them are buried. Shah Alam, who was blinded by Ghulam Qadir, remained a prisoner in the Red Fort in the hands of Ghulam's conquerors, the Marathas, until rescued by Lord Lake in 1803. Two kings, who were not yet adults, were set up by the Sayyids but they died of consumption, and then came Mohammad Shah, the last Mughal to sit on the exquisite Peacock Throne in the Red Fort. Early in 1738, Persian King Nadir Shah crossed the River Indus and was on his way to Lahore. The emperor was not strong enough to face the army of Nadir Shah; so he decided to meet Nadir Shah in his camp, accompanied by a scanty retinue to settle the terms of peace. It was decided that the Persian army would rest in Delhi, while Nadir Shah would collect an indemnity for the trouble and expense incurred in coming this far. The two emperors, the Persian on a horse, the Mughal on an elephant, entered Delhi and were lodged in the Red Fort; Nadir Shah making his

An artist's impression of Shah Jahan looking at the Taj Mahal.

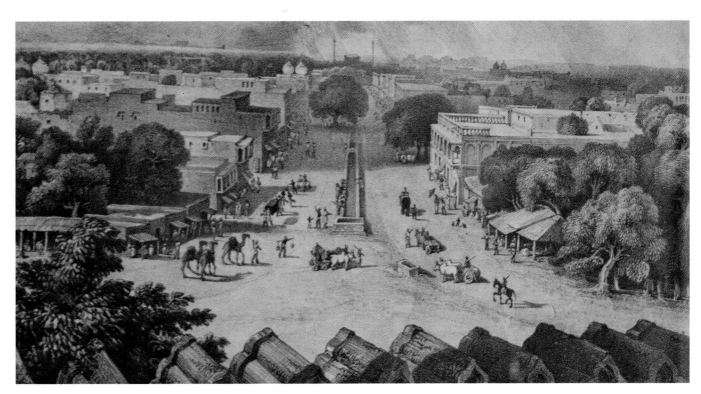

Chandni Chowk—the principal street of Delhi before 1857.

headquarters in the Diwan-e-Khas. A false rumour originated that Nadir Shah had been murdered on the command of the Mughal emperor. The citizens of Delhi rose in sheer blind terror and fell upon the Persians. At midnight the officers of Nadir Shah, frightened and trembling, told their master that 3,000 of his men had been murdered. In retaliation, Nadir Shah seized his sword and issued the order for slaughter.

Chandni Chowk, Dariba Bazaar and the buildings round the Jama Masjid were set on fire through nine fearful hours of destruction. Nadir Shah watched the carnage from the Golden Mosque in Chandni Chowk. Mohammad Shah and the nobles of Delhi approached him with a plea for mercy. The massacre ceased the instant Nadir Shah gave the order. Many thousands (some say 20, some a 100,000) lay dead amid their burning homes. Nadir Shah seized all the royal jewels and started out for Persia with the most skilful workmen and artisans of Delhi. He also took back with him the magnificent Peacock Throne. On his way to Persia, however, Nadir Shah was assassinated in his tent by his own followers in 1747. His empire fell into the hands of an Afghan chief, Ahmad Shah Daurani, who marched to Delhi the next year. There, he met the army of Emperor Mohammad Shah. He killed the *Wazir* of Delhi. This broke the heart of the emperor and he died soon after. Titular and feeble emperors succeeded him; each

reigned for barely a few years. Ahmad Shah Daurani returned once more to India in 1756. His troops repeated the horrors of Nadir Shah's invasion. In 1759 he returned to India again, and his approach was the signal for the murder of Emperor Alamgir II. Delhi was then attacked by the Rohillas and the Pathans. It is said that the aged Emperor Shah Alam was blinded in the Diwan-e-Khas in August 1788 and imprisoned by the brigand Rohilla chief Ghulam Qadir. Some months later the emperor escaped through Salimgarh with his followers, crossing the five-arched bridge that connected it with the Red Fort. The Rohillas stripped many of the rooms of the Red Fort of their marble ornaments and picked out the stones from the borders of many floors. In November 1806, Mohammad Akbar Shah II succeeded his father, Shah Alam. He was a mild and benevolent prince, more suitable to reign under the protection of the British Government than in the troubled times of his unfortunate father and his immediate predecessors. Akbar Shah died in September 1837 at the age of 81 and his eldest son Bahadur Shah II succeeded him. However, by then Delhi was under the charge of the British Army and Bahadur Shah was only a puppet king.

This heralded the beginning of the end of a great empire, witnessed by the Red Fort. The citadel was to become the centre again of many of the dramatic events that would shape Indian history.

5
An Empire is Lost

The Red Fort is an important testimony of Mughal grandeur and a magnificent era that ended with the exile of its last emperor, Bahadur Shah II. The uprising that broke out in northern and central India during 1857, known as the Sepoy Mutiny or India's First War of Independence, was bound to have its tremors felt at the Red Fort where Bahadur Shah lived and held court. Though an ineffectual leader, the people turned to him during this stage of rebellion and unrest.

Actually, the history of this revolt can be traced right back to the days of Robert Clive and the East India Company. It was Clive who laid the foundation of the British rule in India in 1765. By 1856 most of India was under the control of the East India Company. During this period Lord Dalhousie, an imperialist, initiated the policy of Doctrine of Lapse.

According to this policy, if the ruler of a dependent state died without a natural heir, the state would be annexed by the British and not inherited by the adopted son. Bahadur Shah was also told that his successors would not be regarded as kings and would have to abandon the Red Fort. Thus, by 1856, the British Empire was at its zenith but, ironically, discontentment against the British rule was also brewing.

The immediate reason for revolt, however, was the rumour that the cartridges used for battle were greased with the fat of cows and pigs, offensive to both the Hindus and the Muslims respectively who refused to use the new Enfield rifles. Beginning at Barrackpore, the rebellion soon spread. The soldiers at Meerut got together and marched to Delhi where they were joined by soldiers from Delhi. The forces captured Delhi and they proclaimed Bahadur Shah II, later known as Bahadur Shah Zafar, the Emperor of India.

Bahadur Shah is believed to have held daily *durbars* at the Red Fort during the occupation of Delhi by the freedom fighters. Questions regarding payment of these troops and reports on the progress of the fighting were discussed here and letters were written to induce others to join the revolt. Suspected traitors were also dealt with and *nazars* (presents) given to those who were loyal.

The emperor, however, was treated with scant ceremony, his orders generally disregarded. When the occupation of the city by the British was just a matter of days, the Red Fort became a site of pandemonium. The freedom fighters, cavalry and infantry, occupied the beautiful gardens, damaging them considerably. Magazine stores were kept by them in the Diwan-e-Khas, where they also spread their beddings. The emperor gave orders to the rebel troops not to occupy the royal premises and the cavalry was told to evacuate the gardens. These places had never been entered on horseback even at the time of Nadir Shah, Ahmad Shah Daurani or by any of the British governor generals.

On 11 May 1857, the sepoys from the mutinying regiments at Meerut arrived in Delhi and clamoured for admittance to the Red Fort, declaring that they had killed the British at Meerut. Captain Douglas of the Palace Guard wished to go down and speak to them, but was dissuaded by Bahadur Shah. He, therefore, contented himself by addressing them from the balcony of the Musamman Burj. The sepoys of the Palace Guard, belonging to the 38th Native Infantry, admitted the freedom fighters. Captain Douglas proceeded to the Calcutta Gate in order to speak to the rebels. But the party was attacked by the sepoys and forced to retreat to the Lahore Gate of the Fort. The Native Infantry on guard refused to fire on the freedom fighters and Simon

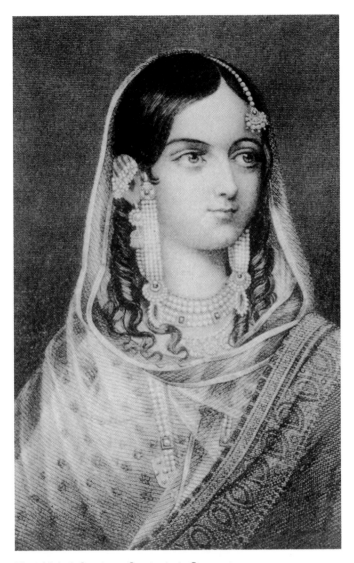

Zinat Mahal. Courtesy: Swatantrata Sangram Sangrahalaya, Red Fort.

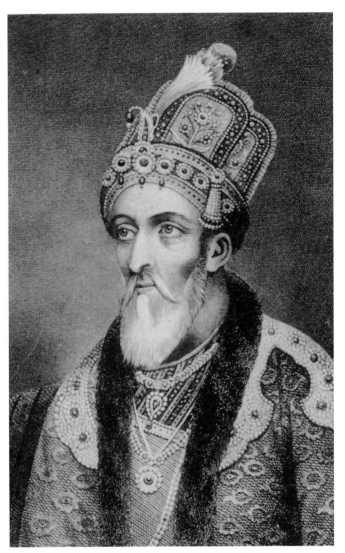

Bahadur Shah Zafar. Courtesy: Swatantrata Sangram Sangrahalaya, Red Fort.

Fraser, Commissioner, Delhi, rebuked them for their behaviour. He then turned to mount the steps leading to the rooms in the upper part of the Lahore Gate. As he placed his foot on the first step, two men rushed forward and cut him down. Captain Douglas, already wounded in the ankle, was carried upstairs. He gave orders for all doors and windows to be closed. The news of the death of some more officers reached the Fort, followed by the arrival of a regiment of cavalry who took up their positions at the Diwan-e-Khas. Many of the men forced their way into the Fort that had by now become a scene of the wildest confusion.

Formerly, a silver throne had been kept in the Diwan-e-Khas, where the emperor sat on special occasions, but since 1842 this practice had been discontinued. The throne was placed in a recess, in a passage behind the emperor's sitting room and had been in disuse till 12 May 1857, when it was brought out again for him.

The emperor left the Red Fort and proceeded through the city on an elephant to allay the fears of the inhabitants. On his return, he found the Diwan-e-Khas full of soldiers and pointed out that the enclosure was only meant for royalty. But the emperor's words were disregarded. On 14 May, he was so distracted by the turmoil around him that he refused to meet anyone.

Bahadur Shah ordered a search for the bodies of Simon Fraser and Captain Douglas so that they could be given a Christian burial. A couple of days later, a large number of freedom fighters assembled before the palace and threatened the emperor, accusing him of concealing about 40 Europeans. They also threatened to abduct Zinat Mahal, the Queen, and hold her hostage for the emperor's loyalty. On this day, at about ten in the morning, all the Europeans in the palace, principally women and children, were murdered in cold blood near a tank in the centre of the square, before the Naubat

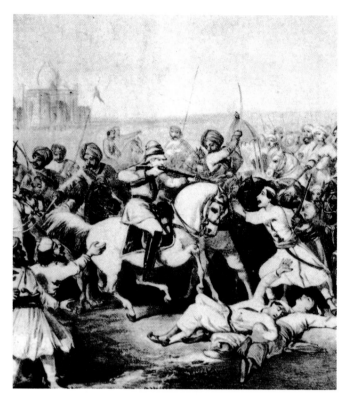

Capture and death of the princes of Delhi at Khooni Darwaza.

Capture of two princes Mirza Buktawar and Mirza Mendhoo at the Qutb Minar.

Khana. On 12 May, the palace was crowded with a howling mob of men demanding their pay. Bahadur Shah left the Red Fort a few days later and proceeded to the Jama Masjid for prayers. The next day it was discovered that someone had filled the guns in Salimgarh with stones. Hakim Ahsanullah Khan was suspected and narrowly escaped with his life. The killings continued. An unnamed European, dressed as a Hindu fortune-teller carrying an almanac, was brought to the Red Fort and murdered. News poured in that the freedom fighters had been defeated by the British at Hindon. Subsequently, many wounded men appeared in the city. The emperor was perplexed at the turn of events.

News of the massacre of the British at Bareilly reached the Red Fort on May 31 and, on the same day, the emperor issued orders that he would no longer receive any petitions in person. All petitions would have to come through Mahbub Ali Khan and Hakim Ahsanullah Khan. Some soldiers came forward and asked permission to raise the flag of *jihad* (religious war). On June 10, the emperor issued a proclamation for the forcible opening of all shops in the city. The freedom fighters lost heavily in duel on the same day, while some hundred Englishmen were also killed. Their heads were cut off and paraded through the city. The next day, the emperor ordered 100 mounds of gunpowder to

be prepared. A confidential report was received that the Queen of England, on news of the First War of Independence, had ordered the dispatch of 24,000 troops. Bahadur Shah expressed displeasure at the failure of the freedom fighters to drive away the British. On June 17, seven carts with lime were dispatched for the repair of Salimgarh, while a cannon that had been lying at the door of the palace, since the time of Shah Jahan, was mounted at the Lahore Gate.

At a large *durbar* held a few days later, Bahadur Shah received reports about the state of affairs. He addressed the *sardars* (leaders) of the sepoys and pointed out that they were destroying a kingdom that had lasted 500 years. He expressed the wish that they should all leave the city and the following day issued a general order to this effect.

On 2 July Muhammad Bakht Khan, a Bareilly mutineer, was appointed Commander-in-Chief and given full control, not only of the army but of the civil administration as well. The days of bloodshed at the Red Fort and its surrounding areas seemed to be endless. Bahadur Shah visited the battery at Salimgarh and also held *durbars* at the Red Fort. These were days of turmoil and despair when hope was negligible. Finally, on 14 September 1857, the British with their allies took the city, sacking, looting and plunging in

massacre in cold blood great swathes of the population. In one *mohalla* (locality), Kucha Chelan, some 1,400 people were cut down. The emperor, therefore, remained in his private apartments. The British assault proved successful and Bakht Khan told the emperor that his only safety lay in flight and begged him to accompany him. Bahadur Shah, however, allowed the army to depart without him and took refuge in Delhi's Humayun's Tomb. On the same day, the Lahore Gate at the Red Fort, which appeared to be totally deserted except for an occasional gunshot fired at the troops at the end of Chandni Chowk, was blown up. The Punjab Infantry broke the chain of the inner gate by firing muskets close to it and they charged down the vaulted passage (Chhatta Chowk) into the palace. A single sentry remained in the passage and he fired directly at Lieutenant McQueen, but the bullet went right through the officer's helmet.

Lieutenant Hodson captured the emperor a few miles south of the city, and on the following day the princes, Mirza Mughal, Mirza Khizr Sultan and Mirza Abu Bakr, were taken into custody at Humayun's Tomb. They were placed in a bullock cart and brought to the city. When they reached near the Delhi Gate, Lieutenant Hodson shot the princes at the place that is known as the Khooni Darwaza. On that day a royal salute was fired in honour of the capture of the city and a thanksgiving service was held in the Diwan-e-Khas. The following January, the emperor was brought to the Diwan-e-Khas and kept in a cell, where he stayed for 40 days of trial in gloom. Not a word did he speak. In silence he sat with his eyes cast on the ground. Some heard him quoting verses of his own composition:

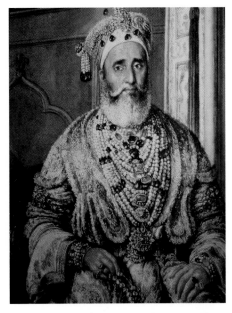

Bahadur Shah was confined to his bed during the days of his trial. Courtesy; Swatantrata Sangram Sangrahalaya, Red Fort.

Lagta nahin hai jii mera, ujray dayar mein
Kis ki banii hai aalam-e-na-payedar mein

Kah do in hasarataun se kahiin awr jaa basen
Itanii jagah kahan hai dil-i daaghdaar mein

Umr-i daraaz maang ke laaye the chaar din
Do aarazu mein kat gaye do intizaar mein

Hai kitana badanasiib Zafar dafn ke liye
Do gaz zamiin bhii na milii ku-i yaar mein

The English translation reads:

My heart is not happy in this despoiled land
Who has ever felt fulfilled in this transient world

Tell these emotions to go dwell elsewhere
Where is there space for them in this besmirched (bloodied) heart

I had requested for a long life a life of four days
Two passed by in pining, and two in waiting

How unlucky is Zafar! For burial
Even two yards of land were not to be had, in the land (of the) beloved

Bahadur Shah surrenders. Courtesy: Swatantrata Sangram Sangrahalaya, Red Fort.

After an investigation that lasted for 40 days, Bahadur Shah Zafar was convicted for having made war against the British, the reigning sovereign of India, and with causing, or being accessory to, the death of many Europeans. He was exiled and sent to Rangoon where he died on 7 November 1862.

History reveals that the sacrifices that took place at the Red Fort during these eventful days in 1857 did not go in vain. The revolt shook the British. The misrule of the East India Company came to an end and was replaced with direct rule of the British Crown and Parliament.

6
History on Trial

The First War of Independence, coupled with the socio-religious reforms introduced at the time, spread consciousness among the people and a different kind of movement began to take shape. This soon took the form of a countrywide struggle for freedom and ultimately led to the formation of the Indian National Congress (INC) in 1885.

Feelings of patriotism found expression in immortal songs and poetry, works of literature. At the convention of the INC in 1896, Rabindranath Tagore sang the immortal song, *Vande Mataram*, composed by the novelist Bankim Chandra Chatterjee.

In the beginning, the British had a sympathetic attitude towards the Congress but it soon changed and they adopted a policy of divide and rule. Some of the new Indian leaders such as Bal Gangadhar Tilak, Lala Lajpat Rai, Aurobindo Ghosh and Bipin Chandra Pal had by then emerged on the scene. Fiery speeches of Tilak shook both, his countrymen and the British. He declared in unambiguous terms, '*Swaraj* is my birthright and I shall have it.'

The partition of Bengal in October 1905 saw the INC enter its second phase—which was dominated by the Extremists. Through the different stages of the national movement, the Congress merged more and more with the people and encouraged them to fight together as a nation. In 1906, the Muslim League was formed under the leadership of Salimullah Khan, with the support of the British Government. Two important declarations

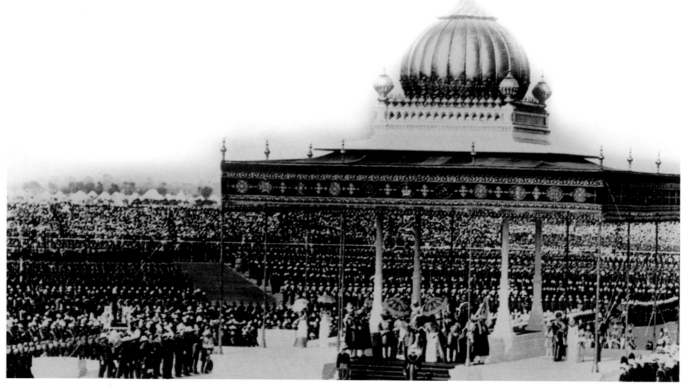

Coronation Durbar, Delhi.

The Red Fort trial of Shah Nawaz Khan, Prem Kumar Sehgal and Gurbaksh Singh Dhillon. Courtesy: Swatantrata Sangram Sangrahalaya, Red Fort.

were made at the Delhi Durbar of 1911, when King George V and Queen Mary visited India. One was that the capital of British India would be shifted from Calcutta (Kolkata) to Delhi and the other was the annulment of the partition of Bengal. Far away in Europe, North America and some Asian countries, many Indians set up revolutionary centres. These included Shyam Krishna Verma, V.D. Savarkar, Madan Lal Dhingra, Madame Bhikaiji Cama, S. Dutt, Barkatulla and Champakarman Pillai. Madame Cama designed a flag for free India and unfurled it at the International Socialist Conference in Stuttgart, Germany, in August 1907. At this stage Mohandas Karamchand Gandhi (Mahatma Gandhi) entered the national movement and founded the Sabarmati Ashram at Ahmedabad where he preached the ideals of truth and non-violence. He soon became the leader of the masses across the country.

In the morning hours of 10 April 1919, a crowd had been proceeding towards the residence of the Deputy Commissioner of Amritsar to demand the release of two popular leaders—Dr. Satyapal and Dr. Saifuddin Kitchlew—against whom deportation orders had been issued. The crowd was fired on by a military picket. Later in the day, violence erupted and spread throughout the city.

In Amritsar, the police provoked violence by firing on unarmed demonstrators. The city was handed over to Brigadier-General Dyer on 13 April 1919. Thousands of people, unaware of the curfew imposed gathered at Jallianwala Bagh where Dyer ordered firing without any warning. Hundreds of innocent people were killed. In protest, Tagore renounced his knighthood and Gandhi returned the Victoria Cross.

The Lahore session of the INC in 1929 was presided over by Pandit Jawaharlal Nehru, in which the Congress demanded complete independence. In 1929, the Hindustan Socialistic Republic Association was formed. Two of its active members, Bhagat Singh and B.K. Dutt, threw a bomb in the Central Legislative Council and shouted *'Inquilab zindabad'* to protest the introduction of a public safety bill. While Jatin Das died after a hunger strike, Bhagat Singh, Sukhdev and Rajguru were hanged in 1931.

In August 1942, the Congress intensified the Quit India Movement. There were countrywide strikes and processions in open defiance. Netaji Subhash Chandra Bose resigned from the Congress and formed the Forward Bloc but was soon arrested for his inflammatory speeches. However, he escaped in 1941 to Afghanistan, and from there to Russia and then to Germany and finally to Japan. With the help of the revolutionary Rash Bihari Bose, he formed the Indian National Army (INA) or Azad Hind Fauj. The INA fought many battles and openly defied the British.

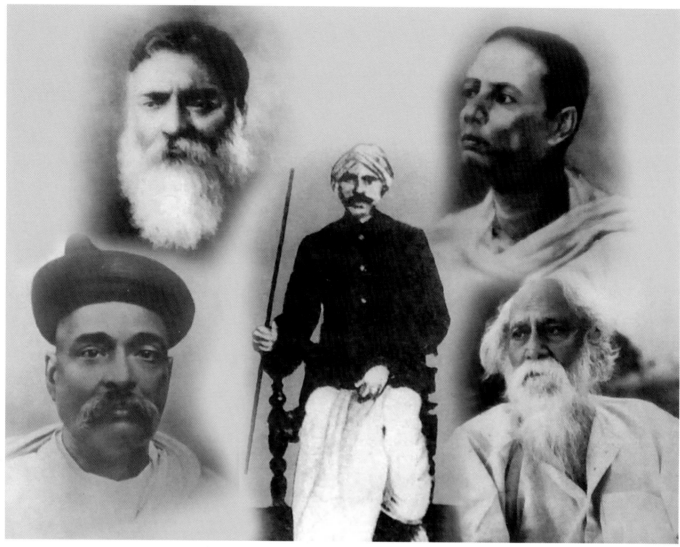

Heroes of the Swadeshi Movement—(anti-clockwise) Krishna Kumar Mitra, Lokmanya Bal Gangadhar Tilak, Subramaniam Bharti, Rabindranath Tagore and Brahm Bandhu Upadhyay.

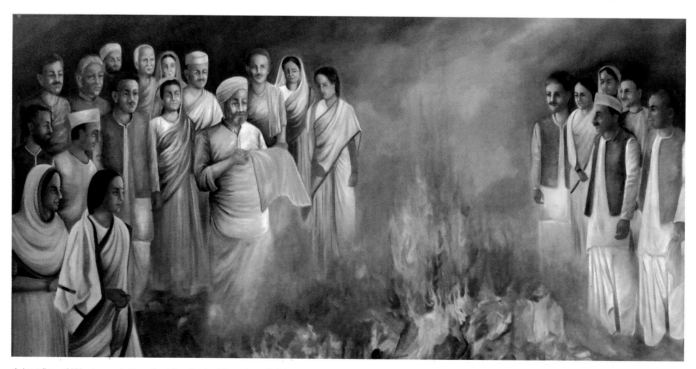

A bonfire of Western clothes by Khadi-clad freedom-fighters.

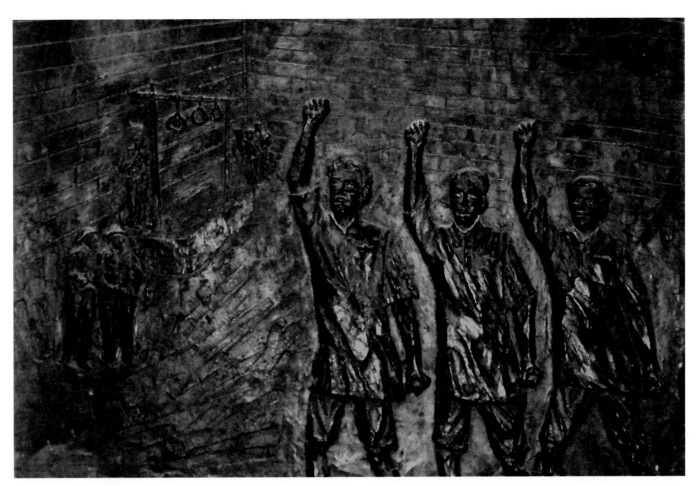

The supreme sacrifice of Bhagat Singh, Sukhdev and Rajguru. Courtesy: Swatantrata Sangram Sangrahalaya, Red Fort.

However, following the collapse of the Japanese in the Second World War, the INA was defeated and forced to surrender. The British imprisoned the INA officers, transported them to India and lodged them at the Red Fort. About 17,000 men of the INA are believed to have been held as prisoners of war. Ironically, the very men who ought to have marched to Delhi as victors, hoisted the national flag on the ramparts of the Red Fort and held a victory parade there, were now declared prisoners. Inside the Red Fort, they awaited a trial for waging war against the British.

It was only after the Second World War ended, in mid-August 1945, that rumours were heard in India that some INA men were confined in the Red Fort and that six of them had already been shot. The subject was too dangerous for public comment with the war still on. But on 20 August, Pandit Jawaharlal Nehru in his first statement to the press said: 'It would be a very grave mistake, leading to far-reaching consequences, if they were treated just as ordinary rebels. The punishment given to them would in effect be a punishment to all of India and all Indians and a deep wound would be created in millions of hearts ...'

This set the tone for the whole country and the INA became a burning topic. The public demanded the immediate release of the INA prisoners. Mahatma Gandhi, who was then staying at Harijan Colony in Delhi, met the INA officers at the Red Fort.

In a Foreword to Moti Ram's classic documentary record of the historic Red Fort trial of Captain Shah Nawaz Khan, Captain Prem Kumar Sehgal and Colonel Gurbaksh Singh Dhillon, Jawaharlal Nehru wrote on 17 January 1946: 'The trial dramatised and gave visible form to the old contest "England versus India". It became a trial of strength between the will of the Indian people and the will of those who held power in India. And it was that will of the people that triumphed in the end.' Shah Nawaz, Sehgal and Dhillon were tried by a military court presided over by Major General Blaxland. The trial took place on the second floor of a dormitory inside the Red Fort. It was open to the press and the public. The country was literally flooded with columns of newspaper reports of the proceedings. A headline in the *Hindustan Times*, 4 November 1945, stated: 'INA trial opens in Red Fort, charges of murder and waging war against the King,

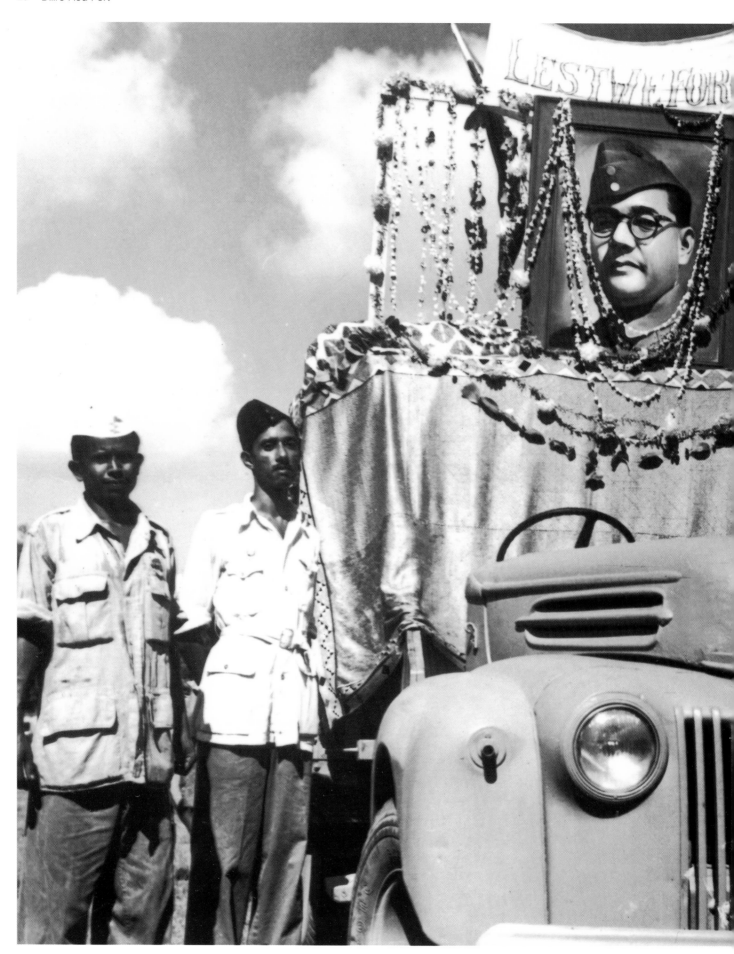

A portrait of Netaji Subhash Chandra Bose being carried to the Red Fort during the Independence Day celebration on 15 August 1947.
Courtesy: Photo Division, Ministry of Information and Broadcasting, Government of India.

Defence asks for three weeks adjournment.' British and American news agencies and newspapers also sent their men to Delhi to report the trial. The court martial began on 5 November and ended on 31 December 1945. The three accused were in their uniforms minus their badges of rank. The court described them by their original ranks in the British Army and referred to them as Captain Shah Nawaz, Captain Sehgal and Colonel Dhillon. To the rest of India, they were known by their INA ranks, namely, Major General Shah Nawaz, Colonel P.K. Sehgal and Colonel G.S. Dhillon. The chargesheet was read out to them. There were many charges against each of them individually but the one common charge against all three was that they had waged war against the King. They pleaded not guilty. Donning his barrister's robe after a lapse of some thirty years, Jawaharlal Nehru was the cynosure of all eyes in the courtroom.

In view of Sir Tej Behadur Sapru's indifferent health, Bhulabhai Desai was entrusted with the responsibility of conducting the defence in close consultation with his other colleagues of the defence committee. Day after day, Desai went to the Red Fort and there, in a tented enclosure, he met Shah Nawaz, Sehgal and Dhillon and a number of other INA officers detained in the Red Fort, to prepare the case of the defence. The Red Fort reverberated with shouts of 'Jai Hind'. An outstanding and romantic figure in the Red Fort those days was General Mohan Singh, the creator of the first INA Trial in 1942, who defied the Japanese. Mohan Singh and other INA leaders ordered the INA to disband after severe disagreements with the Japanese. Mohan Singh was subsequently arrested by the Japanese and exiled to Pulau Ubin. He preferred to remain in detention till the war was over.

On 3 January 1946, the court martial found the three accused officers guilty of waging war against the King and sentenced them to transportation for life, cashiering and the forfeiture of arrears of pay and allowances. The Commander-in-Chief remitted the sentence of transportation for life against them but confirmed the sentence of cashiering and the forfeiture of arrears. The three officers were released on the same day. The country went delirious with joy and the heroes of the Red Fort trial were overwhelmed by the uproarious welcome they received wherever they went. History had once more been made in the Red Fort and the mighty monument stood a silent witness to these significant happenings.

7
Tryst with Destiny

Barely had the curtain fallen on the INA drama that it rose again on the final act of the British regime in India that came to an end eighteen months after the historic INA trial. Lord Louis Mountbatten succeeded Lord Wavell as the last British Viceroy of India and he delineated a schedule for the withdrawal of the British from India. Mountbatten stayed for some time as independent India's first Governor General and was succeeded by C. Rajagopalachari.

Jawaharlal Nehru became independent India's first Prime Minister on 15 August 1947. The very next day, he hoisted the national flag of free India over the turreted battlements of the historic Red Fort. The old guards of the INA rallied to redeem an unfulfilled pledge and held a victory parade inside the Red Fort. The words of India's first Prime Minister, spoken at the Red Fort, are part of our history. 'We are a free and sovereign people today and we have rid ourselves of the burden of the past. We look at the world with clear and friendly eyes and at the future with faith and confidence,' said Nehru triumphantly. 'The burden of foreign domination is done away with, but freedom brings its own responsibility and burden, and they can only be shouldered in the spirit of free people, self-disciplined and determined to preserve and enlarge that freedom.' Over the years, the Red Fort has become synonymous in India with our Independence Day, 15 August, when the Prime Minister of the country delivers an address to a vast gathering from the ramparts of the Lahore Gate.

The citadel, the witness of many historic events, is certainly the most appropriate venue to commemorate India's freedom struggle and the Swatantrata Sangram Sangrahalaya museum was thus set up in its premises. The museum provides a glimpse into the major phases of India's struggle for freedom, including the INA trial at the Red Fort.

Here, history is depicted through photographs, documents, posters, paintings, lithographs; objects such as guns, pistols, swords, shields, rank badges, medals, dioramas, panels in relief, busts, sculptures and more. India's then Prime Minister, PV Narasimha Rao, said on 27 September 1995, while dedicating the museum to the nation and to the memory of the heroic men and women, peasants and workers, students and professionals who participated in the attainment of *swaraj*: 'The establishment of the Swatantrata Sangram Sangrahalaya has come not a day too soon. The museum will be a tribute to those great sons and daughters of India who participated in the freedom struggle and who have left a lasting legacy for generations of Indians to admire and emulate. The museum will capture the events of those momentous times. Every individual who walks into the museum will be able to experience the spirit of the freedom struggle and the trials and tribulations of those known and unknown leaders and men and women across the length and breath of India to whom we owe our freedom today.'

He commented that millions of people from India and abroad visit the historic Red Fort to get a glimpse of India's heritage. So it was only fitting that the museum should be located in the Red Fort for it saw the beginning of the First War of Independence in 1857 and it was also in the barracks of the Fort that the freedom fighters were tried. The Red Fort is a symbol of free India. Each brick here reverberates with anecdotes from India's rich past. A walk through the Red Fort, amid the ruins and the remains, is like turning the pages of history.

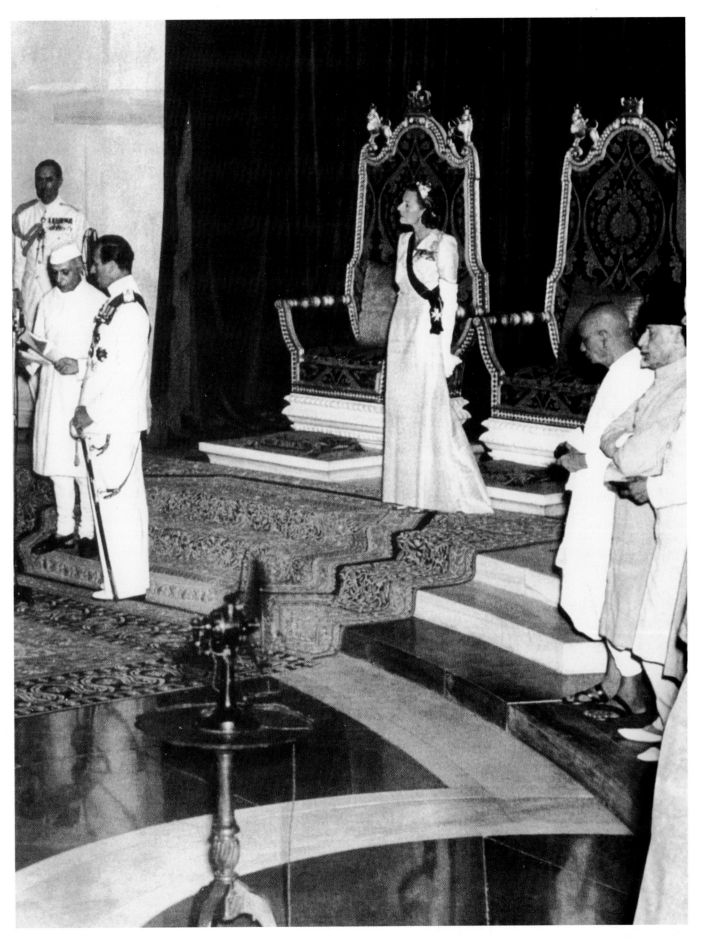

Pandit Jawaharlal Nehru being administered the oath of office as the first Prime Minister of independent India on 15 August 1947 by Lord Mountbatten, the Governer General. Also seen are Lady Edwina Mountbatten, Sardar Vallabhbhai Patel and Maulana Abul Kalam Azad. Courtesy: Nehru Memorial Museum and Library.

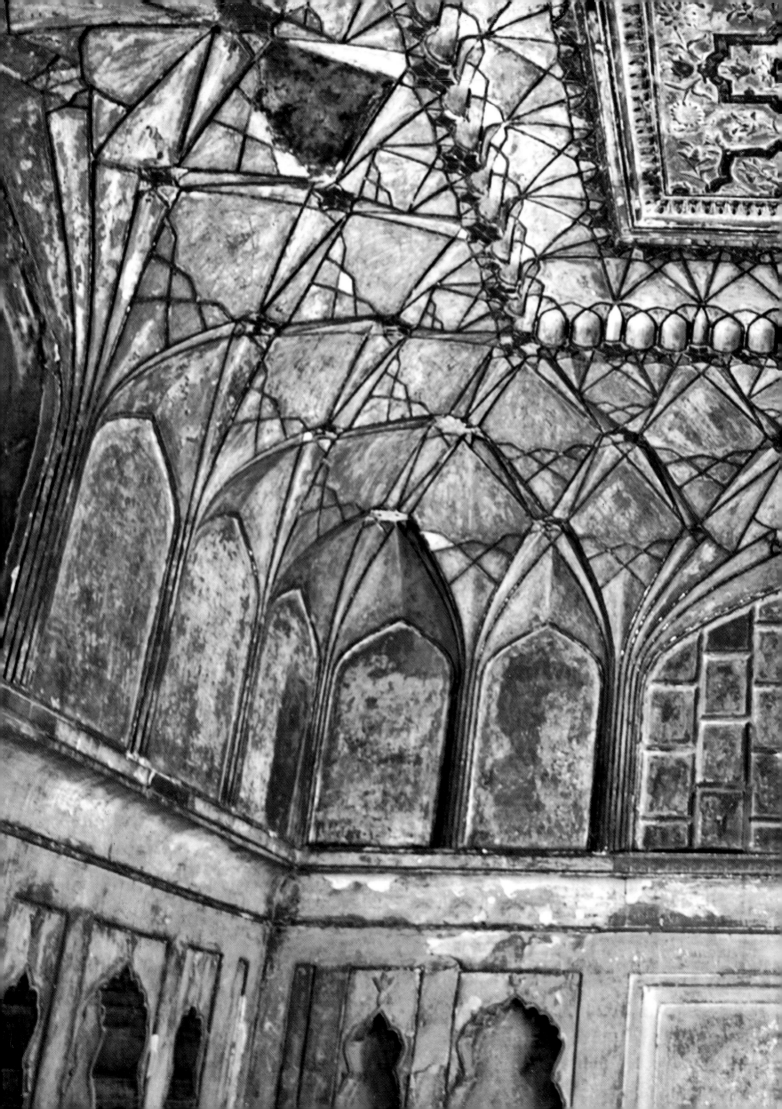

PART II

Inside Out

1

The Fortunate Citadel

*Praise be to God! How beautiful
are these painted mansions and
how charming are these residences:
a part of the high heaven. When I say the
high-minded angels are desirous of
looking at them, if people from different
parts and directions [of the world] should
come [here] to walk round them as [they walk]
round the old house [Ka'ba], it would be
right; and if the beholders of the two worlds
should run to kiss their highly glorious threshold
as [they kiss] the black stone [of Ka'ba],
it would be proper. The Lord of the World,
the founder of these heavenly, pleasant mansions,
Shihabu-d-Din Muhammad, the second
Lord of Felicity, Shah Jahan, the King, Champion
of Faith, opened the door of favour to the
people of the world.*

[English translation of the inscription on the southern and northern arches at the Khas Mahal, said to be the work of Sa'dulla Khan, the *Wazir* (Prime Minister) of Shah Jahan.]

* * *

The Red Fort has inspired many to write about its splendour and glory. Its imposing exteriors and overwhelming interiors combine to create a structure that is simply incomparable. Though both time and man have not been kind to this edifice, it is still considered an important part of any tourist's itinerary for it is the largest of Delhi's medieval monuments. Even today, the walls of the Red Fort, its palaces and pavilions, tell a tale of the dramatic incidents that took place here. Open on all days of the week, except Mondays, the Red Fort attracts the curious and the eager from different parts of the world. They gather here to enter the Lahore Gate and walk down the lanes of yesterday.

In the reign of Shah Jahan and Aurangzeb, the Fort was known as Qila-i-Mubarak (Fortunate Citadel) or Qila-i-Shah Jahanabad and during the reign of Bahadur Shah II, it was called Qila-i-Mualla (the Exalted Fort). Today it is recognised the world over by its red sandstone as the Lal Qila or the Red Fort.

Facts and figures, dimensions and other data combine to underline the marvel of this monument. The citadel lies on the western bank of the River Yamuna, the course of which has since changed and receded towards the east. It is an irregular octagon in plan, with its longer sides on the east and west. It measures approximately 900 metres from north to south and 550 metres from east to west. It has a parameter of 2.41 kilometres along the fortification wall with a height of 33.50 metres on the town side and 18.00 metres on the riverside.

The wall has been constructed in brick masonry, veneered with fine red sandstone. The fortification, along with the ramparts, has been strengthened with broad massive circular bastions at regular intervals and octagonal bastions at corners, with kiosks or *chhattris* crowned with domical cupolas. Such architecture has rarely been seen in Delhi.

The Red Fort has an aesthetic character that has been skilfully blended with its military requirements. It is surrounded by a moat about 22.86 metres wide and 9.14 metres in depth. On the roadside is a drain with holes for rainwater. It was earlier filled with water and, as recorded by the historian Bernier, the moat was stocked with fish. Adjoining it were large gardens, full of flowers and green shrubs at all times, which, contrasted with the stupendous red wall was a beautiful sight indeed.

Exquisite jali *work in the Red Fort.*

SALIMGARH

SHAH
BURJ

NAHR-E-
BAHISHT

MOTI MAH

HAYAT BAKHSH G

SAWAN

ZAFAR MAHA

MEHTAB BA

Present Buildings

Past Buildings

MUSAMMAN
BURJ

CHOTI
BAITAK

MUMTAZ
MAHAL

ASAD
BURJ

DIWAN-E-KHAS

KHAS
MAHAL

RANG MAHAL

HAMMAM

MOTI
MASJID

DIWAN-E-AAM

NAUBAT
KHANA

STREETS

ARCADED STREETS

DELHI
GATE

BARBICANS

CHATTA CHAUK

LAHORE
GATE

BARBICANS

N

N.T.S.

Conjectural plan of the Red Fort showing Mughal buildings
demolished after 1857, and the existing Mughal buildings.

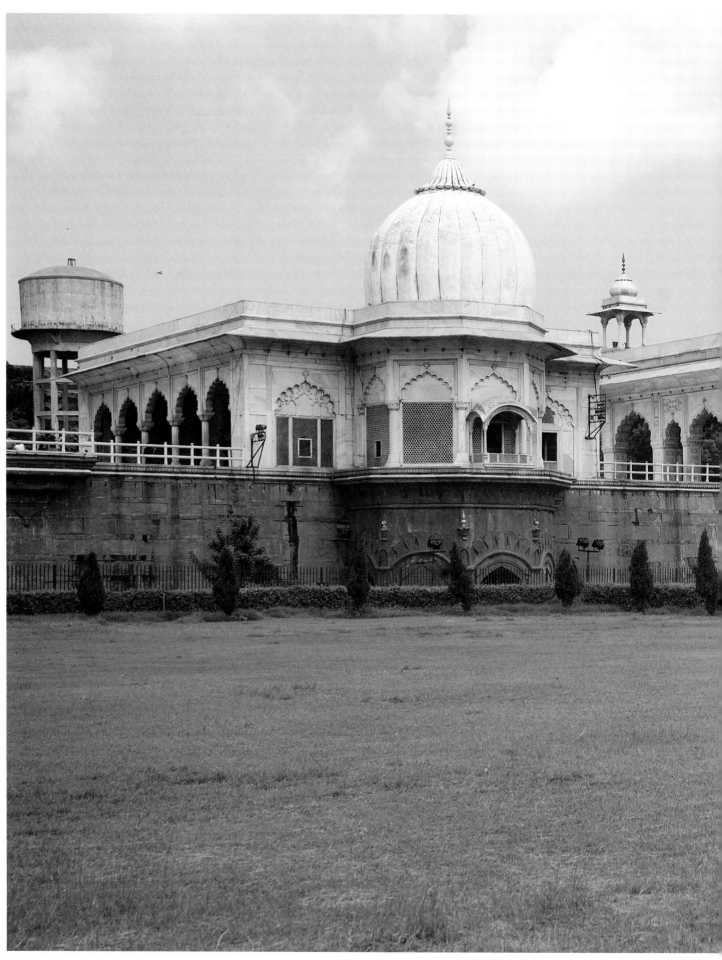

The eastern façade comprising the Mussaman Burj, the Diwan-e-Khas and the Hammam.

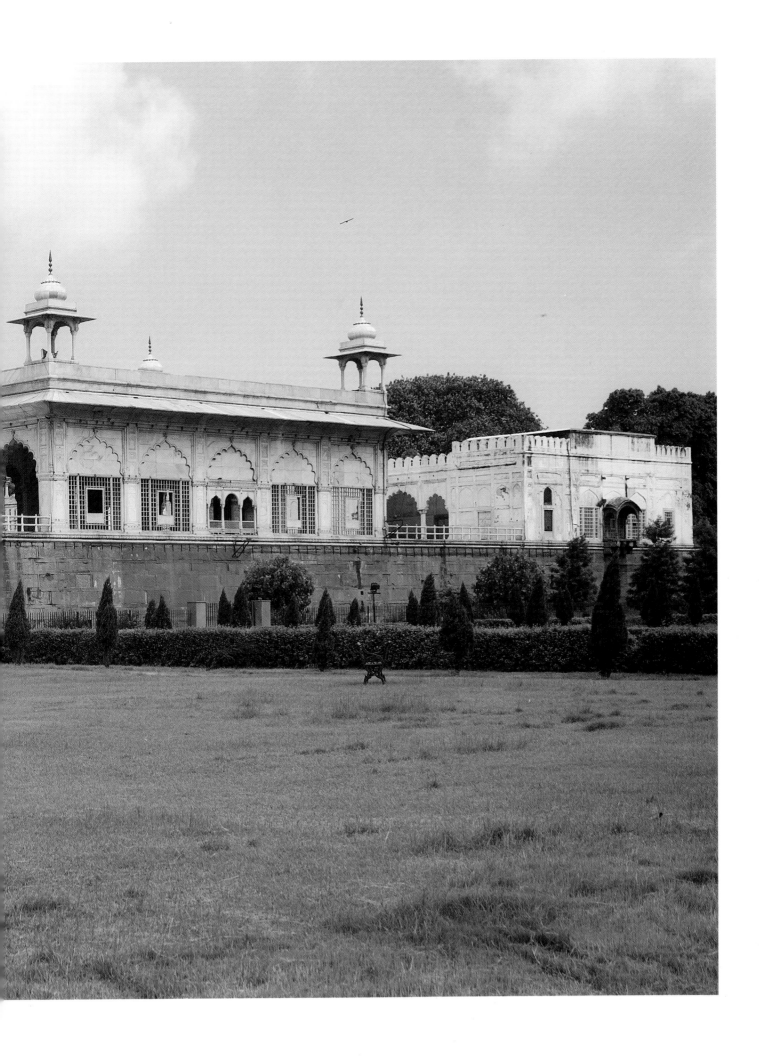

The bridge connecting Salimgarh and the Red Fort over the Ring Road that now faces the eastern façade.

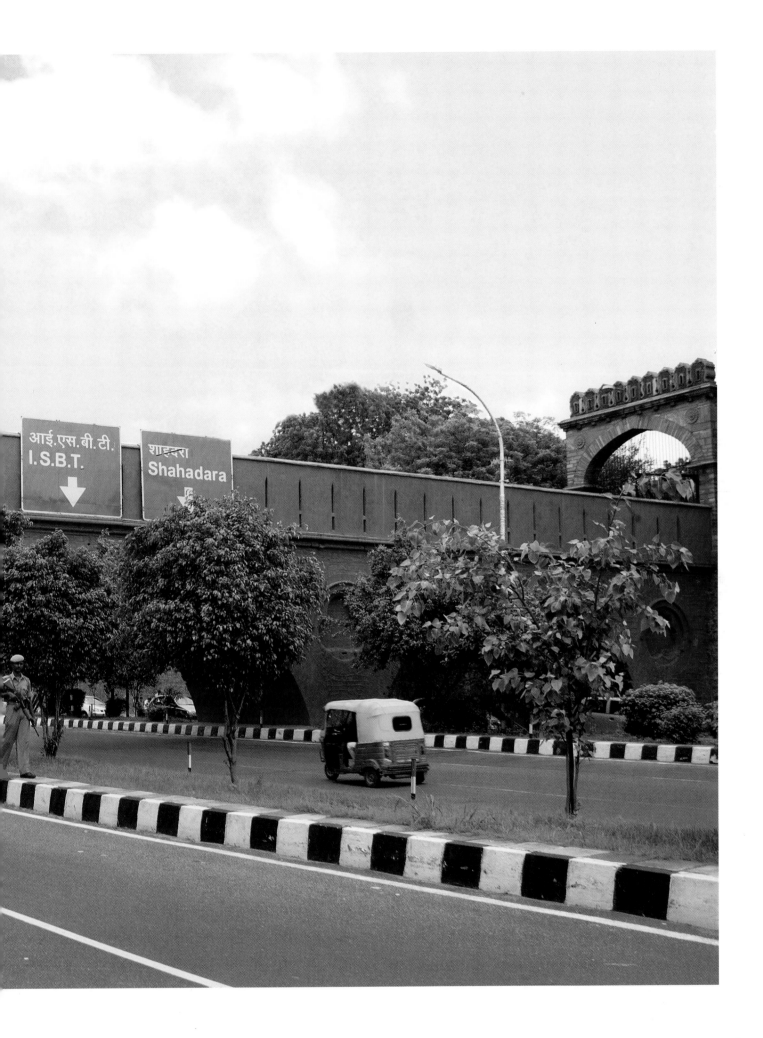

It appears that the Red Fort met the requirements of the forts mentioned in old treatises such as *Devi Puran* and Kautilya's *Arthashastra* as it is partly surrounded by water bodies and moats. Its walls are on the city side and the river surrounded the other sides. It is devoid of any natural protection. Its height also meets the requirements of the categories of forts mentioned in the old treatises. The Red Fort protects the inhabitants from the flow of wind through the city.

Apart from the emperor, his family and servants, the Red Fort housed hordes of courtiers, ministers, scribes, musicians, dancing girls and hangers-on of the oriental court, in addition to the emperor's personal bodyguard, the permanent garrison and a few shopkeepers. It was intended as a fortress, with the palace built inside it for greater safety. Of the 100 lakh rupees spent on the building of the Red Fort, half was spent on the wall and the other half on the buildings within.

The historian Bakhtawar Khan, writing during the reign of Aurangzeb, differs in his detailed break-up of the expenditure. According to him, 60 lakh rupees were spent on the Fort and the buildings within it; 28 lakh rupees on the royal mansions; 14 lakh rupees on the Diwan-e-Khas (including the silver ceiling and fittings); 5.5 lakh rupees on the Imtiaz Mahal (Rang Mahal) with its bed chamber and surroundings; 2 lakh rupees on the Diwan-e-Am; 6 lakh rupees on the Hayat Baksh garden with the Hammam; 7 lakh rupees on the palace of Jahanara Begum and other royal ladies; 4 lakh rupees on the bazaars and squares and 21 lakh rupees on the walls and moat. The workmen's wages amounted to 10 million rupees. The red sandstone and marble was provided by the governors and the kings of the locality. Red sandstone was also brought in large quantities from Fatehpur Sikri by boat.

It took a lot of money, time and effort and the end result was the spectacular citadel that is considered one of Delhi's most beautiful sights. The Red Fort is more than Emperor Shah Jahan's vision translated in sandstone; it is a doorway to a world of architectural splendour. The entire complex of the citadel—fortification walls, gateways, bazaars, palaces, gardens, canals, fountains and so much more—have, sadly, been subject to the vagaries of time and fate. The uprising of 1857 and the events that followed have caused considerable portions of the Red Fort to be either dismantled or shorn of much of its glory. Enough still remains, however, to give some idea of the original plan in all its magnificence.

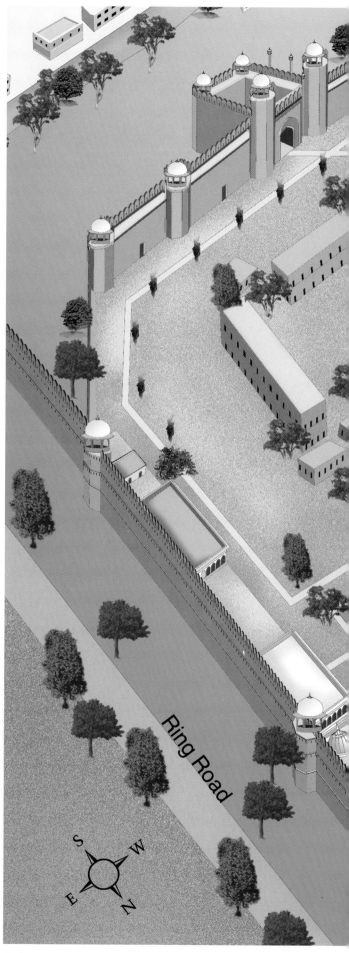

An isometric conceptual view of the Red Fort.

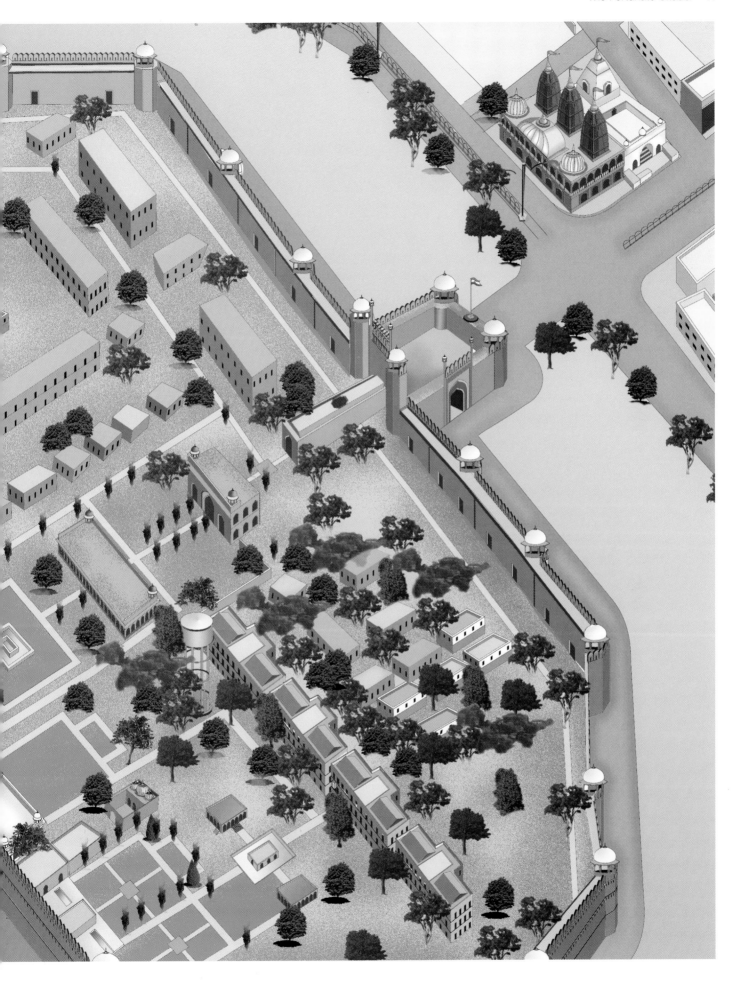

2
Gateways to Immortality

The citadel has in all five gates, among which the best known are the Lahore Gate and the Delhi Gate. The whole structure has been profusely decorated. The architects during Shah Jahan's reign spared no efforts in giving the gates a colour and character suitable to the entrance of an imperial citadel. The magnificence and grandeur of the gateway was, no doubt, intended to impress all visitors to this magnificent edifice.

The exquisite gates were planned ingeniously. The architecture has been devised so as to give the defendants an advantageous position. The lofty and massive structural and octagonal bastions that projected outwards and loomed up were properly safeguarded on either side of the gateway. Battlements with high merlons were provided on the ramparts to shelter the defendants, who could safely fire at the besiegers.

Loopholes and embrasures were built in such a way so as to facilitate the defence. Other devises were provided from where the garrison under cover could spy the exposed besiegers from above and shoot them. A drawbridge, which connected the mighty Red Fort with the mainland, could be easily lifted; this device thus rendered the Red Fort inaccessible to the invading elephants.

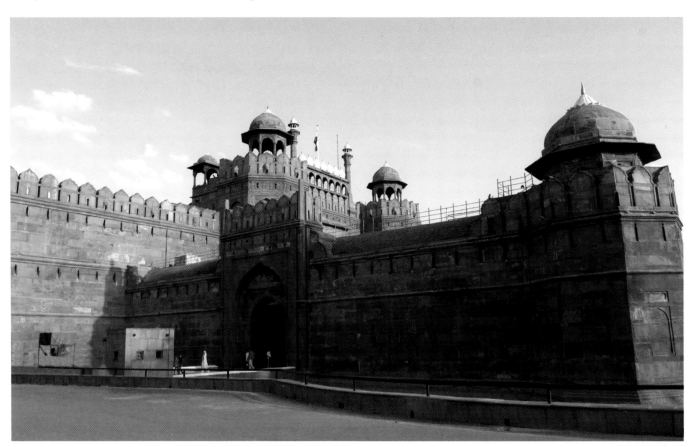

The main entrance to the Red Fort from the Lahore Gate.

Lahore Gate

A long, almost serpentine queue, men and women in separate lines, can be seen waiting to enter the Gate. This Gate is an imposing entrance in the western wall of the Red Fort with wooden doors adorned with brass sheets sporting geometrical designs. It is called Lahore Gate as it faces Lahore, now in Pakistan. It also faces Chandni Chowk, the principal street of the city of Shahjahanabad (Old Delhi).

The entrance has a pointed arch of Gothic character recessed into an arch of the same design, the spandrel of which is embossed. In the central portion is a projected balcony or oriel window shaded by red stone *chhajja* (sloping cornice). This window provides the only ornamentation to the front of the gateway and now remains shut. Its parapet has six *kanjuras* (stepped battlements) in the middle, flanked by another six *kanjuras* on either side. It is further crowned with seven kiosks with white marble miniature domes and spikes. On either side of the kiosks are red sandstone pinnacles that bear marble kiosks crowned with a marble dome and spikes. At this gateway are octagonal towers with embattled parapets, in the top centre of which are arched pavilions crowned with red sandstone domes that have white marble finials. On the rear side of the gate, at the top, are small pavilions of the same design.

The surface of these towers is decorated with sunken niches, some of which had openings that are now closed and railings that are missing at some places.

The Lahore Gate is a three-storeyed gate, octagonal in plan, with chambers on either side, on each floor; the access to the upper floor is through the stairways provided on the inner side of the gateway. The upper floors were occupied by the courtiers and later by an Assistant Resident during the British period. Officers of the Indian Army also lived here. The chambers of the ground floor on either side are now occupied by traders of artifacts. The Gate is additionally protected by a barbican, the work of Aurangzeb. The entrance gate of the barbican is on the north side and measures 12.19 metres in height and 17.31 metres in width. It is surmounted by an embattled parapet, flanked by slender minarets or pinnacles, the finials of which are missing. It is said that Shah Jahan, while in prison at Agra, wrote to his son Aurangzeb about these barbicans, observing, 'You have made the Fort a bride, and set a veil before her face.' The original wooden

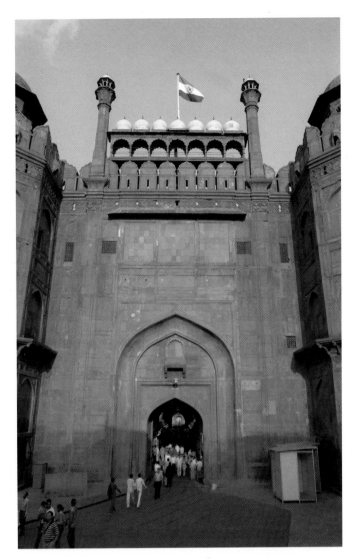

The Lahore Gate.

drawbridge of the barbican has gone and has been replaced by bridges built by Emperor Akbar II. The inscription on the arch of the bridge stated that these bridges (the second is at the Delhi Gate) were built in his reign under the supervision of Dilawar-ud-Daulah, Robert McPherson and Bahadur Diler Jang. These inscriptions are also missing today.

The tents of the paid rajas who used to guard the Fort during the Mughal days were pitched in front of this Gate, in the roundabout that intersects Chandni Chowk and Netaji Subash Marg. A bazaar for an endless variety of things and astrologers sitting on dusty carpets in the open were also seen here. Busy traffic now dominates the scene. Chandni Chowk, stretching from Lahore Gate in the east and Fatehpuri Mosque to its west, is one of Delhi's busiest avenues and quaint shopping centres today, attracting a curious mix of shoppers, businessmen and tourists. The portion of Chandni Chowk from the Red Fort to Dariba was originally called the Military Bazaar.

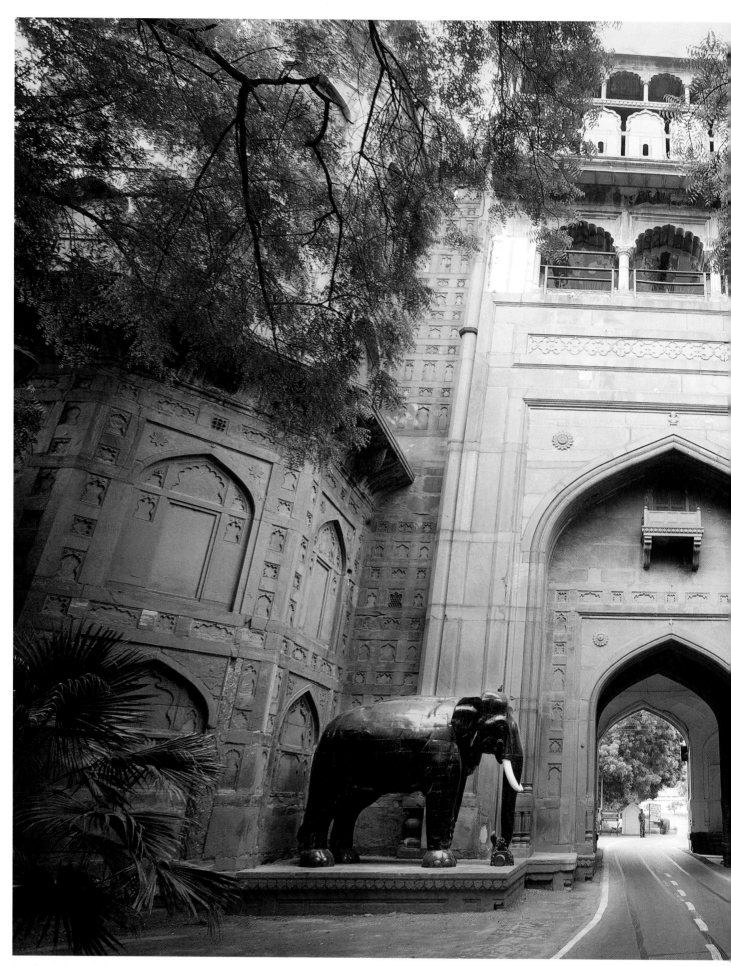

The Delhi Gate flanked by two stone elephants.

Delhi Gate

This Gate opens up the southern wall of the Red Fort and is so called as it faces the old cities that existed before this Fort was built. It is similar in design to the Lahore Gate, but is rendered more interesting by the presence of two stone elephants, standing on either side of the entrance arch. There are many theories about the history of the original elephants and their riders. It is believed that their riders were the celebrated Rajput heroes, Jaimal and Patta, but it seems more probable that the figures were only those of *mahouts* and that the animals were ordinary fighting elephants. The strict religious views of Aurangzeb would not allow the presence of these statues and he ordered their demolition. Nothing more was heard of them till 1863, when, during the demolition of some of the old buildings for military purposes, some 125 fragments of the original statues were found buried in the Fort. Three years later, an elephant was reconstructed from these fragments and set up in the Queen's Garden, now known as Mahatma Gandhi Garden (opposite the Railway Station).

In 1892, the statue was removed to a site in Chandni Chowk and ten years later to a place in front of the Town Hall. In 1903, at the instance of Lord Curzon, the present statues were erected, but the original fragments (now placed in the museum) could not be reused as they were mutilated. The restoration work was entrusted to R.W. Mackenzie, an artist with a wide experience of Indian art. The Delhi Gate is protected by a barbican, similar to that in front of the Lahore Gate. The bridge was erected during the reign of Akbar II by Robert McPherson.

Other Gates

There are three other gates in the Red Fort. One leads into Salimgarh and the British King passed through it during the Coronation Durbar. This bridge is still used by tourists to visit the Salimgarh Fort from the Red Fort. Near it was an old bridge built by Jahangir but this was removed to make way for the present railway bridge. The old bridge had five arches and was built of rubble stone. It was strengthened by a series of arched ribs, giving it an appearance of lightness but with great strength. The inscription from this bridge is now in the museum. The present bridge, like the gate, is modern. There is also a *khirki* (wicket gate) between the bridge and the Shah Burj bastion.

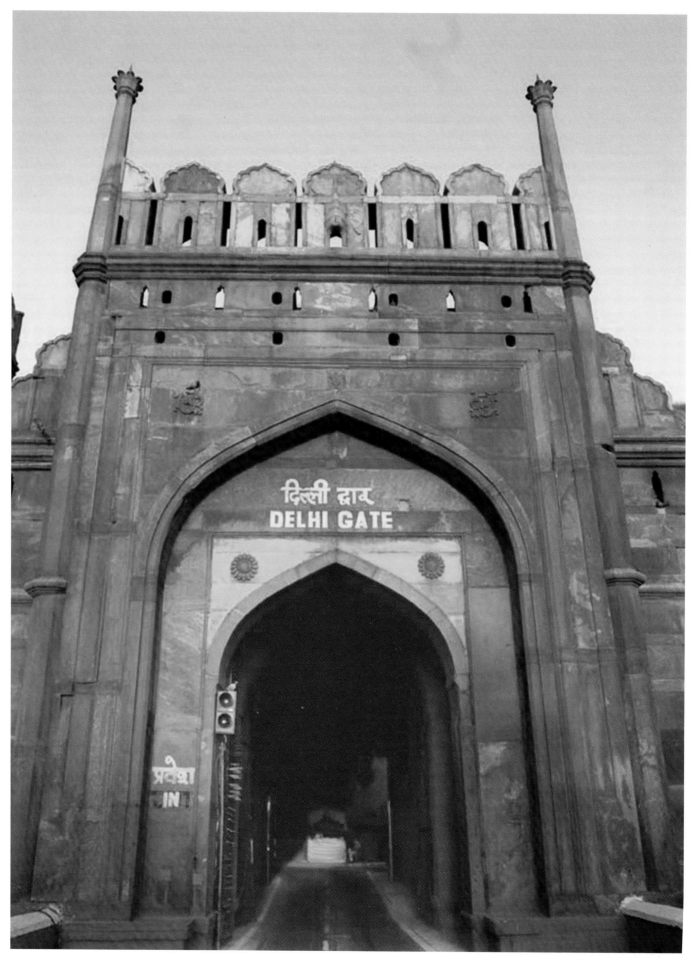

The Delhi Gate—an entrance for special visitors to the Red Fort.

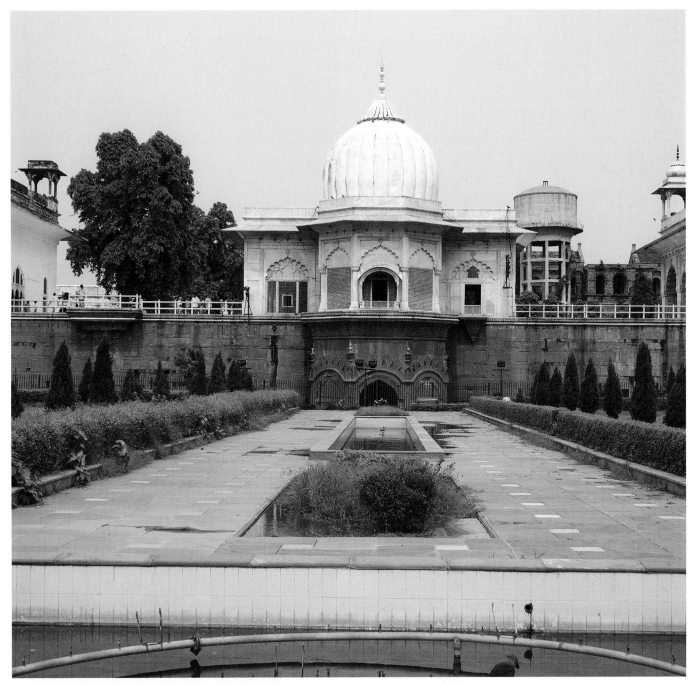

A view of the Mussaman Burj showing the Water Gate.

*A drawing of
the Lahore Gate.*

The Khizri or Water Gate lies under the Musamman Burj. It was this gate that Captain Douglas wanted opened on the morning of 11 May 1857, so that he could go down and reason with the freedom fighters, who had assembled on the low ground near the river.

The Water Gate is of an extremely interesting and characteristic design, but owing to its location is seldom visited. The inner gateway can only be reached by a long flight of steps and is protected by a barbican, with an outer gate facing the river. Some few metres south of the Rang Mahal is a wicket in the base of the wall; closed up, as it would seem from the character of the masonry, by the Mughals themselves. An attempt was made to excavate the ground at the back, but nothing was found, save what appeared to be a large underground drain. The story that it was known as the King's Gate, which was only used to take the dead body of the King out of the palace for burial, is interesting, but lacks historical authentication.

3
Yesterday's Street

From Lahore Gate the visitor passes through Chhatta Chowk, an arcaded street built in Gothic style covered with a very high ceiling decorated with arabesque design. The street is now popularly known as Meena Bazaar. There is a hustle and bustle here that one associates with any marketplace. A colourful mask catches your eye; a necklace of semi-precious stones glitters enticingly. The vendors call out to you.

Chhatta Chowk terminates at a square that is located in front of the Naubat Khana. It measures 70.1 metres in length and 8.3 metres in width. On either side are 16 cells on the ground floor with cusped (engrailed) arched openings, now covered with signs. In all there are 32 such cells, occupied by different traders. In the centre of this street is an octagonal *chowk* (crossing) with an open ceiling and with thoroughfares in all directions. The thoroughfare to the north leads to the Army barracks. The other four alcoves of this Chowk are occupied by traders. The upper floor cells are single rooms, entered through the rear, with balconies that have red sandstone railing, overlooking the bazaar. The balconies are bricked up and the windows have been barricaded. These rooms were earlier occupied by Army officers.

The cells were used to cater to the ladies of the court, who would shop for silk brocades, velvets, gold and silverware, jewellery and so on. The shops are now occupied by traders selling jewels, artifacts, handicrafts, textiles, marble and ivory goods. These cater to foreign as well as local tourists. The shopkeepers have agreed to restore the original ambience of this bazaar by exposing the original arched façade of the structure. Signboards and other modern additions are also being removed, so that visitors can experience the true flavour of the original Meena Bazaar.

The Meena Bazaar.

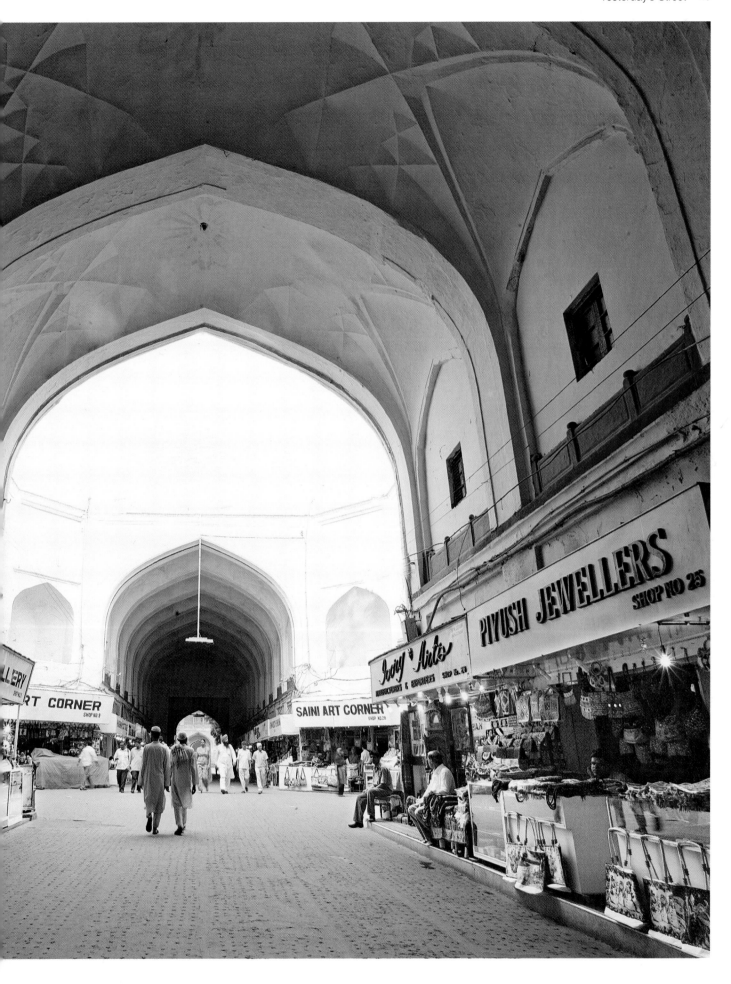

Colourful wares on display at Meena Bazaar.

Bags, jewellery and more at Meena Bazaar.

The east end of this arcade earlier opened onto a 70-metre courtyard, surrounded by colonnades that were used by the *umarahs*. At the south-west corner of the square stood public buildings where the emperor's *Nazir* (Superintendent of the Household) contracted business. The square and the tank, with a surrounding building and the stone railings along with a street to the north and south of the square that was open to the sky, have all disappeared. These were demolished after the First War of Independence to accommodate British barracks. A new system of streets and drains was constructed to meet the requirements of the garrison. In the centre of the square courtyard was a tank fed by the canals that ran to the north and south towards the Mehtab and the Hayat Baksh garden and the Delhi Gate respectively. On either side of the canals were arcaded rooms raised about 1.37 metres from the ground and about 1.2 metres wide, in front of a row of arched rooms, running the entire length of the street. The collectors of market dues worked here undisturbed by the horses and passersby in the streets below. The water of the canal ran into the seraglio and would intersect every part and fall into the moats.

There were also many smaller streets to the northern and southern parts of the citadel, which led to the quarters where the *umarahs* stood guard. The places where these duties were performed were of great splendour as the *umarahs* were themselves responsible for decorating them. In general there were divans, raised platforms or alcoves facing gardens embellished by small canals of running water, reservoirs and fountains. Earlier, during the Mughal period, the junior officials used to transact business here and the *mansabdars* (junior *umarahs*) would mount guard during the night. Once a week, in regular rotation the guard duty was performed by them. While on guard they had their meals supplied by the emperor. There were many buildings and workshops in different parts of the Red Fort, which served as offices for public business. In these buildings were employed embroiders, goldsmiths, painters, varnishers, tailors, shoemakers, manufacturers of silk, brocade and fine muslin. Works of great beauty were created here. A whimsical fair was held here every month during which the emperor was shown a variety of wonderful things from across the world. It was a charming scene, with the emperor admiring the wares, fixing prices and, at times, bargaining. The ladies, too, were present in large numbers, enjoying these special occasions.

4
Housing Memories

To the east of the former square, now converted into a semi-circular lawn, lies a three-storeyed building, the Naubat or Naqqar-Khana (the place from where drums and *shehnais* were played), in carved red sandstone. Trumpets and cymbals were kept at the Naubat Khana and these were played during concerts. Musicians would also play for the emperor and announce the arrival of the princes and royalty. The building was earlier painted in gold and decorated with arched niches adorned with paintings and floral inlay work. The surface decoration has faded and even obliterated at places and the original paint on the façade has vanished.

Honoured visitors dismounted here from their elephants and then walked to the courtyard in front of the Diwan-e-Am. No one could pass mounted through this entrance except the princes. Even in the last days of Bahadur Shah Zafar, emperor only in name, the entrance was guarded and when Frances Hakim, Resident of Delhi, passed through it mounted on a horse, he was dismissed from his job. The most serious charge against him was that he had violated the sanctity of the royal palace by riding under the gateway of the Naubat Khana.

The Naubat Khana measures 30.17 metres north to south and 20.72 metres east to west and is 17.22 metres high from the level of the plinth to the top of the roof. The access to the first floor is through the stairways provided from the extreme end of the building from the rear side. Further access to the top floor has been provided by extending and projecting the stairways. The plinth is the same level as the courtyard in front of the Diwan-e-Am. It has three archways on the façade and rear side; the central one is open and is 8.83 metres high and 4.87 metres wide.

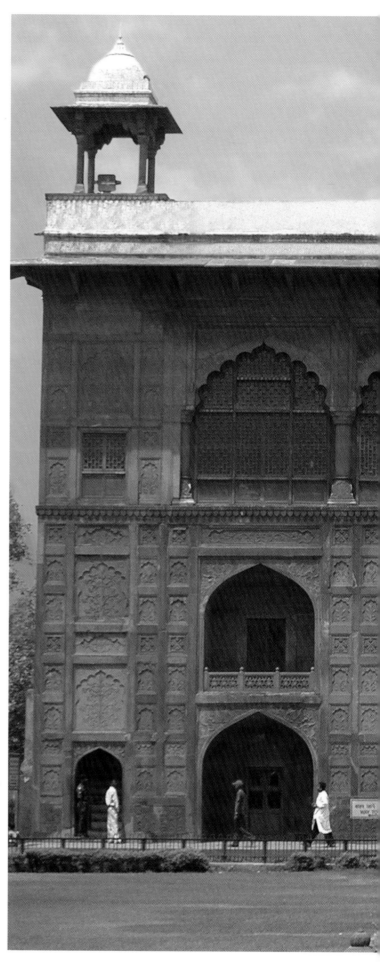

The entrance to the Red Fort from the Naubat Khana.

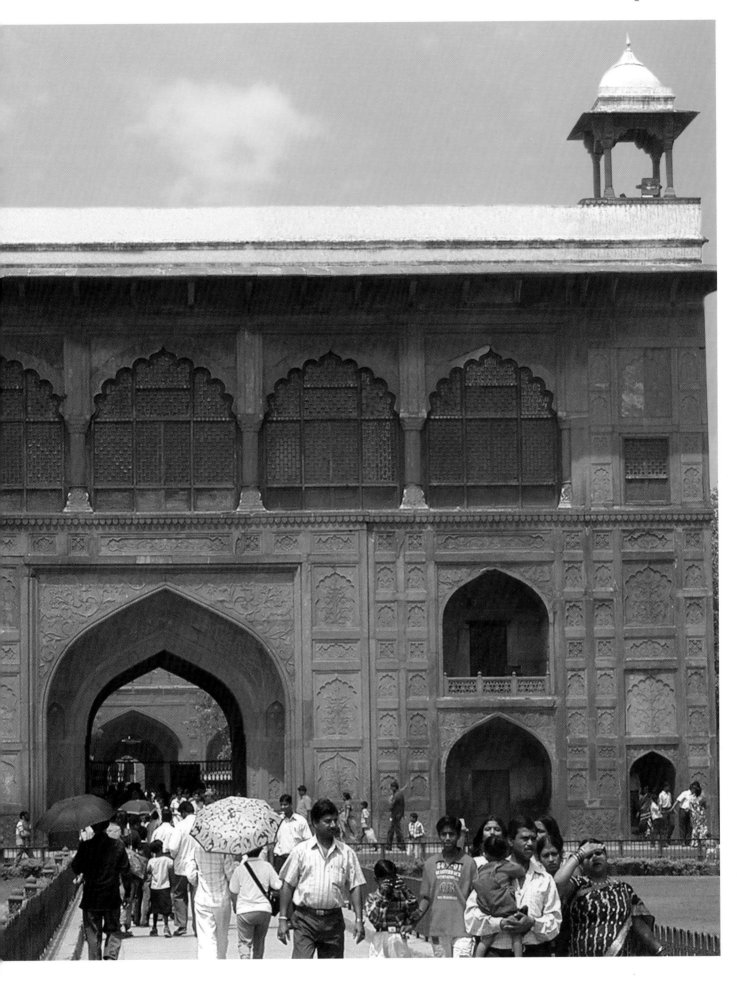

A stone arch with jali *work at the side entrance of the Naubat Khana.*

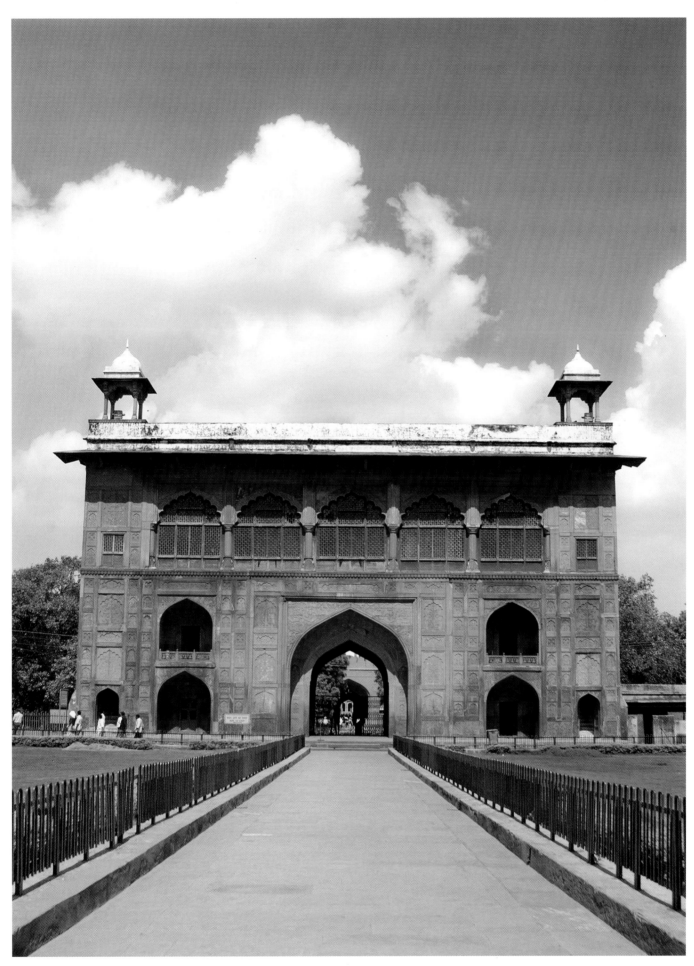

Rear view of the Naubat Khana.

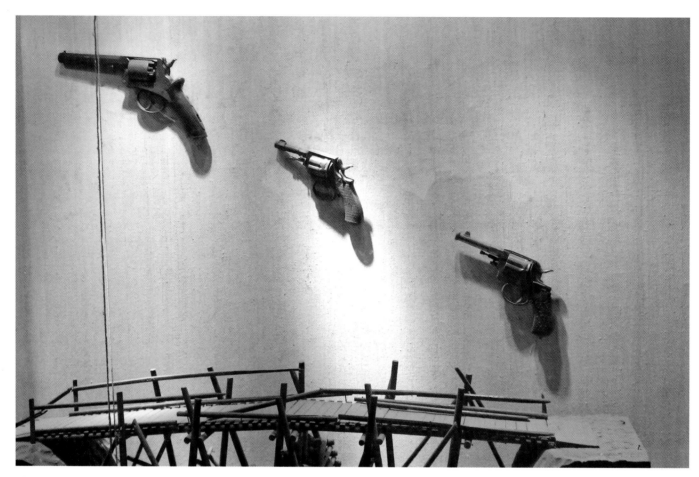

Model of a wooden log bridge.

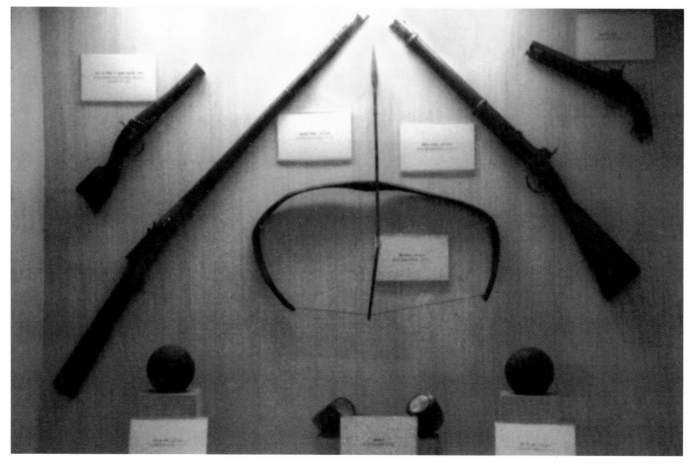

Bow and arrow, rifles and pistols.

Model of an Arab boat.

Chain armour.

Helmet and other body armour.

Service uniforms—knee gumboots, ankle boots and khaki pantaloons.

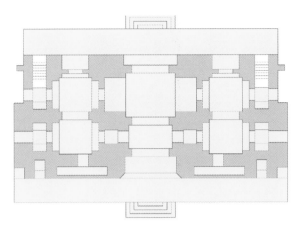

A drawing of the Naubat Khana.

It now serves as a main entrance gate to the area protected and maintained by the Archaeological Survey of India (ASI). The building on the ground floor is divided into three compartments—the central one is an oblong entrance hall, with conventional floral decorations on the walls and honeycomb designs on the ceiling. It is surrounded on either side by rooms connected to other small chambers. The ground floor is being used as an office of the senior conservation assistant of the ASI. It was earlier used as a Museum of Archaeology till 1911; this museum has now been shifted to Mumtaz Mahal. The first floor with two bay arches has been partitioned and is used as the office of the ASI. The top floor with two bay arches partition into a number of exhibition chambers.

The front and rear façades of this hall have nine cusped arched windows that have been closed with wooden doors and grills for reasons of security. The corners of the top of the roof are provided with kiosks crowned with domes. The upper floor hall has been converted to the War Memorial Museum. Bows and arrows of cane, helmets and other body armour, curved and inscribed swords with sheaths, double-edged dagger maces with hilts, decorated shields and long spears belonging to the Mughal period are exhibited in this museum.

In addition, there are the imperial service uniforms, knee gumboots, embroidered *kurtas*, *pagris*, inscribed swords with sheaths, pantaloons, buzzers, portable telephones, telegraph recorders, German signal lamps, models of Arab boats, Basra dockyards, Army transport carts, shoulder badges, telescopes, measuring instruments and Turkish match lock guns of the period 1914-18. These exhibits transport the visitor to a bygone era—when war was a combination of chivalry and undying loyalty to the emperor.

5
Passage to Eternity

There were two halls in the Red Fort where the emperor would hold audience—the Diwan-e-Am (Hall of Public Audience) and the Diwan-e-Khas (Hall of Private Adience). It is said that the emperor would never miss the two assemblies, unless he was seriously ill. In fact it is believed that even if he was ill, he was carried to one or the other hall, if not to both, for he always felt the need to connect with his people.

The Diwan-e-Am is a grand assembly hall located on the east of the Naubat Khana. It is 24.38 metres long, 12.19 metres wide and 9.14 metres high from the plinth, which is raised 1.22 metres from the ground. It is three-aisles wide with a façade composed of an arcade of nine bold cusped arches supported on strong ornamental double columns carved out of red sandstone. The hall has 40 pillars and pilasters. The arches are well proportioned and represent the perfect form of a cusp that springs up from the stout double columns with carved bases. The ceiling, the soffit and the spandrel of arches were originally painted and covered with gold ornamentation. Traces of old decoration can still be seen. On the corners of the roof are domical *chhattris* (turrets).

Set in the recess in the centre of the western hall is a marble pavilion 3.3 metres high with a curved roof (baldachin) known as the Nashiman-i-Zill-ilahi (The Seat of the Shadow of God), panelled with marble and inlaid with precious stones. It was here, on ceremonial occasions, that the famous Peacock Throne was installed. In front of this stands a marble dais that was earlier richly decorated with floral inlay work. It is supported on beautiful and ornamental marble pillars. It measures 2.13 metres by 0.91 metres and was used by the *Wazir* while presenting petitions to the emperor who was seated under the canopy. The emperor would

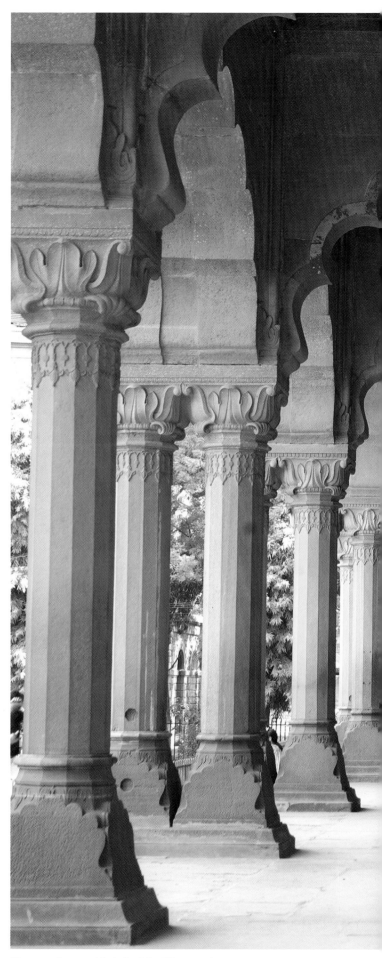

The grand assembly hall of the Diwan-e-Am.

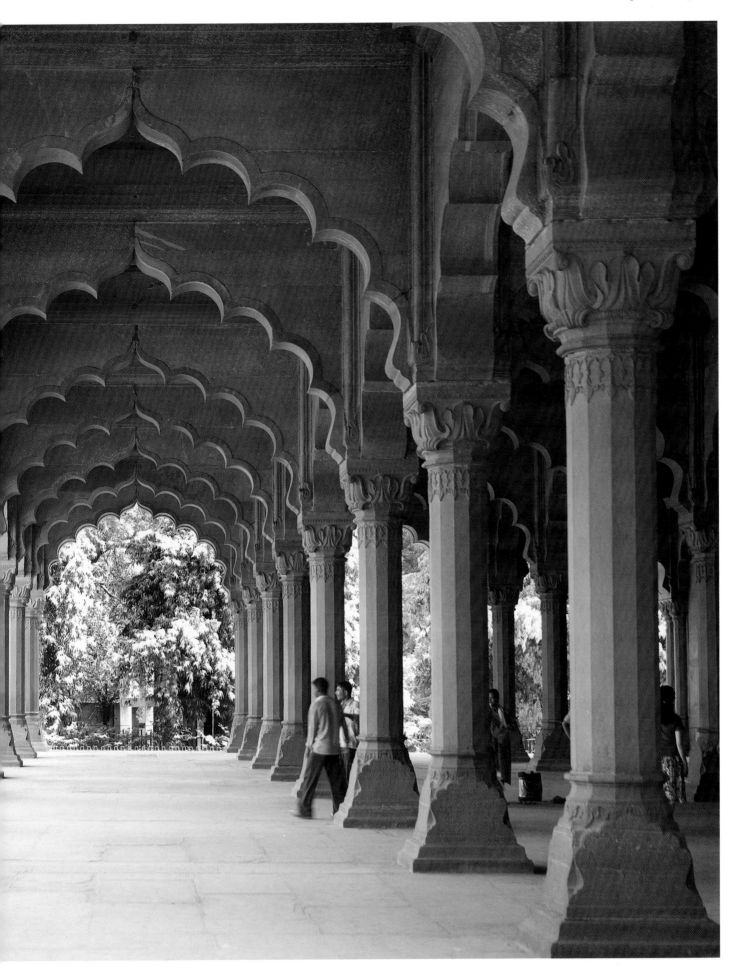

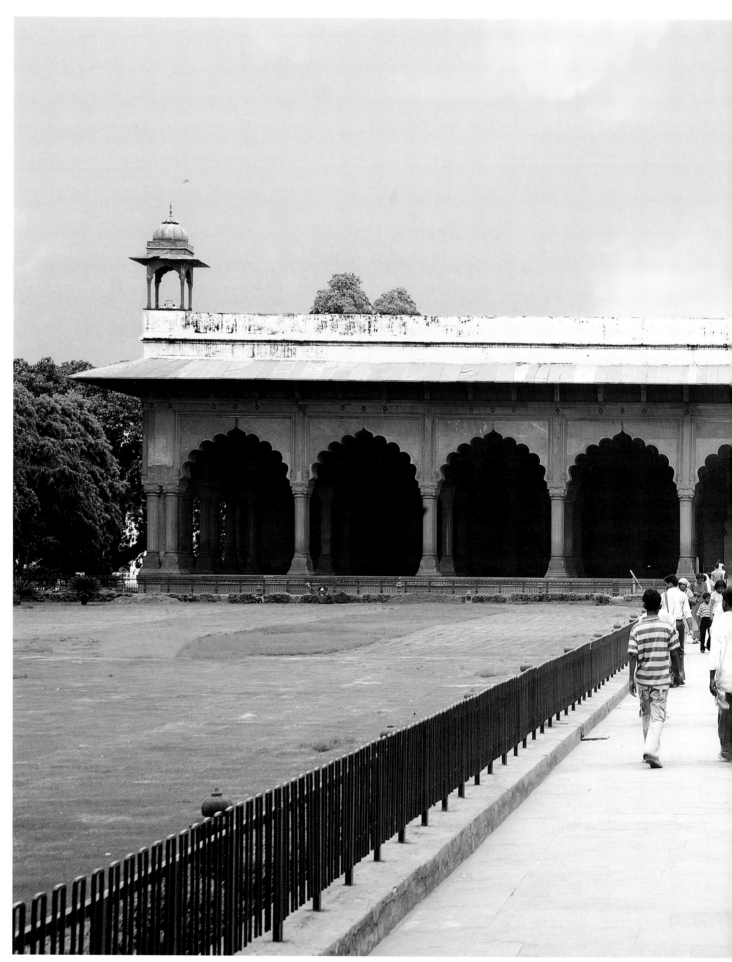

Front view of the Diwan-e-Am.

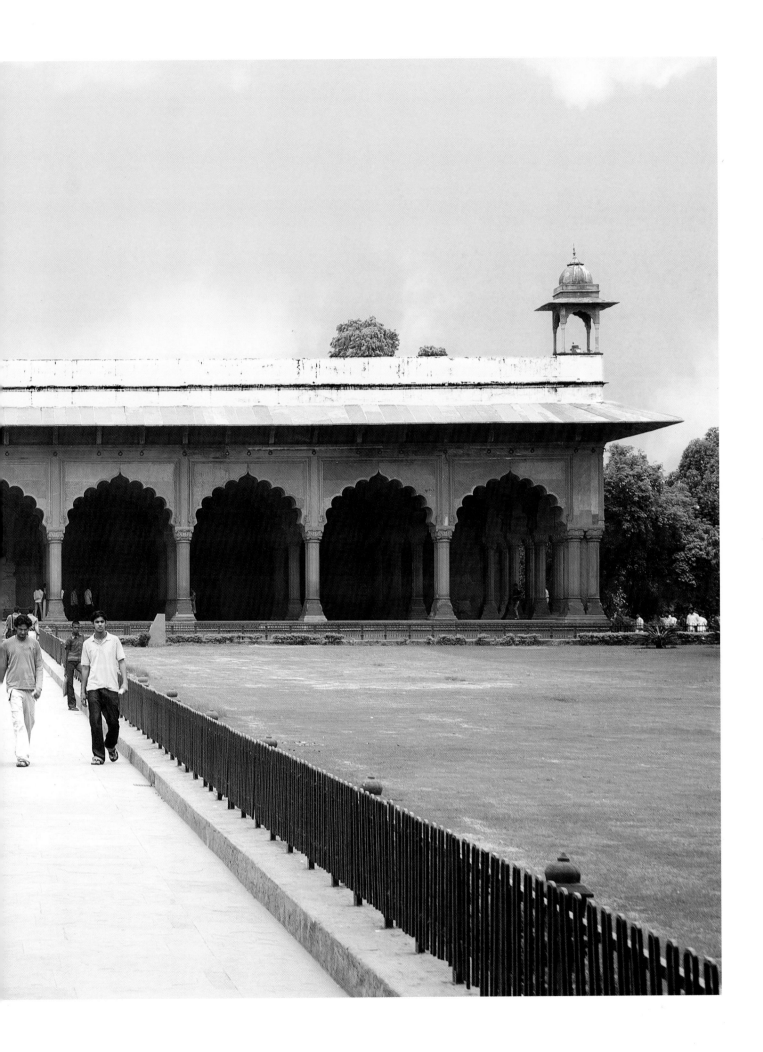

sit on the throne in the Diwan-e-Am to listen to his subjects gathered there. His sons stood to his right and left, while eunuchs flapped away the flies with peacock tails, waved the air with large fans, or waited with profound humility to perform the duties allotted to them. Immediately under the throne was an enclosure, surrounded by silver rails now replaced by steel, in which assembled the whole body of *umarahs* and ambassadors, their eyes bent downward and their hands crossed. Outside the Diwan-e-Am was a Gulal Bari (Red Enclosure) where the *mansabdars* also stood in the same position with profound reverence.

The spacious room and indeed the whole courtyard was filled with persons of all ranks—high and low, rich and poor. Those who visited the Fort to attend the assembly at the Diwan-e-Am were generally royalty and carried a retinue of servants, footmen and mounted horsemen. During the two hours that this ceremony continued, almost daily, a certain number of the royal horses, elephants and other animals would pass before the throne, so that the emperor could see that they were well maintained. Besides this procession of animals, the cavalry of one or two *umarahs* frequently passed for inspection before the emperor.

All the petitions put forth in the crowded assembly in the Diwan-e-Am were brought to the emperor and read out. The persons concerned were ordered to step out and were examined by the emperor himself, who often took decisions on the spot to grant justice to the aggrieved party. The *pietra dura* or inlay work over the recessed wall of the main assembly hall of the Diwan-e-Am, behind the baldachin and around a door that opens to the private chambers, is said to have been originally executed by Austin De Bordeaux, a renegade European jeweller.

The designs consisted of flowers, fruits and birds in a most natural manner. Among the other unique designs the Frenchman, Bordeaux, introduced was a picture of Orpheus playing on his lute, with a lion, a hare and a leopard lying apparently captivated at his feet. This tablet was removed after the capture of the Fort by the British in 1857 and placed in the South Kensington Museum. Eleven inlaid panels were also removed. They were restored to their original position later at the instance of Lord Curzon. It was fortunate that the old drawings of the mosaics were available from which it was possible to restore the decoration to its original

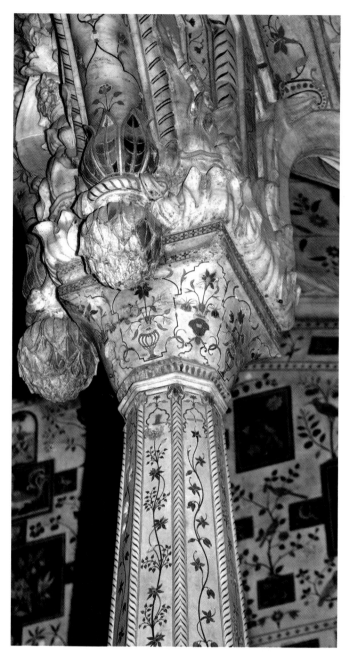

Moulded and profusely carved marble pillar.

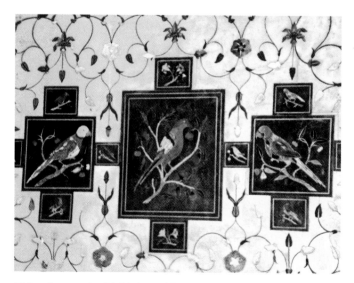

Pietra dura *work with birds and floral patterns.*

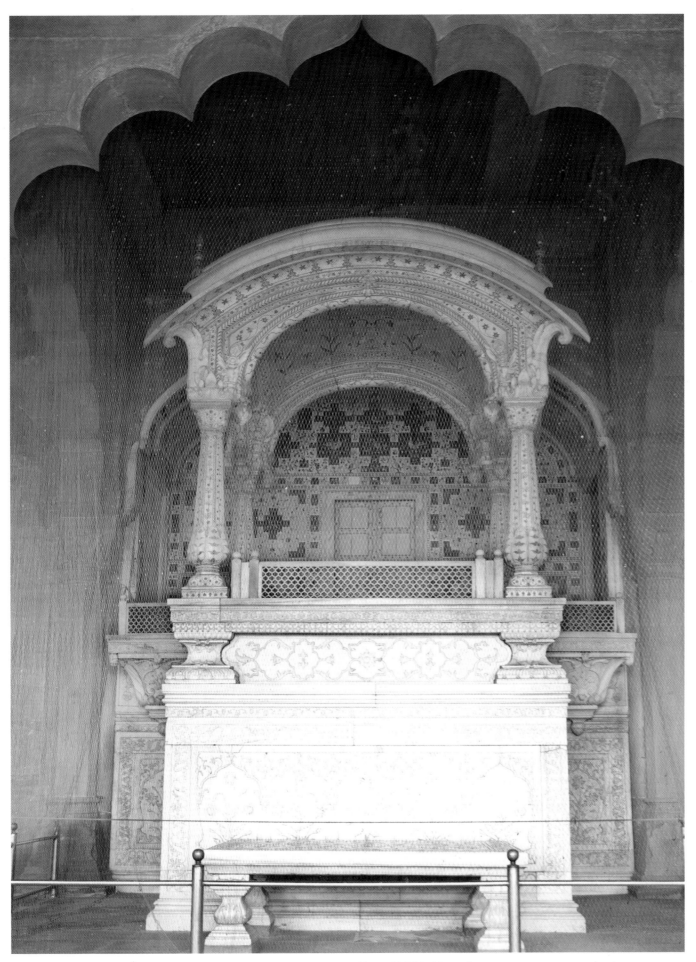

The seat of Emperor Shah Jahan at the Diwan-e-Am panelled with marble and inlaid with precious stones.

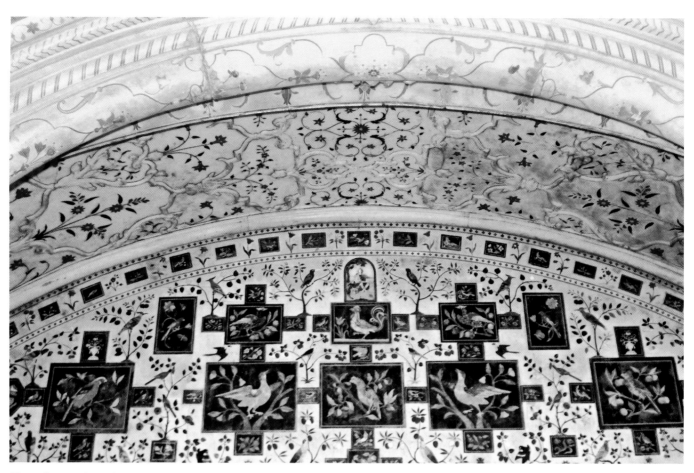

Pietra dura *work on the recessed wall of the marble pavilion.*

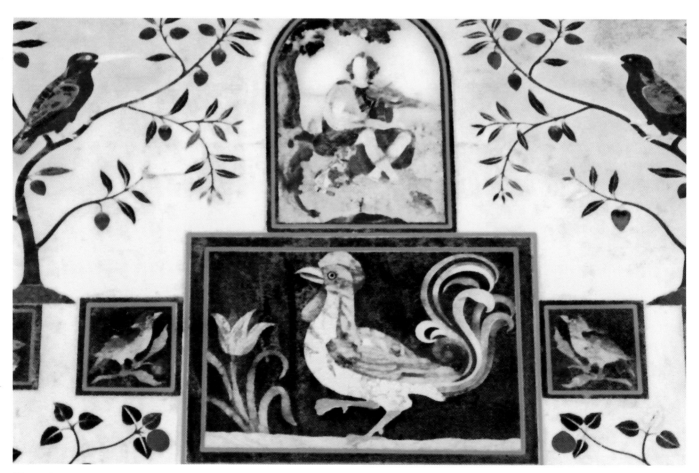

Pietra dura *work showing Orpheus playing on his lute.*

form. For this purpose an Italian 'mosaicista' was brought especially to India and the work completed in 1909.

There is a chamber behind the central recessed arch at the level of the marble pavilion with a central door and two more doors each on the northern and southern walls that lead to the chambers below. To the east of this chamber on the first floor is a five-arched balcony overlooking the garden in front of the Rang Mahal and to its north and south are other arched balconies. From the northern balcony a winding stairway leads to the ground on the eastern side. This chamber is said to have been covered with shell plaster, polished like the brightness of the morning.

When the emperor felt like taking a walk he would go into this chamber and ascend the steps to reach the verandah on the first floor overlooking the garden between the eastern façade of the Diwan-e-Am and the western façade of the Rang Mahal. He would go down through the winding stairways, pass corridors or colonnades that no longer exist today, and would for a while seek relief in the cool Rang Mahal. The subdued murmur of falling water and the voices of his chosen ladies were enough to relax and soothe his frayed nerves. Those were the times when joy came from within the peaceful precincts of the Red Fort itself.

To the west of the Diwan-e-Am was a large courtyard, 167.64 metres long and 91.44 metres wide and surrounded by arcaded apartments. Each bay of the arcade was separated by a wall that had doors connecting it to the apartments. The rooms were raised with a plinth of about 1.06 metres and were occupied by the *umarahs* on duty. They were decorated on special occasions. It is said that the *umarahs* vied with each other in the splendour of their adornment. These arcades were demolished after 1857.

Their original location was, however, demarcated and is now indicated by shrubberies. The shrubberies on the south of the court could not be placed on the exact boundary of the original apartment and had to be shifted further north than the former arcade.

To the north of the courtyard stood the imperial kitchen, adjoining which were the Mehtab and Hayat Baksh gardens. North of this was a canal, running from the

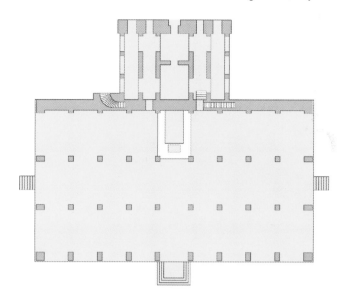

A drawing of the Diwan-e-Am.

west to the Shah Burj on the east. To the north of the canal were the imperial stables, east of which were private dwellings, both extending up to the north wall of the Fort. To the south of the square were the imperial seraglios and the residences of nobles extended up to the south wall of the Fort. Behind the Diwan-e-Am, to the east, was the Imtiaz Mahal, with the Rang Mahal further eastwards. North of the Diwan-e-Am, in the centre of the east wall of its arcade, was an arched gateway. In front, was a red screen that gave it the name of Lal Parda. This gateway led into a small square or a courtyard, in the east wall of which was another gateway leading to the square or a comparatively bigger courtyard of the Diwan-e-Khas. On the north side of this square was a doorway leading to the Moti Masjid.

All the structures of the courtyard between the Naubat Khana and the Diwan-e-Am were demolished during the British period and the entire area was redeveloped into a lawn and a pathway. This was lined with a railing on either side to connect the Naubat Khana to the main entrance gate and to the archaeological area where royal buildings are preserved.

In that era long gone by, the King was considered a representative of God; his word was final. People looked up to him for justice; they presented their petitions to him, confident of fair treatment.

Today, visitors gather at the Diwan-e-Am to recreate in their mind's eye the splendid assembly of the emperor and to relive those days of royal glory.

6
Special Space

To the north of the Khas Mahal stands the large Hall of Private Audience, or the Diwan-e-Khas, on a raised platform of white marble, about 1.37 metres high. This platform measures about 37.79 metres by 20.42 metres. It has a marble railing towards the riverfront, in the centre of which is an arched hall measuring 30.17 metres by 20.42 metres. Its western façade consists of an arcade of five equal engrailed arches with others of varying sizes of the same design on the shorter sides, thus providing a cool and airy interior as it is open on all sides. The floors of the entire hall are of marble with fine polish, reflecting the massive piers enriched with inlaid flowers. Its foliated arches were painted in gold and in different colours, the textural effect of which illuminated the whole interior with a soft mellowness.

The arched opening on the riverfront is provided with a marble grill or rectilinear railing. The central one is decorated with a semi-circular arch flanked on either side by engrailed arches. The surface of the wall above used to be richly decorated with inlay work in many precious stones.

The central chamber was the pride of place of the famous Peacock Throne. This chamber measures 14.63 metres in length and 8.23 metres in width and is enclosed by 12 square pillars. The surface of these pillars up to the dado is decorated with borders in inlay work with carved plants or foliage in the middle. It was decorated with precious and semi-precious stones. Profuse inlay work in a highly stylised manner is visible everywhere in this grand chamber.

The ceiling was filled with silver leaves inlaid with gold while the window overlooking the river was covered with gracefully perforated screens with glasswork finish. The pillars, arches, soffits and spandrels were profusely decorated with inlay work of conventional floral designs adorned with precious and semi-precious stones such as carnelian, lapis lazuli, jade, rose quartz, jasper, onyx, turquoise, beryl and bloodstone. The interior has been treated very artistically and there is no doubt that Shah Jahan had at his disposal a group of thoroughly skilled artisans with complete mastery over their art.

A water channel in marble, known as the Nahr-i-Bahisht (Canal of Paradise), 3.65 metres wide, runs through the middle of this hall. Thirty-two marble columns support the arches; their shafts are square in shape with moulded bases.

The northern and southern arches of the chamber are inscribed with beautiful, flowing Persian characters. In raised and gilded letters written by the great calligraphist Rashid are these famous lines composed by Sa'dulla Khan: *'Agar Firdaus baru-i-zamin ast, hamin ast, hamin ast, hamin ast.'* (If there is a paradise on earth, it is this, it is this, it is this.) This chamber was partitioned with an elaborately perforated screen, behind which a curtain of fine silk was hung to ensure privacy to the queen and ladies of the harem. At the same time, it enabled the queen to hear everything that was discussed behind the screen.

Unfortunately, this 'paradise on earth' was looted long ago, not only by Nadir Shah, but by Ahmad Shah Daurani and, later, by the Jats of Bharatpur, during the reign of Mohammad Shah Rangeela. These precious stones may also have been thoughtlessly spoiled by the soldiers of the British Army with their bayonets, when they took possession of the Red Fort in 1857. The Diwan-e-Khas was then used as a church by the regiments.

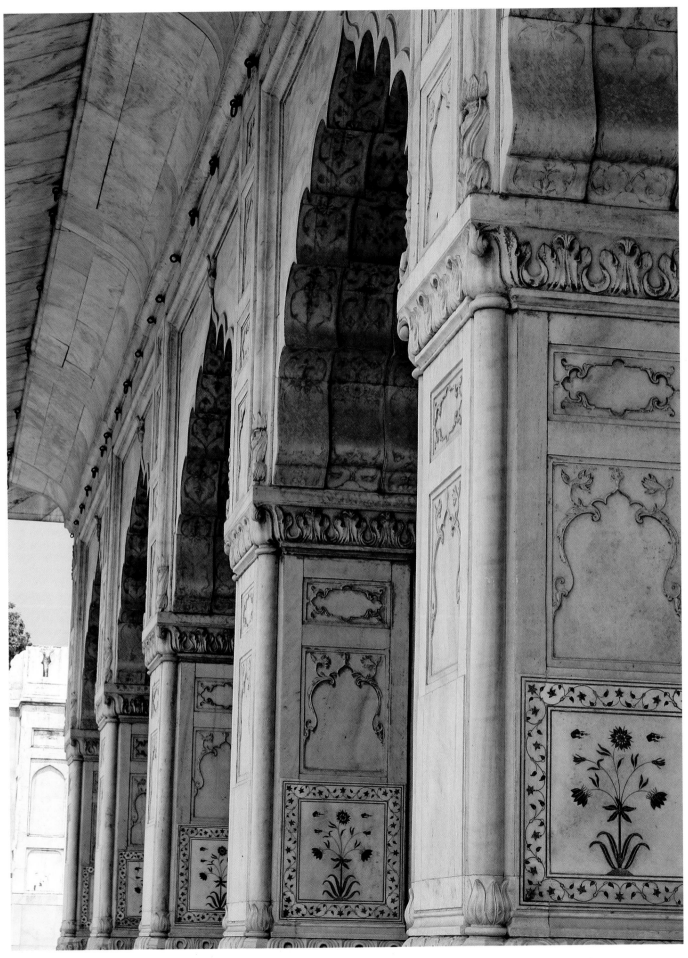

A series of massive piers enriched with inlaid flowers.

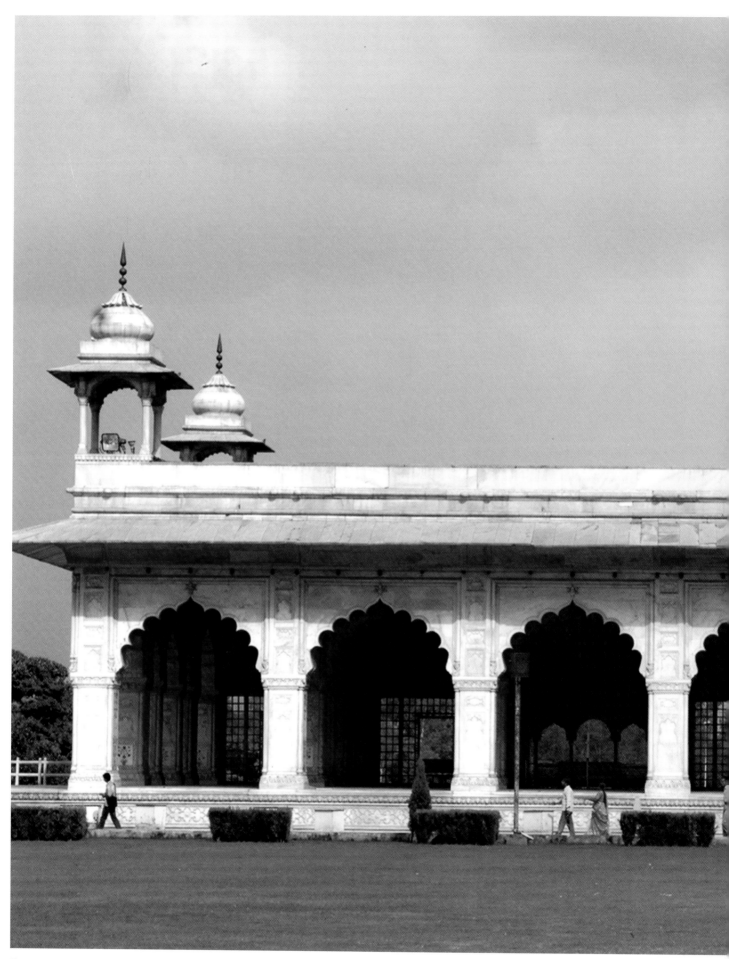

Front view of the Diwan-e-Khas.

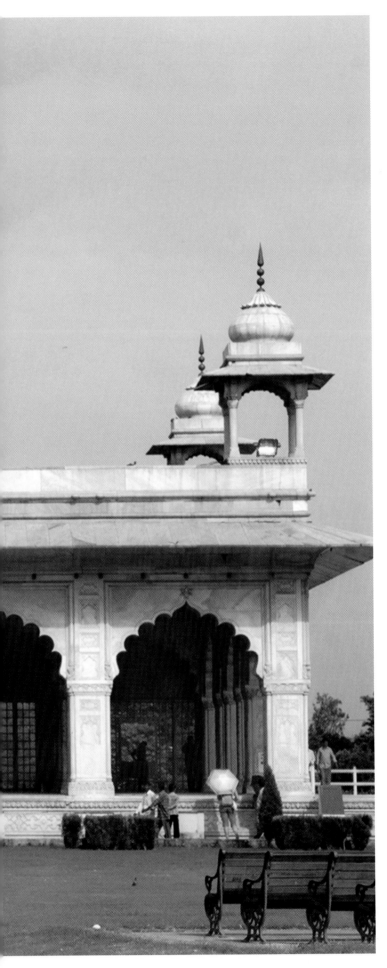

A drawing of the Diwan-e-Khas. Courtesy: Archaeological Survey of India.

The interiors of this airy space, the impressive Diwan-e-Khas, seems to echo with these tragic tales. It is indeed a strange mix—pristine white marble providing the backdrop to conspiracy and violence. Over the years the Red Fort has been plundered and looted several times for its jewels and other precious items. It is said that Sadashiv Rao Bhao, slain in battle against Ahmad Shah Daurani in 1761, took the silver from the ceiling of the Diwan-e-Khas and exchanged it for money.

The original ceiling cost 39 lakh rupees. When the silver was melted down by the Marathas, it fetched 28 lakh rupees. In 1788, the old Emperor Shah Alam II was blinded by Ghulam Qadir here and, in January 1858, Bahadur Shah was found guilty of having declared war on the British during the First War of Independence.

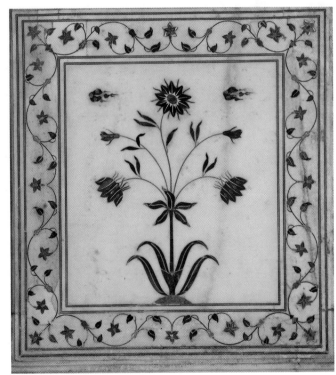

Inlaid work on the pillars.

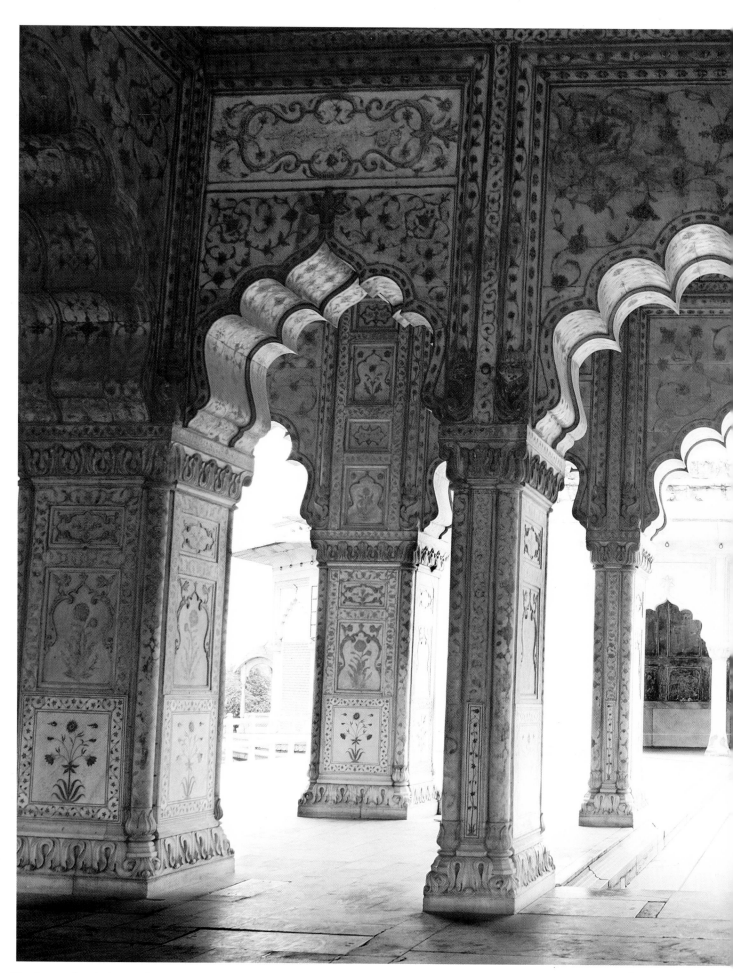

The famous inscriptions of Sa'dulla Khan engraved on profusely carved arches of the Diwan-e-Khas.

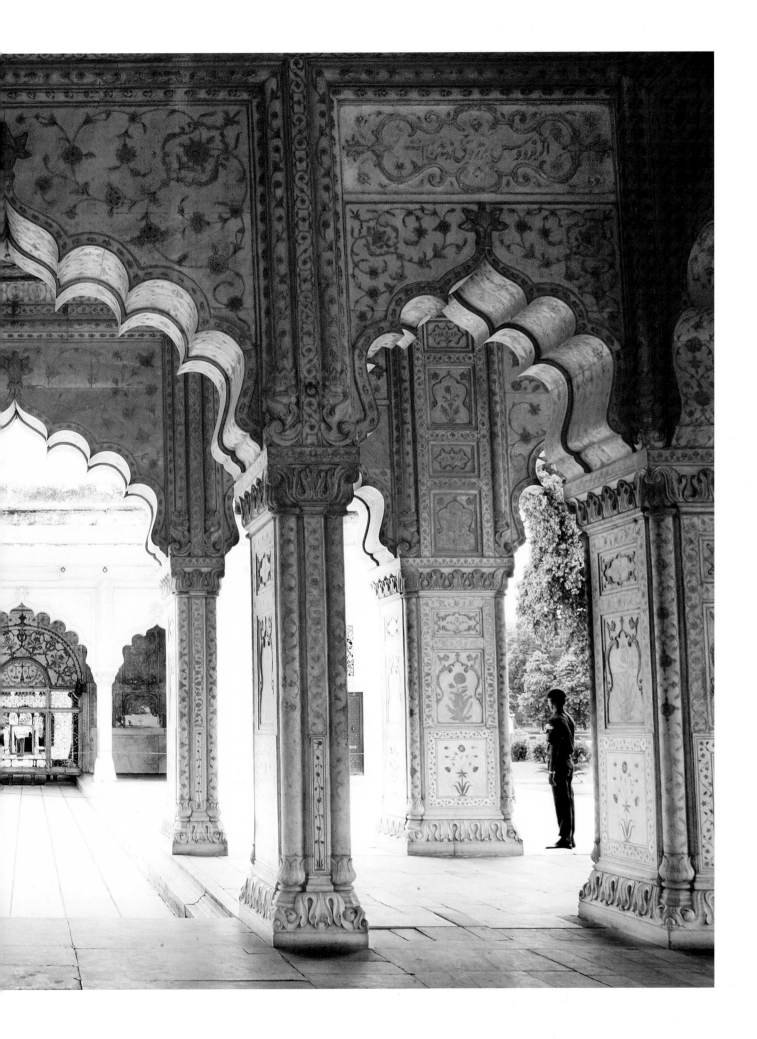

Peacock Throne

The Mughal emperors used to receive their subjects on state occasions while seated on the exquisite Peacock Throne (*takht-i-taus*), so called because it has the figures of two peacocks. Indeed, the Peacock Throne stole the hearts of many emperors and poets alike who have paid many tributes to its beauty.

Jean Baptiste Tavernier, who saw it in 1665, described it as being 6 feet by 4 feet and shaped like a bed, supported by four gold feet that were 20 to 25 inches high. Three gold steps led up to the throne, which was decorated with 108 rubies and 116 emeralds. Twelve columns set with rows of large pearls supported the canopy. These, in Tavernier's opinion, were the most valuable parts of the throne. The canopy itself was fringed with pearls and covered on the inside with diamonds and pearls. On its four-sided dome stood a peacock whose tail was made of sapphires and other coloured stones, the body of gold inlaid with precious stones. There was a large ruby on its breast, from which hung a pear-shaped pearl of 56 carats or thereabouts.

On the front of the canopy glowed a great diamond surrounded by emeralds and rubies—the world famous Koh-i-noor or the Mountain of Light. Flanking the legendary throne were two tall red velvet umbrellas embroidered and fringed with pearls; their sticks thickly studded with diamonds, rubies and pearls.

And this is how the *Badshahnama* describes the grand throne: 'Since time immemorial and year in and year out various jewels of great price, each of them worthy to be an earring of Venus and to be set in a belt for the sun, had been kept in the Imperial Treasury. It occurred to the inspired mind [of the emperor] in the early years of the beneficent reign, that the collection of such rare presents and accumulation of so many precious things, were only meant for the adornment of the Empire, and to increase its ornamentation. Therefore, they ought to be made use of in such a place that spectators might enjoy the world-enlightening beauty of the produce of the ocean and the mine, and that they should lend an added lustre to the palace. Orders were issued that all kinds of rubies, diamonds, pearls and emeralds, the value of which was estimated at 200 lakhs of rupees, and in addition, those in the charge of the provincial treasury officers, should be brought for His Majesty's inspection, excepting only the

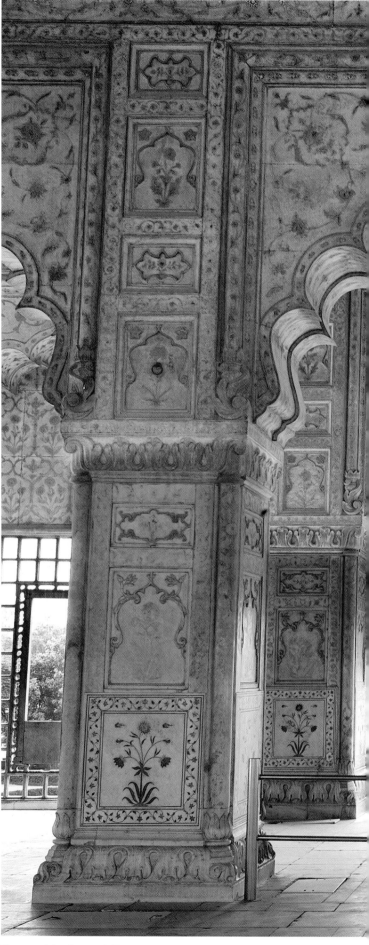

The exquisite Peacock Throne once occupied the pride of place here.

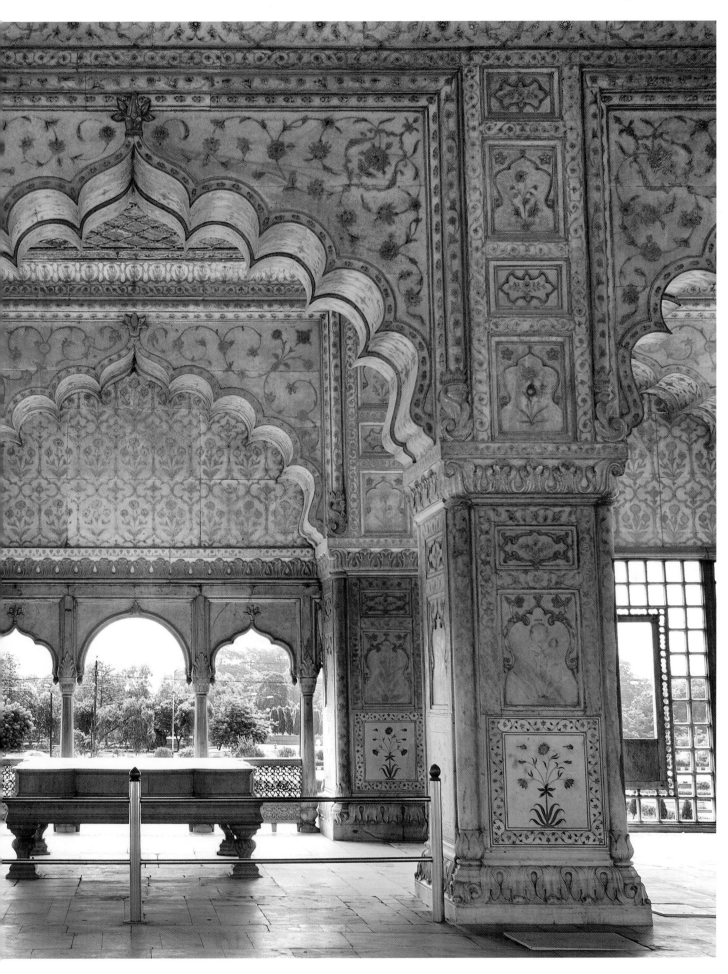

emperor's personal jewels, kept in the jewel office of the heaven-like palace.'

The ceiling of the throne was enamelled and the body set with jewels. The outside was adorned with rubies and other precious stones. Above the ceiling two images of peacocks, set in bright gems, were made and a tree of rubies, diamonds, emeralds and pearls was fixed between them. Three steps studded with beautiful gems were prepared to ascend the throne. This splendid throne was completed in the course of seven years at the cost of 100 lakh rupees. Of the 11 slabs covered with jewels and erected around the throne, the central one was valued at 10 lakh rupees. The ruby at the centre of the throne was valued at one lakh rupees. Shah Abbas had sent it to Jahangir as a present. At first, the sublime name of His Majesty, the Lord of Happy Conjunction (refers to Timur), the pole of the Faith and Religion, and that of Mirza Shah Rukh and Mirza Ulugh Beg, were written over it.

The following verse, composed by a court poet, Haji Muhammad Jan Qudsi, was written by the order of the emperor:

> How auspicious is the Imperial throne which has been made ready by Divine help. On the day when heaven desired to construct it, it first melted the gold of the sun.
>
> By the order of the emperor, the azure of the heaven was exhausted on its decoration.
>
> What is the use of gold or of jewels but to decorate this throne?
>
> On account of its ruby that is beyond value, the heart of the red-lipped beloved is uneasy.
>
> Crowns, set with jewels, and rings, holding jewels in their eyes [the sockets for the jewels].
>
> Waited for long [in the hope that they] might be set in its supports.
>
> The world had become so short of gold on account of its use in the throne, that the purse of the earth was empty of treasure.
>
> Should the sky succeed in reaching the foot of the throne, it will offer to it the sun and moon as a gift.
>
> That august personage who rubbed his head on its base had to add heaven as a step to [approach] the throne.
>
> The tribute of ocean and mine is its robe: the shadow of it is [like] the shelter of the Divine throne and seat.
>
> It is decorated with various jewels: its every particle is a lamp to the world.
>
> In its sides there are flowers of azure-like colour, shedding light like the lamp from Mount Sinai.
>
> As his [Solomon's] hand could not reach it, he set the precious stone of his ring on its steps.
>
> A dark night by the lustre of its rubies and pearls can lend stars to a hundred skies. As it kisses the foot of Shah Jahan, so its rank is above the heavens.
>
> The bestower of the world, and the prosperous king, spends the tribute of the whole earth on one throne.
>
> Almighty Allah, who exalted the heavenly throne and seat, can make such a throne, through His Divine power.
>
> As long as a trace remains of existence and space, Shah Jahan shall continue to sit on the throne.
>
> May such a throne be his seat every day, which has the tribute of seven climes under one of its steps.
>
> When the tongue asked the heart of its date, it replied, 'This is the throne of the Just Emperor.'

The white marble dais on which the Peacock Throne is said to have rested was removed from the central room during the Prince of Wales' visit in 1876. It was then placed in the east aisle of the hall, where it can still be seen.

However, according to some historians, the throne was actually placed in the Diwan-e-Am. Tavernier claims that the great Mughals had seven magnificent thrones and that the principal one stood in the hall of the Diwan-e-Am.

Nadir Shah took away the Peacock Throne to Persia in 1739.

Koh-i-noor

The Koh-i-noor, the most prized jewel in the treasure of the Mughal emperors, was once embedded in the Peacock Throne. This diamond was obtained from the Kollur mine in Hyderabad, Andhra Pradesh. Mir Jumla presented it to Aurangzeb who then passed it on to Emperor Shah Jahan. It weighed 756 carats then. However, when Tavernier was invited by Aurangzeb to see his jewels, among them the Koh-i-noor, he found that it weighed 268.38 carats. It was a Venetian, Sieur Hortensio Borgio, who cut it. But after it was cut he was reproached for having spoiled the stone, which ought to have retained a greater weight. So, instead of paying him for his work, the emperor fined him 10,000 rupees.

The Koh -i-noor. Courtesy: The Royal Collection © 2007 Her Majesty Queen Elizabeth II

A sketch of the Diwan-e-Khas when the British moved into the Red Fort in 1857.

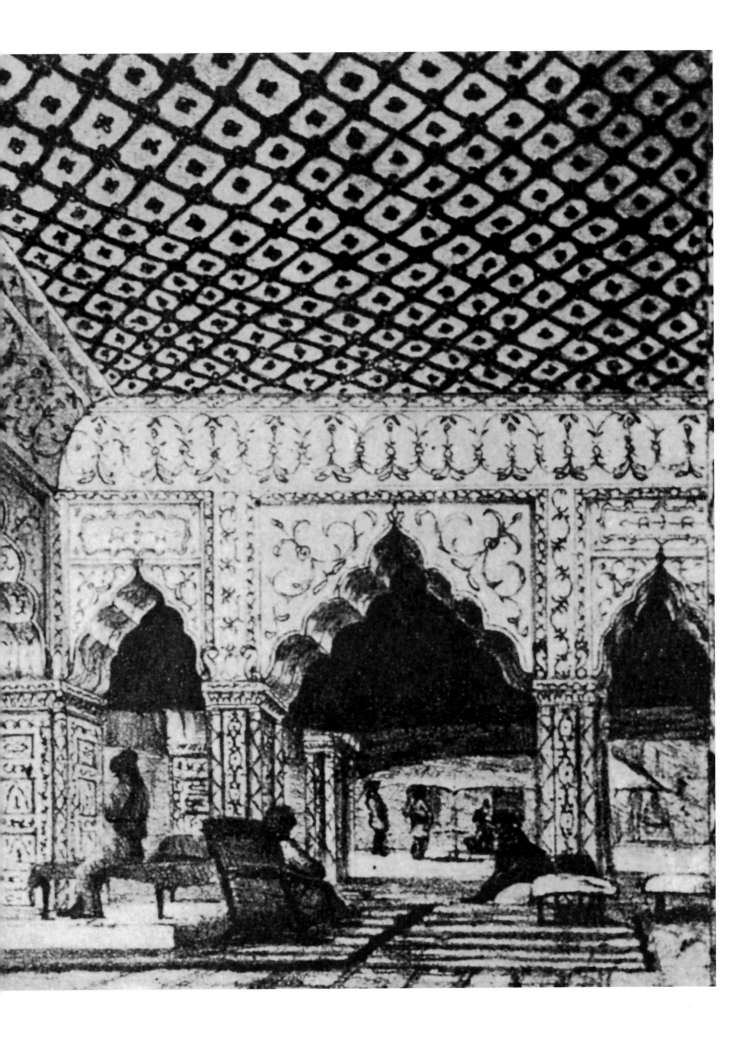

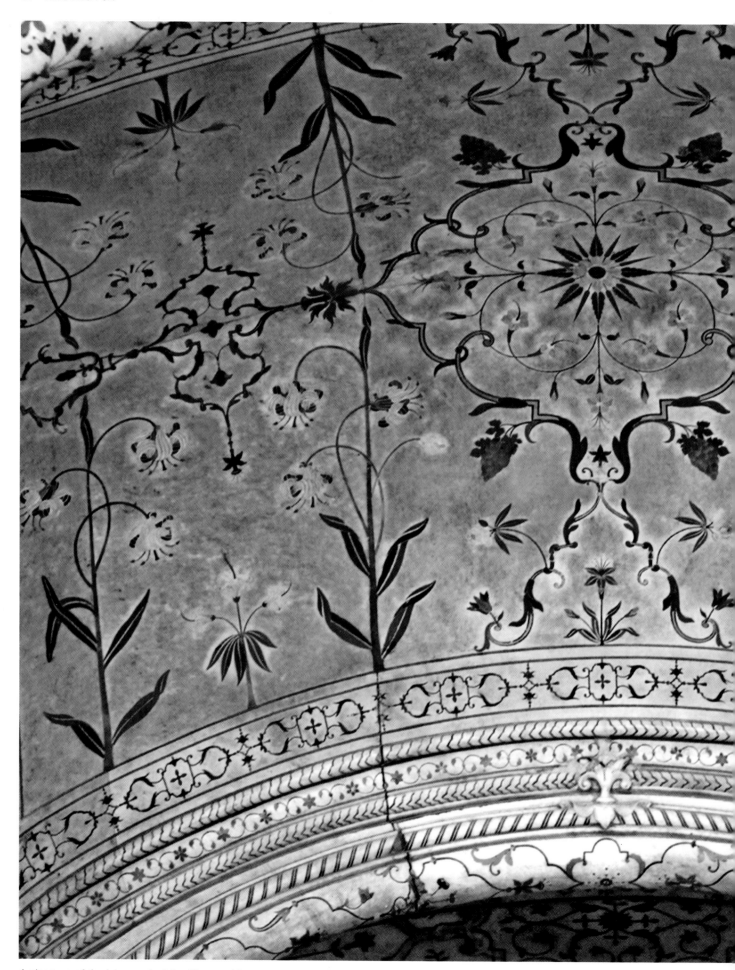

A close-up of the inlay work at the Diwan-e-Khas.

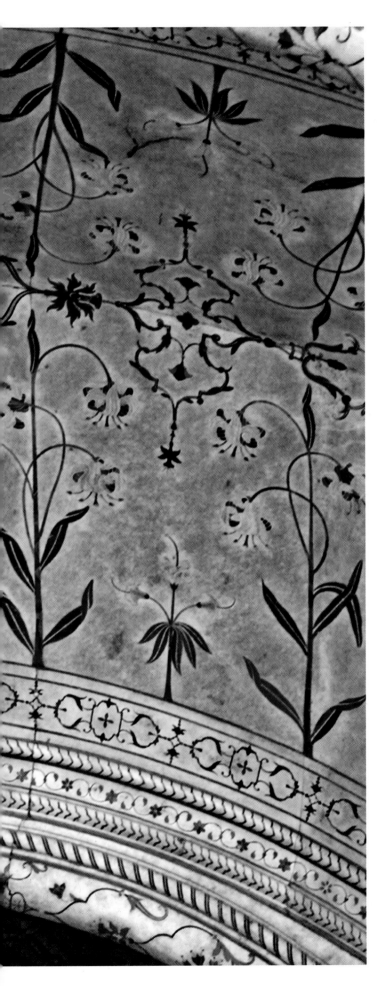

In 1739, the diamond was snatched away from Aurangzeb's descendant, Mohammad Shah. It was on March 31 of that year, when the terrible Nadir Shah of Persia was sipping his coffee with his vanquished host, Mohammad Shah, that he parted with his serviceable *pagri* (head gear) for the bejewelled *taj* of the emperor of Delhi. Nadir Shah is reported to have bequeathed the title of Koh-i-noor when he first glimpsed this magnificent diamond.

After Nadir Shah the diamond passed into the hands of Ahmad Shah Daurani in 1751, Shah Zamin in 1793, Shah Shuja in 1795 and Ranjeet Singh in 1813. The tale goes that Maharaja Ranjeet Singh, the Tiger of Punjab, learned from a spy in the Afghan rulers' retinue that the Amir was so afraid of losing the diamond that he always carried it with him, hidden among the folds of his turban. During one of the banquets hosted by Ranjeet Singh, he insisted on exchanging turbans with his honoured guest, as a sign of friendship. The poor Amir, being unable to refuse, thus had to part with the Koh-i-noor.

Later, when the British annexed Punjab, the Koh-i-noor was handed over to Queen Victoria. It then weighed 186.062 carats. The loss in weight of about 83 carats is attributed to the mutilation to which the diamond was subjected. In 1851, the Koh-i-noor was exhibited for the first time and in 1852 Messrs Garrard cut it again. They employed Voorsanger, a diamond cutter from M. Costar's atelier in Amsterdam. The actual cutting lasted 38 days and its weight was further reduced to 106.062 carats. The cost of the cutting amounted to 8,000 pounds. Nonetheless, despite its reduced weight, the Koh-i-noor lives up to its name—it is indeed a glorious mountain of light that shines on through the centuries.

7
Perfect Pinnacles

The palaces, pavilions and towers of the Red Fort are a tribute to the grand vision and magnificent design of Emperor Shah Jahan. The edifices that stand today tell the story of the days gone by, when the royals lived here. Facing the river, on the eastern terrace, were erected beautiful palace buildings, juxtaposed with green gardens and flowing fountains.

The eastern side of the Fort was no doubt the most appropriate for the construction of royal palaces as it overlooked the River Yamuna and provided a charming river frontage with a pleasing landscape, fresh air and a constant supply of water. In those days, the river touched the Fort and presented a magnificent display of imperial craft—a variety of boats, some with peacock heads, colourful and richly ornamented. There were also many birds here as well as dolphins frolicking in the river. In its place now is a broad road that connects southern Delhi with the northern.

The outer wall of the citadel on the side of the river is raised from the ground that was earlier the riverbed. The wall is built in Mughal or *lakhuri* bricks faced with red sandstone. All the palace buildings are constructed on the eastern ramp that is 18.0 metres high from the riverside and 1.38 metres on the western side from the ground level of the Fort.

Starting from Asad Burj on the south-eastern corner to Shah Burj on the north-eastern side, this row of royal buildings takes the visitor back to an era when kings and queens, along with their retinue, actually lived here.

The Rang Mahal and the Mumtaz Mahal, beautifully designed and ornamented as to defy description, surpass the most magnificent buildings of the world.

Front view of the Mumtaz Mahal.

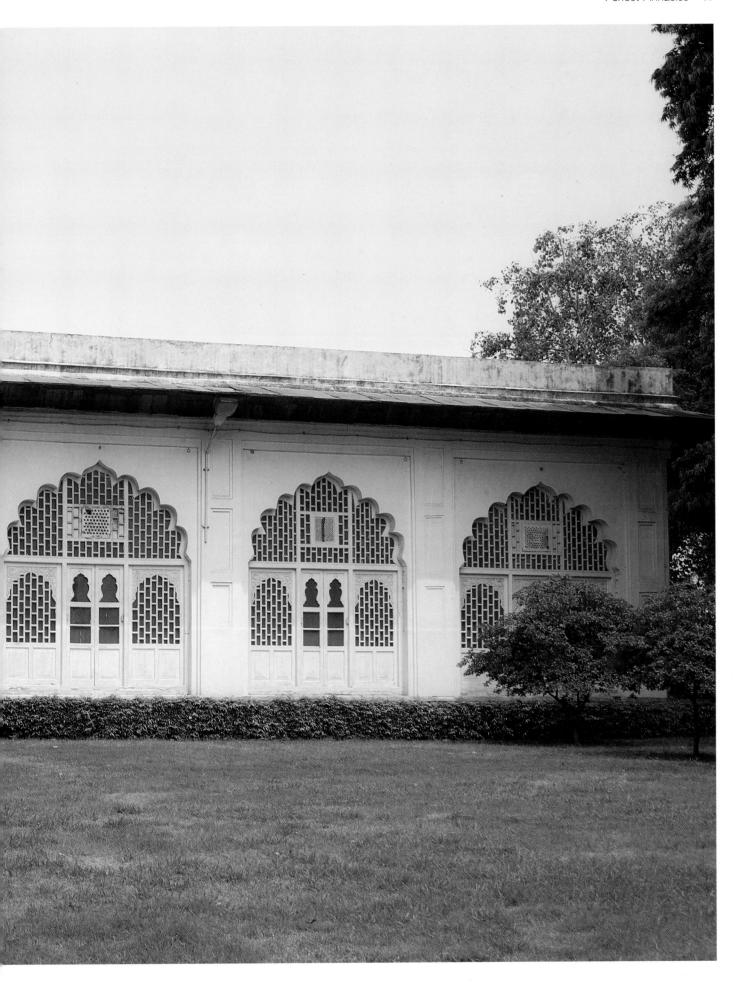

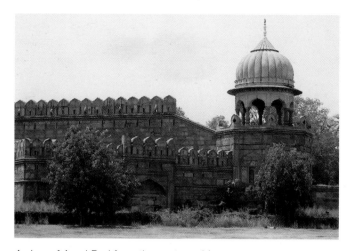

A view of Asad Burj from the eastern side.

Asad Burj

This is an octagonal tower situated on the south-eastern corner of the Red Fort, its topmost pavilion crowned with a dome and similar in design and size to the Shah Burj. The Asad Burj was bombarded and destroyed in the Harnath-Chela riots and was restored during the reign of Mohammad Akbar Shah II to its original structure. A wide-stepped path, open to the sky, leads to an underground chamber and a gateway known as the Water Gate that was earlier opened to the riverside and is now closed.

Mumtaz Mahal

Named after Shah Jahan's favourite queen, the Mumtaz Mahal lies to the north of the Asad Burj and to the south of the Rang Mahal. It is an apartment that is three-aisles wide from west to east. To the east is an extended hall with two enclosed chambers. The western façade consists of five engrailed arched openings, shaded by red sandstone *chhajjas* (sloping cornice). To the north and south are three engrailed arched openings each of a similar design. These have been now barricaded with wooden doors and grills.

The Mumtaz Mahal is today used as an archaeological museum. The hall consists of arches supported by pillars lined with marble. The soffit of the arches was originally decorated with painted inlay work. The entire hall is partitioned to exhibit artifacts of the Mughal period. The museum exhibits documents such as the *farmans* (edicts) of Akbar and his predecessors; Arabic Persian inscriptions of 1578; paintings of Jahangir with Khwaja Salim Chisti and Prince Khurram; Akbar and Jahangir shooting tigers; a specimen of calligraphy in *Nastaliq* or *Naskh* character; manuscripts of Mukhtar Nama (1646) and a *farman* of Shah Jahan. In addition

Zinat Mahal's skirt with blouse. Courtesy: Mumtaz Mahal Museum, Red Fort (ASI).

Bahadur Shah Zafar's painted silk coat. Courtesy: Mumtaz Mahal Museum, Red Fort (ASI).

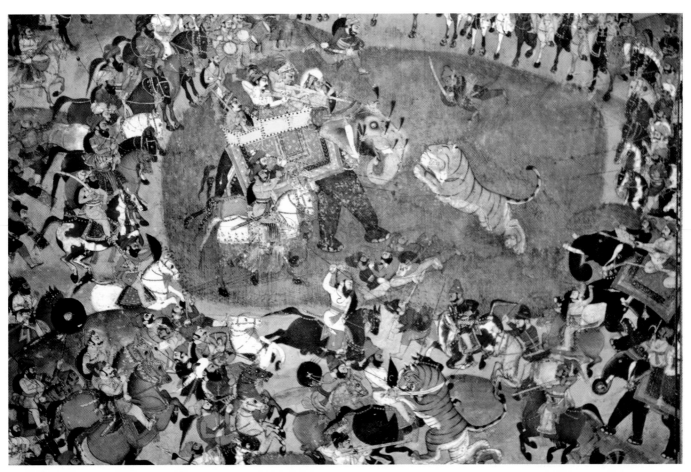

A painting depicting Prince Aurangzeb's hunting adventure with an infuriated elephant. Courtesy: Mumtaz Mahal Museum, Red Fort (ASI).

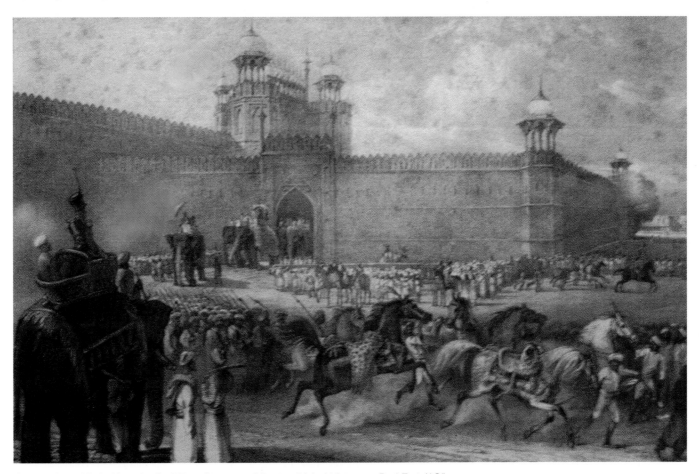

Celebration of Bakr Id at the Red Fort. Courtesy: Mumtaz Mahal Museum, Red Fort (ASI).

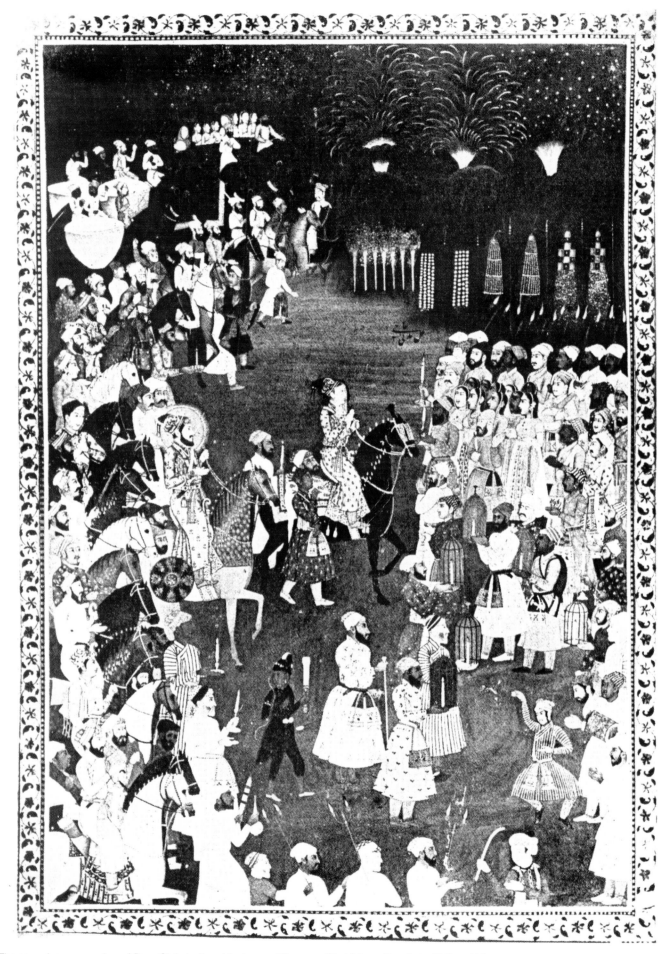

The marraige procession of Dara Shikoh, the eldest son of Emperor Shahjahan: Courtesy, National Museum.

A view of the Delhi Durbar, 1 January 1877. Courtesy: Mumtaz Mahal Museum, Red Fort (ASI).

Bahadur Shah's velvet cushions, rosewater sprinkler and pipe. Courtesy: Mumtaz Mahal Museum, Red Fort (ASI).

there are objects such as Mughal and brass astrolabes and brass and bronze celestial spheres. There is an ivory handle depicting birds, as well as stone, jade and ivory bowls of chalcedony, inlaid with jewels. Also on display are some unique jade vessels, decorated trays and perfume boxes. In one of the chambers of this museum are exhibited a robe, some chairs and day-to-day utility items, including some letters belonging to the Mughal period. There is a Bahadur Shah gallery in the middle of the eastern chamber, with objects belonging to Emperor Bahadur Shah and his queen. The central showcase exhibits dresses, penholders, inkpots, scissors, gun powder horns, rosewater sprinklers and specimens of calligraphy. There are also photographs of the last days of Bahadur Shah in prison at Rangoon.

A few contemporary journals, maps and scenes of Delhi can also be seen here. Other documents include a manuscript of the Holy Quran dating to the 14th century. An 18th-century girdle of brocade; a cotton shirt bearing verses of the Quran used by the Mughal emperors for protection against danger; a painted silken coat of Bahadur Shah; carpets, weights, spittoons, a spouted *hookah* (pipe), embroidered prayer carpets, a velvet *masand* (pillow), a spouted pot with rings, metallic swords and daggers ... the amazing collection here is reason enough to visit the Red Fort.

Period objects, the scene of the siege of the Fort in 1857, different kinds of pistols, armaments, breast plates, brass canons, an armguard, an eight-bladed mace, battle axes, decorated tiles bearing Quranic verses, musical clocks and 8th-century Mughal paintings depicting shooting scenes, Sufi saints and princes dancing—all find a special place in this fascinating museum.

The Mumtaz Mahal was once the residence of the royal princesses. It has also served as a military prison and was used as the sergeant's mess during the British period. Old drawings and photographs of the Fort, dating before the First War of Independence, shows that its structure was similar to the neighbouring Rang Mahal. It is said that a channel in white marble of about 2.74 metres width used to run through it. This channel passed though a marble pond and emptied itself into the octagonal marble tank situated in the courtyard to its west. It had 25 fountains; originally there was a beautiful garden of 61.26 square metres in this court. The plinth of the building is still buried. Excavations made in 1911 revealed the remains of a small marble fountain basin in front of the building on the west side.

The fact that the space between Mumtaz Mahal and Rang Mahal had buildings in the days of the last Emperor of Delhi is evident from old photographs taken before the First War of Independence. It is probable that in the days of Shah Jahan another smaller pavilion existed here. According to Hearn, who wrote *The Seven Cities of Delhi*, a pavilion known as a small sitting place (Chhoti Baithak) and a modern building, the Dariya (River) Mahal, occupied this space. The latter building, he says, was more ornate than the others and had a pediment on the river face surmounted by the figure of a bird. An old photograph of the Fort taken before the First War of Independence shows a building of this design. The range of arcades, which formed the southern boundary of the garden of the Rang Mahal, probably continuing through to the front of the east wall of the Fort, and any interspaces between the buildings on the eastern outer wall, were filled with marble screens to prevent the inmates of the harem from being seen from the low ground between the Fort and the river. The last of the seraglio buildings on the river face (between the Mumtaz Mahal and the Asad Burj) was the Khurd Jahan (Little World).

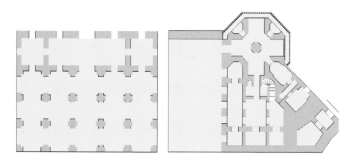

Drawings of the Mumtaz Mahal (left) and the Asad Burj.

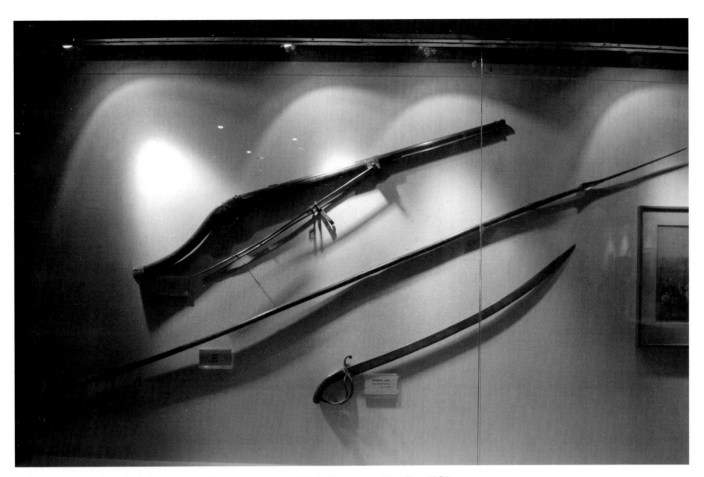

A rifle, a spear and an inscribed sabre. Courtesy: Mumtaz Mahal Museum, Red Fort (ASI).

A chessboard. Courtesy: Mumtaz Mahal Museum, Red Fort (ASI).

Rang Mahal

The Palace of Colour gets its name from the coloured decoration with which it was originally adorned. In the time of Shah Jahan, the Rang Mahal was known as the Imtiaz Mahal (Palace of Distinction). 'In excellence and glory it surpasses the eight-sided throne of heaven, and in lustre and colour it is far superior to the palaces in the promised paradise,' was how a court chronicler described it. It is indeed a pity that only a few traces remain of its former elaborate decoration. The Rang Mahal lies immediately to the north of the Mumtaz Mahal. The building is the largest of the apartments of the royal seraglio, with two basement chambers. The access to these chambers is provided through the stairways from the western façade. It is a three-aisle wide hall with five engrailed arched openings in the western façade. The central archway of the southern and northern façades has been extended with the introduction of an open curtain screen with moulded columns of marble and a triple arch. On top are small ventilators filled with *jali* or tracery work. It is said that the central opening of the western façade was also extended by adding moulded columns and a triple arch.

Above the screens were small windows filled with *jali*, similar to that seen in the north and south façades. The building measures 46.78 metres by 18.05 metres. Inside, engrailed arches on twelve-sided piers with four bases divide the main apartment into 15 bays, each 6.09 metre squares. These are cased in marble up to 3.35 metres of their height. Sunken niches carved in marble and moulded work in bare red sandstone form the interior of the palace. The gilded work on the soffits and spandrels of the arches and the floral designs in rich gold bedazzle the interior. On the soffits of the outer row of arches are remains of the old gilded decoration in the form of conventional flowers. It is believed that the original ceiling was of silver but was later replaced with copper. This was again removed and replaced with a wooden ceiling. Muhammad Salih, writing in the reign of Shah Jahan, describes the original ceiling as being 'gilded and ornamented with golden flowers'.

The eastern wall of the Rang Mahal is pierced by five windows overlooking the river, from where the ladies of the harem could view elephant fights that were held on the sandy shore at the foot of the walls. These were also keenly watched by the emperor from the adjoining Musamman Burj. Four of these windows are now filled with rectilinear tracery of a type reminiscent of a

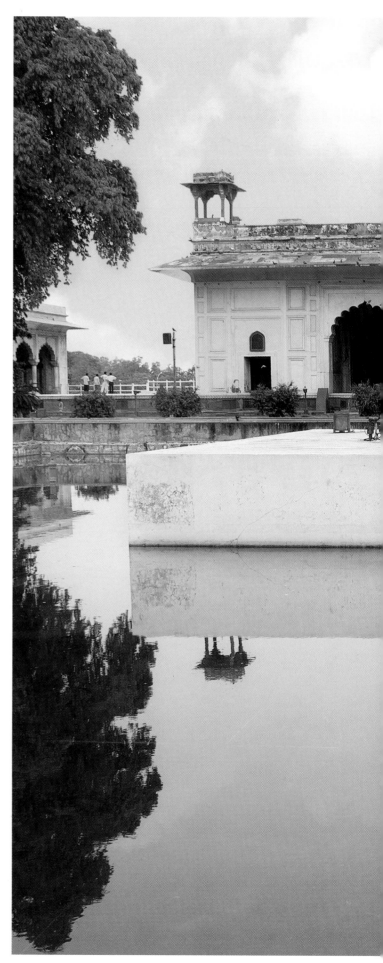

Front view of the Rang Mahal.

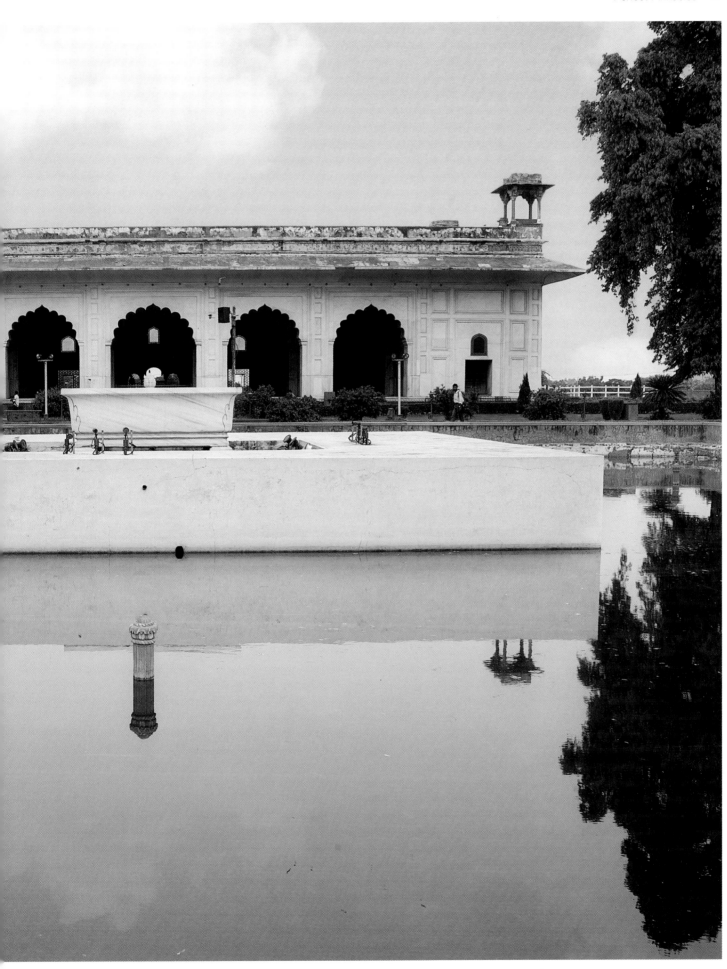

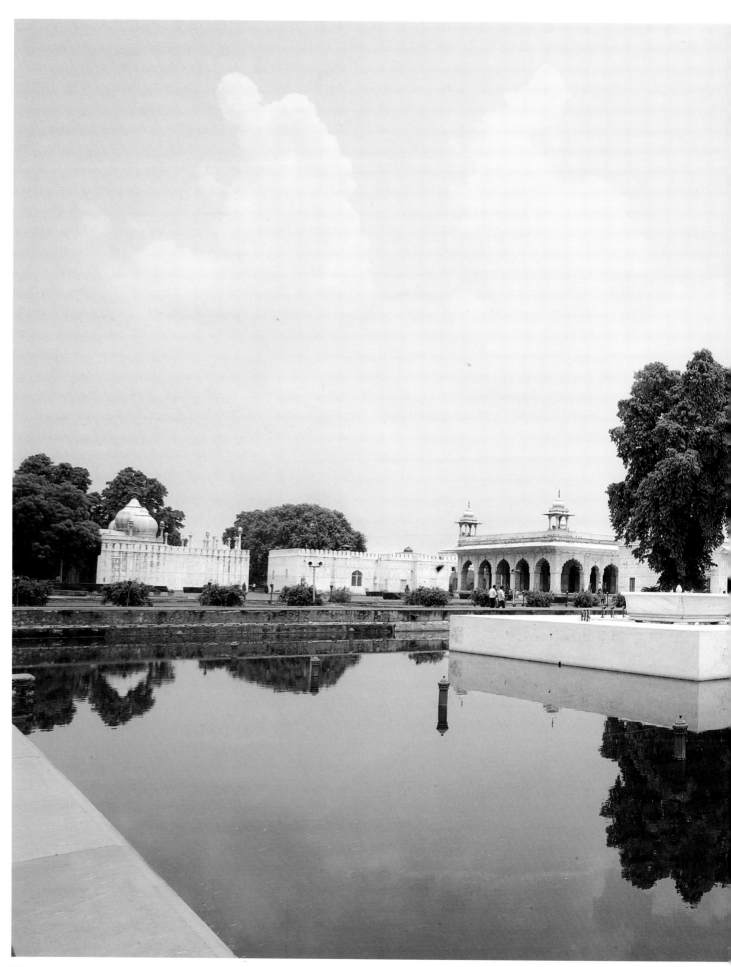

The Rang Mahal, the Khas Mahal and the Diwan-e-Khas.

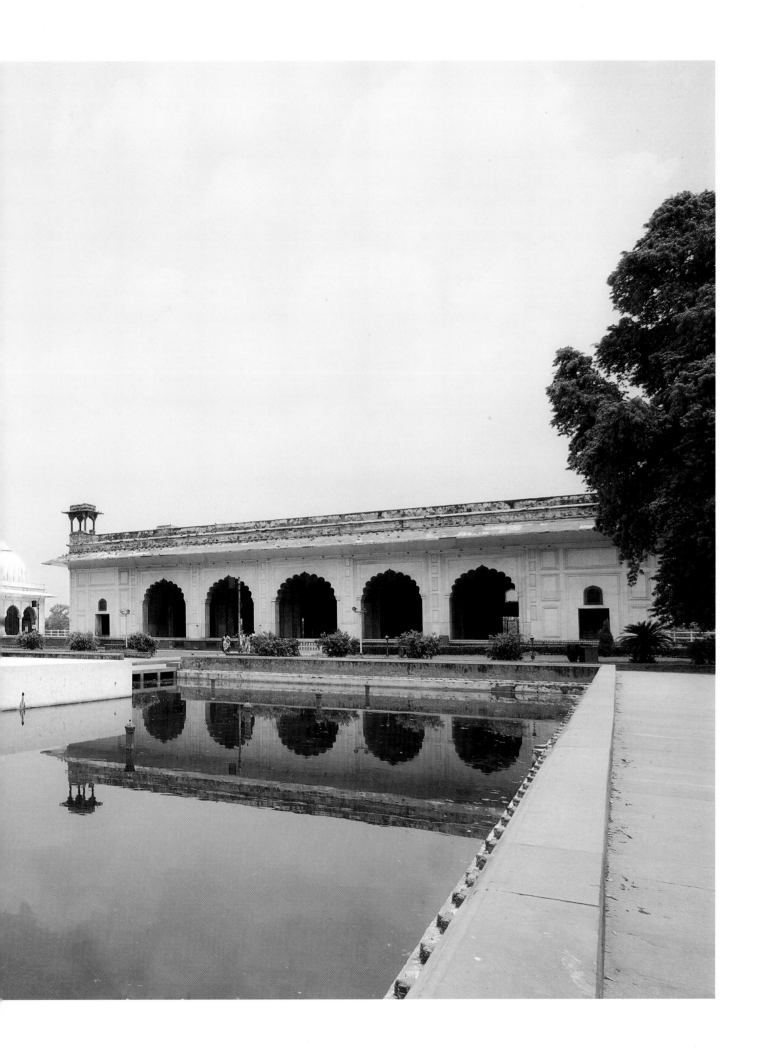

Chinese decoration. The original glazing, which has totally disappeared, was probably of glass in vivid colours and is still seen in one of the windows of the Hammam. The central window opening is enclosed by a frame of flamboyant swirls and bulbous domes and is surmounted by an umbrella-shaped finial. At each end of the main hall are smaller chambers known as Sheesh Mahals (Palaces of Mirrors) as the upper portions of the walls are set off with glass borders and the ceilings are richly decorated with tiny glass mirrors.

There is a shallow marble fountain basin intersecting the channels that flow through the middle bay and were buried till 1908 under the stone flooring. It is in a lotus form, the petals of which are delicately and exquisitely modelled. In the centre is a raised *amlaka*-shaped *kalasa* (vessel) in marble, once profusely inlaid with coloured semi-precious stones. The water cascading from the edges of the vessel and the swaying of the plants and flowers under the flowing water was nothing less than a magical sight. The coloured stones and carvings provided a varied background.

Light also played an important role in the visual effect created by the fountain as the spray and the wet polished surface of the basin reflected the light falling on it. The particular beauty of this is when, full of rippling water, the foliage of the inlay work appears to sway to and fro, greatly enhancing the surroundings and the intrinsic beauty of this building.

The channels on the four sides, fed from this sun-like fountain, poured their waters in the form of a cascade into a basin made of a single piece of marble. On leaving this, the water flowed into the main channel, running into the midst of the gardens. The stone of the basin came from the Makrana quarry in Rajasthan. The basin earlier stood in the Queen's Garden, which was laid out by Jahanara Begum to the north of Chandni Chowk, behind the Town Hall. It was brought back in 1911 to this garden and now stands in the centre of the large tank between the Rang Mahal and the Diwan-e-Am. The bottom of the tank was grassed during the British period and has now been laid with flagstones. The fountains were exposed, renovated and rejuvenated with the help of a motor pump placed in the south-west corner of this garden. The area around the Rang Mahal has been redeveloped into gardens and causeways. Stone pavements have been provided for the convenience of visitors. The courtyard, where this

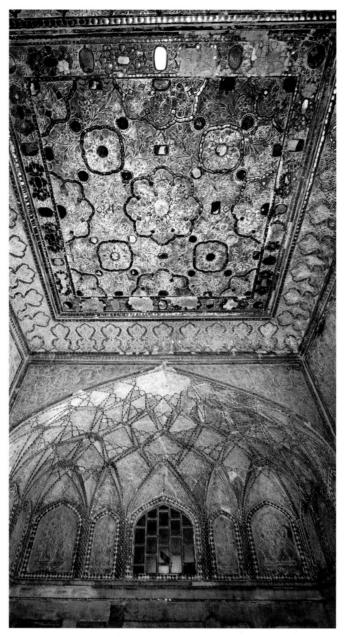

A decorative ceiling, and arches.

The spandrel of an arch showing the original decoration.

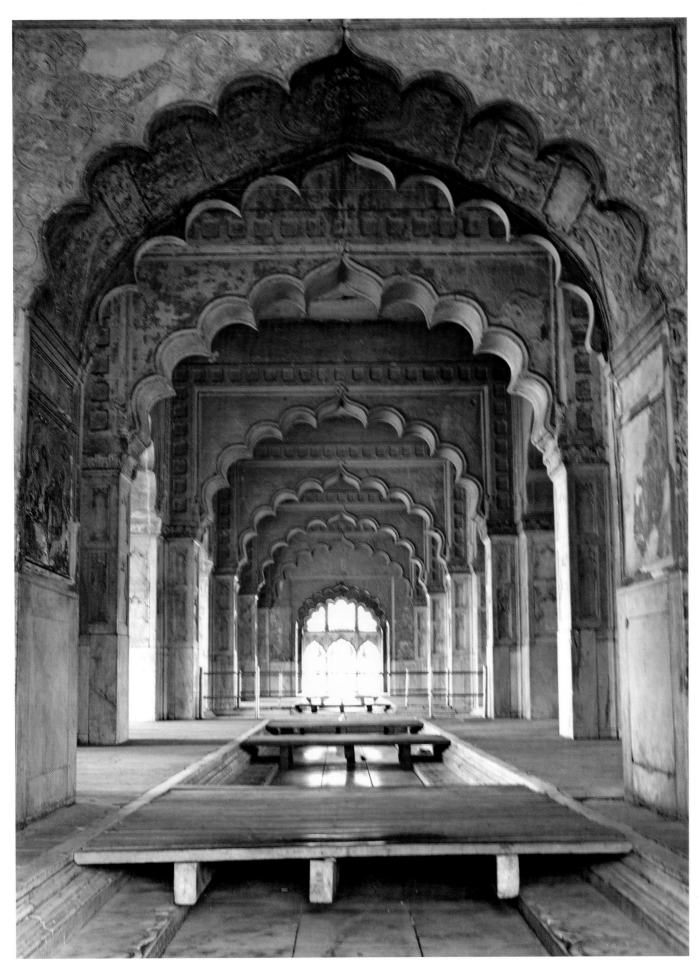

Inner view of the Rang Mahal showing the continuing channel of the Nahr-i-Bahisht.

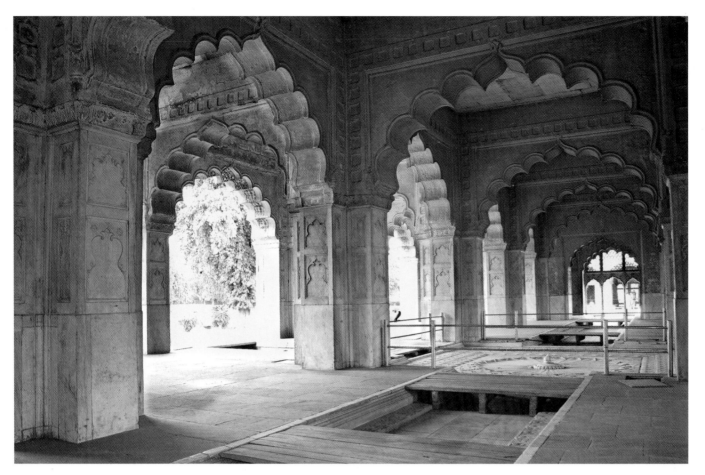

Inside view of the Rang Mahal.

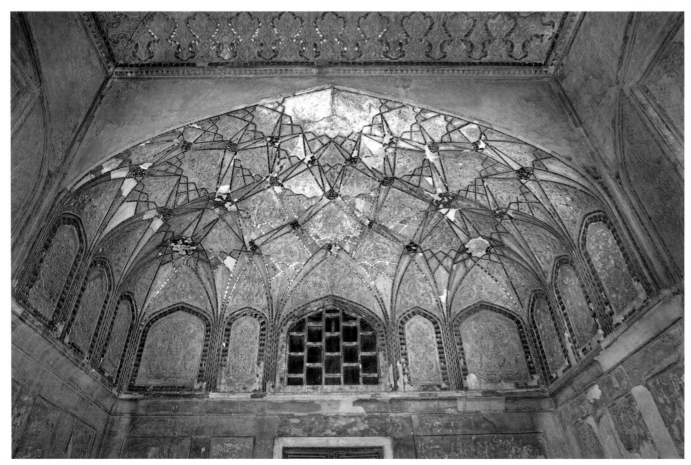

Embossed glasswork in the Sheesh Mahal (Rang Mahal).

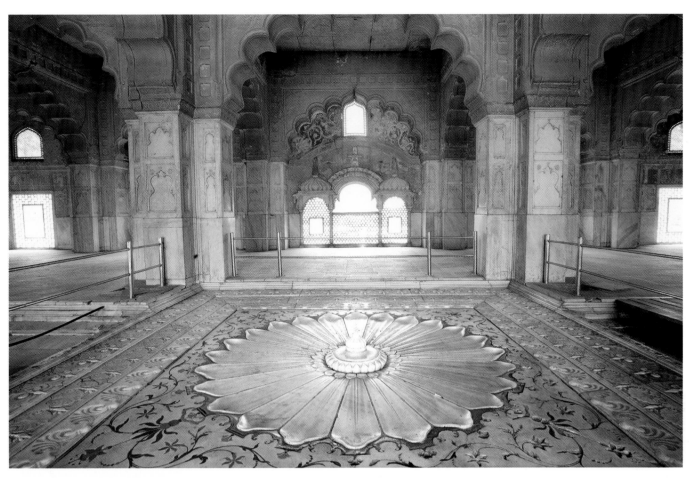

A marble basin shaped like a lotus.

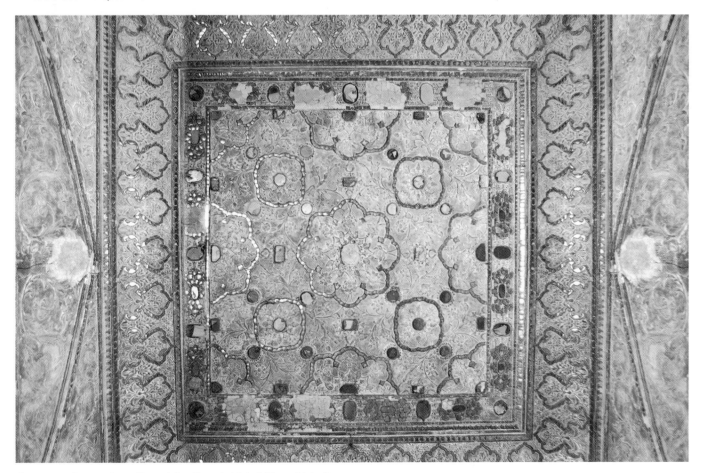

Ornamentation on the ceiling of the Sheesh Mahal (Rang Mahal).

large tank was the central feature, was formerly so extensive that it was laid out as a garden with channels dotted with fountains.

Bishop Heber, writing in the early 19th century, says that all these had been destroyed when he saw the Fort and instead wretched houses had been built there. The garden contained an orchard that was surrounded by a screen-like railing of red sandstone. This screen had been artistically designed with 2,000 pinnacles of gold. On three sides of the courtyard stood mansions and charming arcades. These were 17 yards wide and below the plinth of the palace on the west lay this garden. The large tank between the Rang Mahal and the Diwan-e-Am, which had been filled up and crossed by a military road and a drain, was excavated. In its centre were found traces of a little square building with a central tank, probably designed on the same lines as the Zafar Mahal in the Hayat Baksh garden.

It has not been possible to provide sufficient water for this tank so the bottom has been grassed. Some of the old stones and a stone ring were found here, which probably means the tank must have been screened on occasions from the bright sun by a *shamiana* (marquee).

The south-east part of the fortification wall was exposed in 1977-78, when silt and debris were removed during clearance work. The fountain tank between the Rang Mahal and the Diwan-e-Am then came to light, as did a number of fountains and an earlier causeway in the centre. Channels were cleaned for the reflow of water to the fountains through the original channels. In 1994-95, the fountains in front of the Rang Mahal were fixed and plastered as per the original plan.

A drawing of the Rang Mahal.

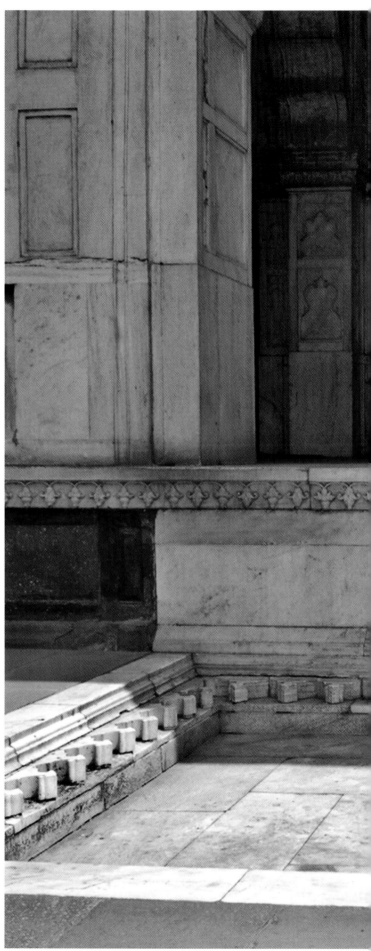

The large tank between the Rang Mahal and the Diwan-e-Am.

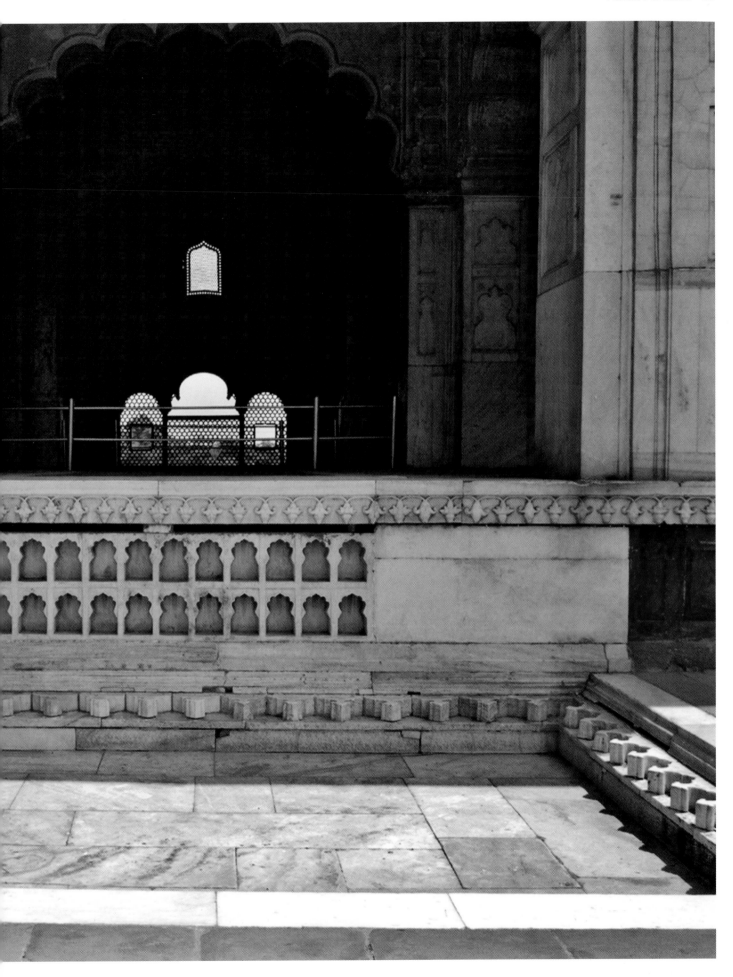

Front view of the Khas Mahal.

Khas Mahal

Small, elegant and cased in marble was a suite of three chambers, together known as the Khas Mahal (The Emperor's Palace). Situated on the immediate north of the Rang Mahal, this whole complex is divided into two equal parts by a marble-lined canal known as the Nahr-i-Bahisht. The space between it and the Diwan-e-Khas is paved with marble.

The three oblong chambers are the Tasbih Khana (the place where praises to God are recounted), the Khwabgah (Dormitory) and the Baithak or the Tosh Khana (the place where people meet to sit and talk).

The Tasbih Khana consists of a row of three rooms facing the Diwan-e-Khas; a second row of three rooms behind this is known as the Khwabgah, and the adjoining hall, which is about half the width of the Khwabgah, facing south, is called the Baithak. This is an oblong verandah that has a five-arched opening.

The walls of this chamber are decorated with inlay work of precious stones. Stones are missing at several places but the cheaper inlay work recently substituted has been very skilfully done.

Together, these three sets of chambers are about equal in size to the Diwan-e-Khas. The Tasbih Khana has three arched openings with two enclosed rooms for women on either side. The walls of the chamber up to the dado level are devoid of any decorations but the surface above the dado is sunk with niches set with inlay work, now faded. The ceilings are gilded and painted with conventional Mughal designs.

The Khwabgah has three rooms in the centre of the building; the middle room is about double the size of those on its east and west. These three rooms connect with one another through arched doors in the central room; the walls are decorated with sunken niches. The restoration of inlay work is in progress. There are semi-circular arched openings covered by marble screens in the northern and southern walls of the central room.

Under the arches are inscriptions of historical fame—the work of Sa'dulla Khan, the *Wazir* of Shahjahan. The English translation of the inscriptions on the southern and northern arches reads as follows:

Praise be to God! How beautiful are these painted mansions and how charming are these residences: a part of the high heaven. When I say the high-minded angels are desirous of looking at them, if people from different parts and directions (of the world) should come (here) to walk around them as (they walk) round the old house (Ka'ba), it would be right; and if the beholders of the two worlds should run to kiss their highly glorious threshold as (they kiss) the black stone (of Ka'ba) it would be proper. The commencement of this great fort, which is higher than the palace of the heavens and is the envy of the wall of Alexander; and of these pleasant edifices and of the garden of Hayat Baksh, which is to these buildings as the soul is to the body, and the lamp to an assembly; and of the pure canal, the limpid water of which is to the person possessing sight as a world-reflecting mirror, and to the wise the unveiler of the secret world; and of the waterfalls, each of which you may say is the whiteness of the dawn or a tablet of secrets of the Table and the Pen (of Fate); and of the playing fountains, each of which is a hand of light rising to greet the inhabitants of heaven; or they are bright pearls alighting to reward the inhabitants of the earth; and of tanks, full of water of light (and) in its purity the envy of the light and the sun; announced on the 12th Dhilhijjah in the 12th holy year of the ascension, corresponding to A.H.1048, the delightful tidings of happiness to the people of the world. And the completion of it, which was effected at the expense of 50 lacs of rupees, on the 24th Rabi'u-l-Awwal in the 21st year of the auspicious ascension corresponding to A.H. 1058, by the glory of the happy feet of the sovereign of the earth, the lord of the world, the founder of these

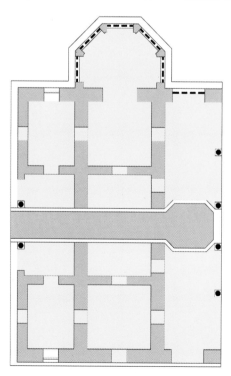

A drawing of the Mussaman Burj (top) and the Khas Mahal.

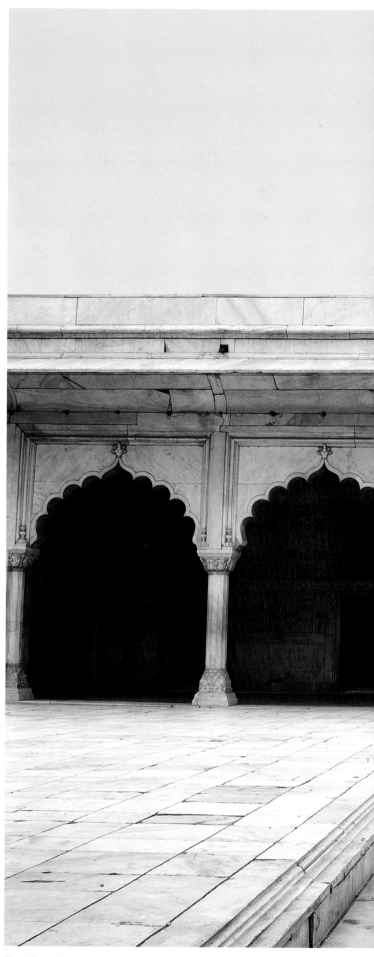

The Khas Mahal and the Mussaman Burj.

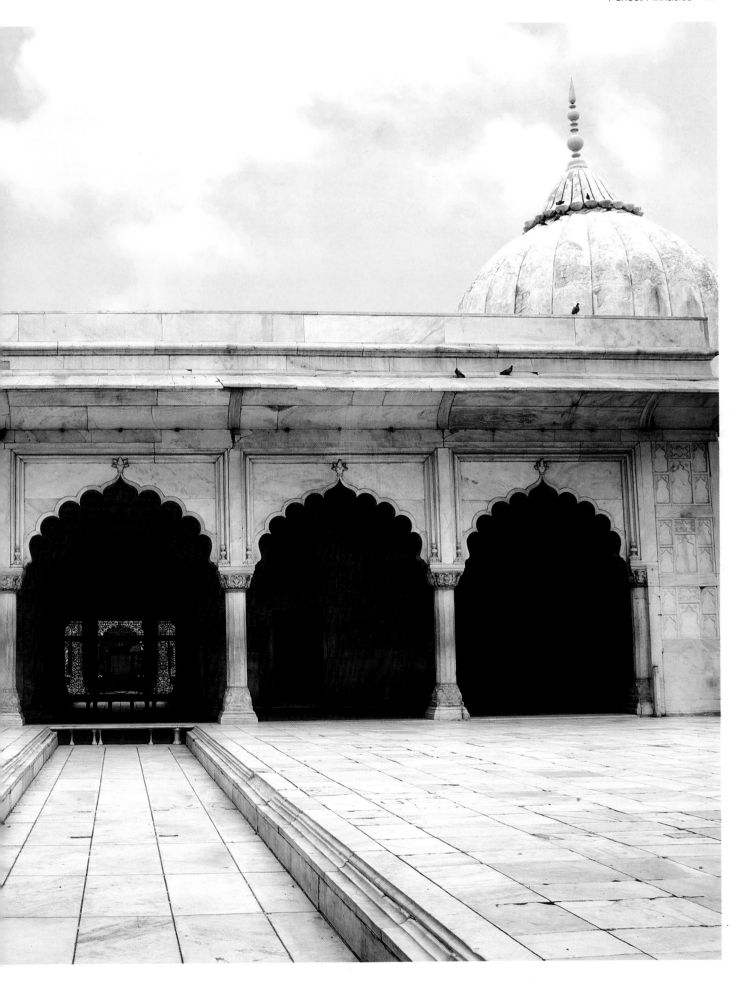

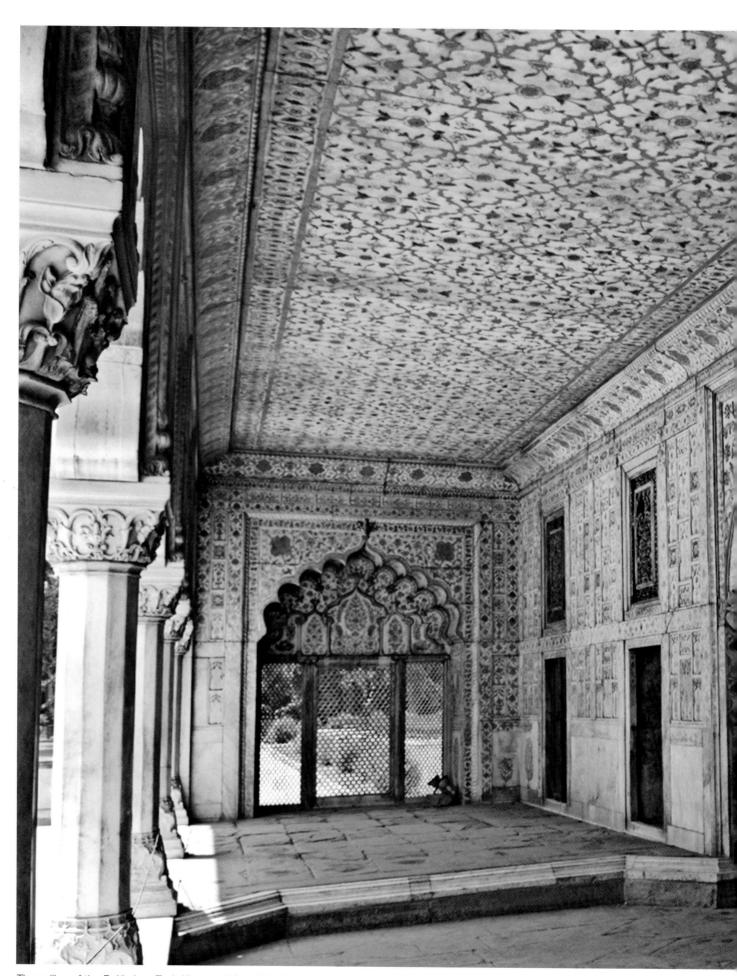

The ceiling of the Baithak or Tosh Khana of Khas Mahal covered with silver leaves and inlaid with gold.

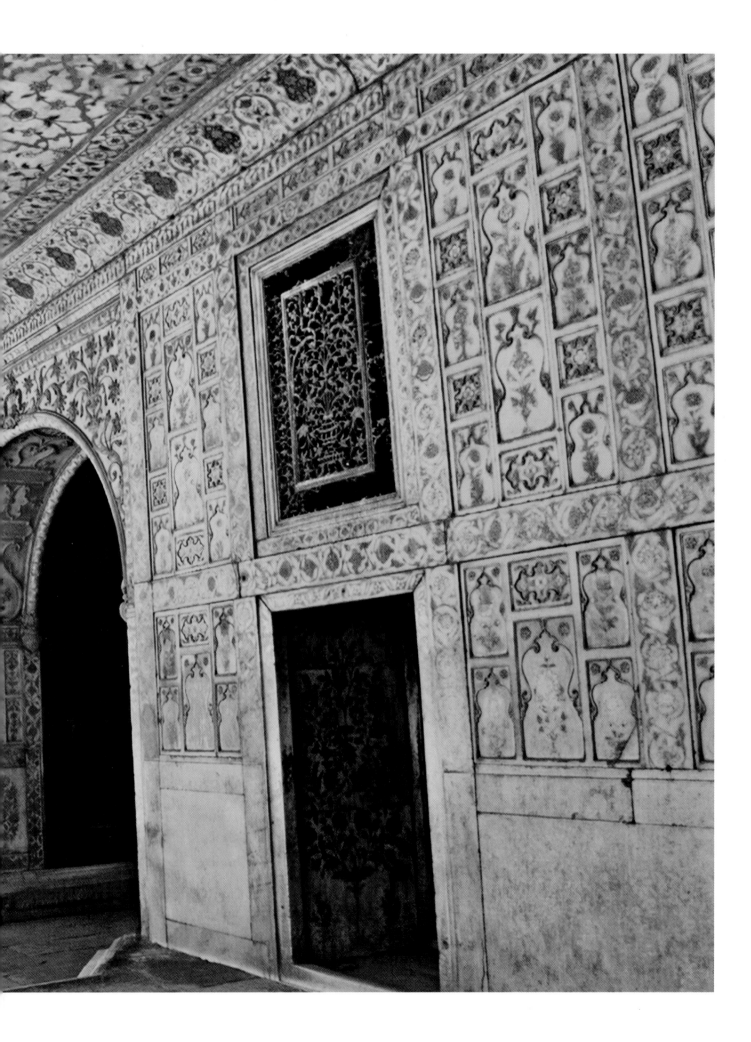

Inscriptions on the arches of the Khawbgah (Khas Mahal).

پسُبحان الله این چه منزلهاست زیرین و چه نشیمنهاست دلنشین

قطعه بهشت این جون لوم که قد وپسیان همت بلند تماشایش ارمند و

اغاز قلعه والا که از کاخ کردون برتبت و رشک سد سکندر این عمارت دکشا

وباغ حیات بخش لعه در منازل جون روح دربدپست وجمع بخن و منه طهر له

بمصافحه آسمانیان مائل بالاتی متلالیست بانعام زمینیان نازل حیاض لعه

تمه آب زندگانی بر بصفارشک یو چشمه خور دوازدهم ذی الحجه

مپست و چهارم ربع الاول سال سبع و یکم جلوس پمایون

موافق سپه نزار و پنجاه و مپست بفرق دوم مپنت لزوم کتبی خدیو

heavenly, pleasant mansions, Shihabu-d-Din Muhammad, the second lord of felicity, Shahjahan, the king champion of faith, opened the door of favour to the people of the world. (inscription on page 106-107)

On the outer face of the screen in the north wall of this room, above the small window in the middle, are the famous Mizan-i-Insaf or Scales of Justice, said to be scales held over a crescent, in the midst of stars rising out of clouds. Leopold von Orlich—a German who came to join the British Army and wrote an account of the Sikhs, visited Delhi in 1843. He observed, 'Before the entrance to the residence of the Great Mogul, a pair of scales are suspended over a stone seat, to indicate that justice alone is administered in these apartments. As we entered the halls which lead to the King's apartments we saw a rhapsodist, who was sitting before the bed chamber of the Great Mogul and relating tales in a loud voice. A simple curtain was hung between him and the King, who was lying on a couch and whom these tales were to lull to sleep.'

Musamman Burj

Adjoining the eastern wall of the Khwabgah in the Khas Mahal, and overlooking the river, is a domed balcony, Musamman Burj (also known as the Burj-i-Tila or Golden Tower). It is octagonal in plan and roofed by a dome, once cased in gilded copper. The emperor would emerge daily from here to greet the crowds gathered below the Fort. The original dome of the

Musamman Burj was quite different from the present one and was covered with copper. The dome was removed after the uprising of 1857, together with the copper coverings of the pavilions at the corners of the roof of the Diwan-e-Khas. Out of the eight sides of this room, three are cut off by the Khwabgah and, of the remaining five sides that overlook the river, four are covered by marble screens. There is a small covered balcony, added by Akbar II, in front of the fifth wall, which is in the middle of the Burj. The inscriptions from the northern arches read:

> Praise and thankfulness are worthy of the Lord of the World,
> Who made such an Emperor the King of the Age,
> Who is descended from a royal father and grandfather down from Timur,
> [And is the] protector of the world, having his court [as high as the] sky, and soldiers [as numerous as] stars,
> Mu'i-nu-Din Abu-n-Nasr Akbar, Ghazi,
> King of the World, Conqueror of the Age, and Shadow of God,
> On the face of Musamman Burj, built anew such a seat that the sun and the moon sewed [fixed] their eyes on it.
> Sayyidu-sh-Shu'ara was ordered to record its date,
> So that the black letters may endure on the white [ground]. The Sayyid wrote the chronogram of this building: May the seat of Akbar Shah be of exalted foundation. The year 1223. *(Inscriptions on facing page, right)*

The inscriptions of the western doorway read:

> O [thou who hath] fetters on thy legs, and a padlock on thy heart, beware!
> and O [thou] whose eyelids are sewn up, and whose feet are deep in the mire, beware!
> Thou art bound towards the west, but thou hast turned thy face to the east.
> O traveller! Thou has turned thy back on thy destination, beware! *(Inscriptions on facing page, left)*

A projecting *burj* of this type on the east wall is a common feature of the Mughal palace and is found in Agra and Lahore as well.

Hira Mahal

On an elevated strip of land along the eastern wall of the Red Fort stood two small pavilions, both built by Bahadur Shah. The northern one was known as Moti Mahal and the southern one as Hira Mahal. The former was removed after 1857; the latter still stands next to

Inscription on the western doorway.

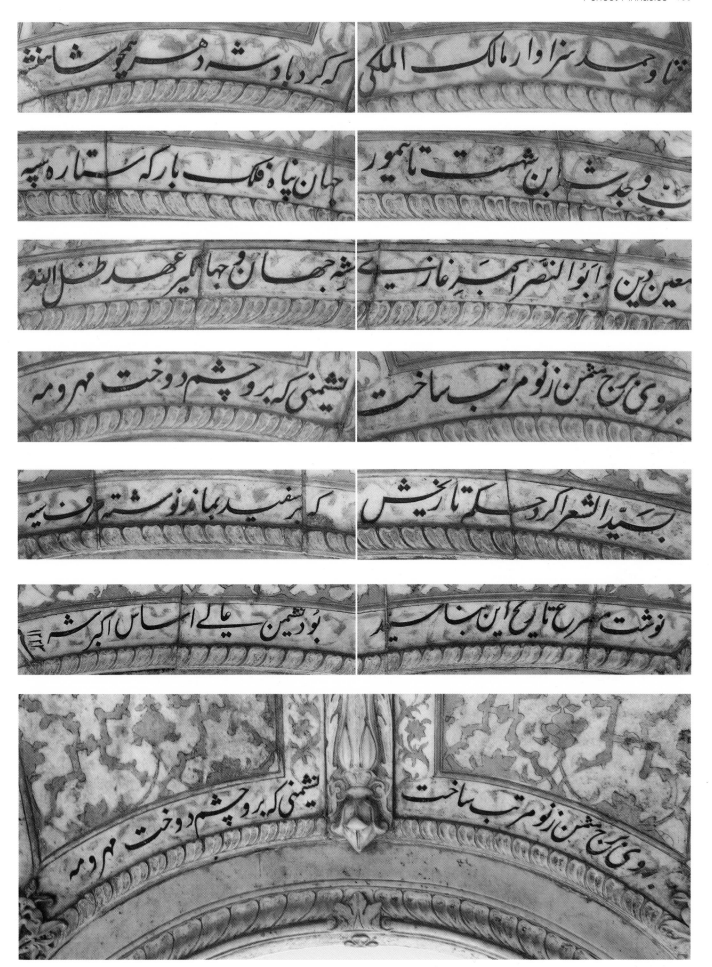

Details of inscriptions at the Mussaman Burj.

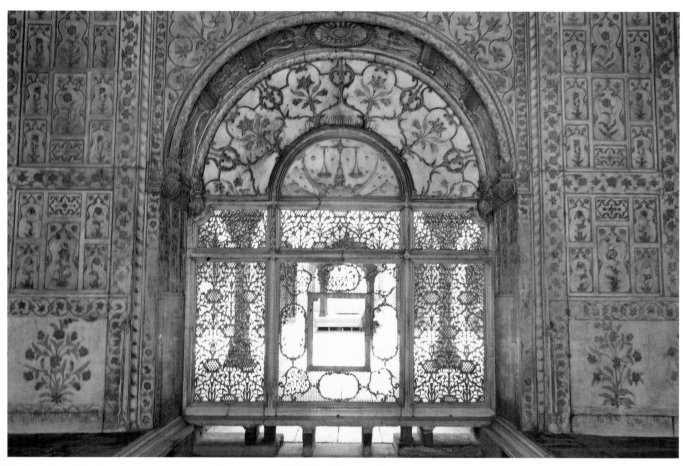

The façade of the Khawbgah showing inscribed verses of Sa'dulla Khan on the southern and northern archways.

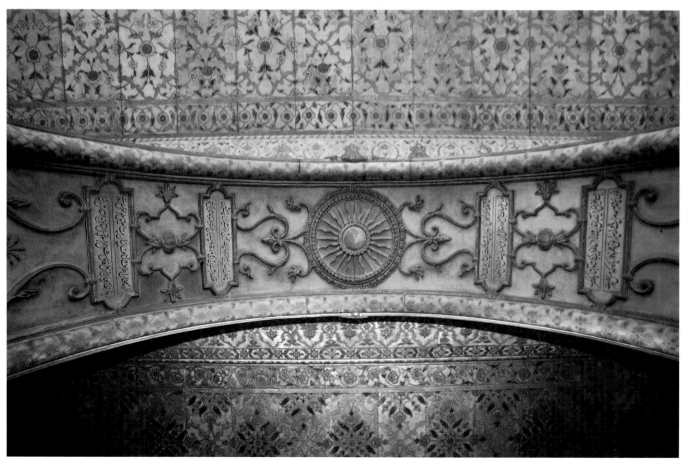

A closer view of Shamsa *(image of the sun) flanked by the inscribed verses of Sa'dulla Khan.*

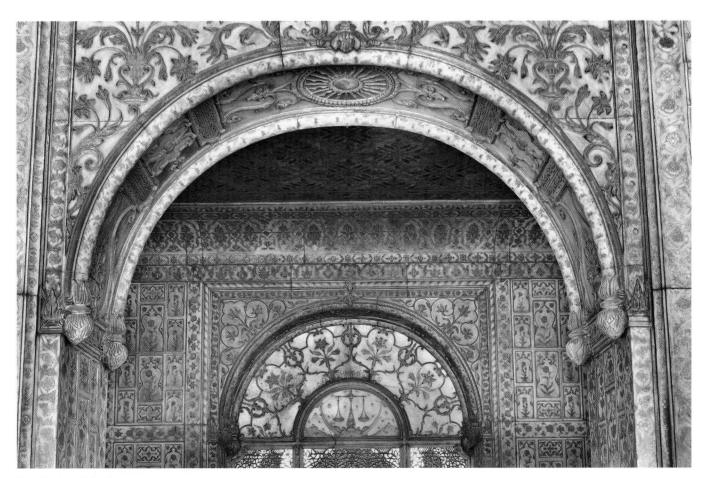

The Scales of Justice.

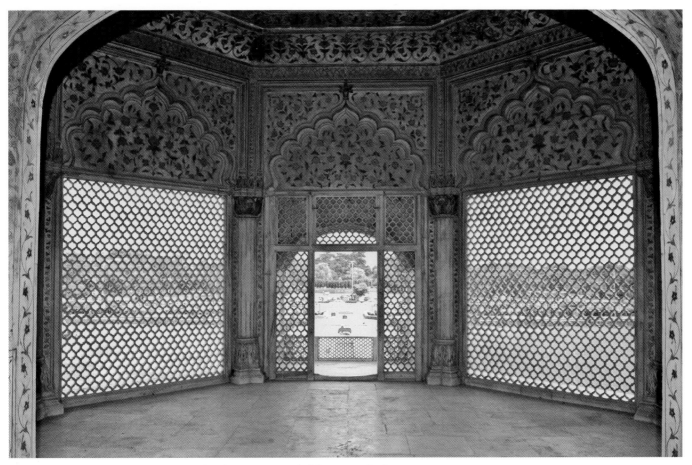

A profusely decorated arched window showing tracery work (Mussaman Burj).

the Hammam. The Hira Mahal is a three-aisle wide pavilion measuring 6.85 metres from north to south and 5.94 metres from east to west. It is open on all sides with three engrailed arches in marble. Its parapet is of marble, devoid of any decoration. This shows the contrast in the quality of late Mughal architecture, as compared with that of the period of Shah Jahan.

Shah Burj

To the north of Hira Mahal, on the extreme north-east corner is Shah Burj—a place where emperors held private conclaves. It is an octagonal tower with a diameter of 14.63 metres. It is in three stories, raised

A drawing of the Hira Mahal.

on a plinth of 10.97 metres in height. Access to the apartment is through a staircase provided on the western side. It was earlier crowned by a domed cupola of a design similar to that on the Asad Burj.

The Shah Burj is faced with white marble up to the dado level; the upper portion is plastered and painted white with floral design. The central hall has four alcoves and two *nashemen* (canopied seats) of white marble of a semi-octagonal plan. The alcoves on the northern and eastern sides measure 3.65 metres by 2.74 metres each, while those on the southern and western sides measure 3.66 metres by 2.74 metres. In the centre is a tank with exquisite ornamentation and on the west is a waterfall. In front of the waterfall is a marble tank, 3.2 metres in length and 2.28 metres in width. A water channel, also of marble, 1.37 metres in width, runs from this tank to the eastern alcove. The entire complex has been tastefully inlaid with precious stones.

This channel extends further to the tank on the western alcove, from where it proceeds to the canal of the Burj

The Hira Mahal.

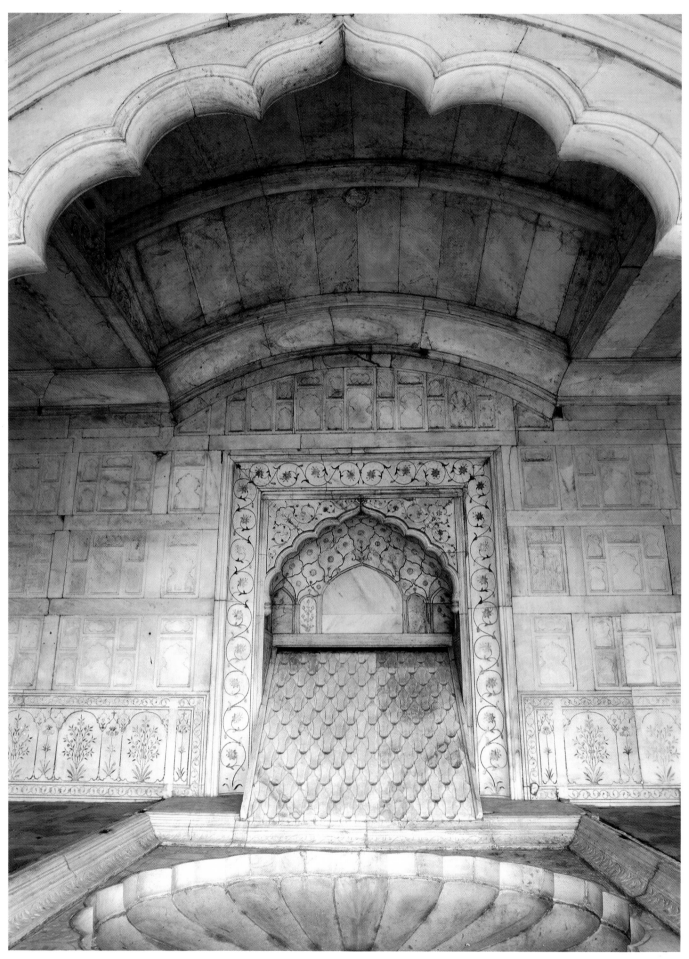

A marble water cascade and a scalloped marble basin.

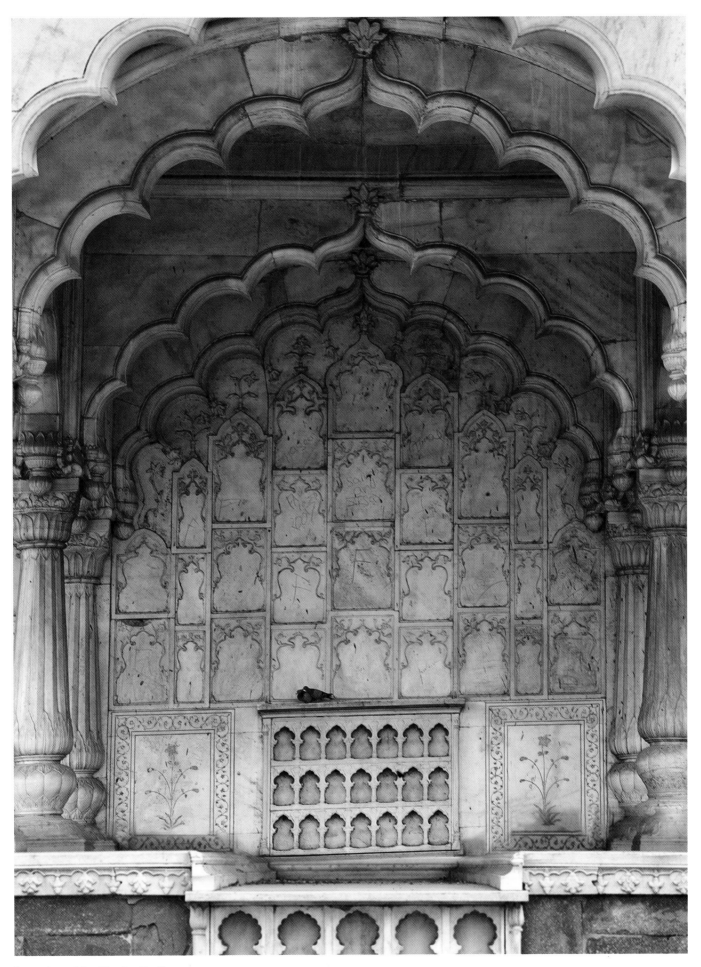

Inner view of the Bhadon Pavilion.

and the octagonal tank. In fact, this portion supplies water to the whole water system of the Red Fort through pipes that are controlled from this point, with each pipe sporting a distinct marking.

The second storey is also octagonal, with a diameter of 7.31 metres. It has an alcove on each side and is supported by 24 pillars. The third storey is a marble-domed pavilion of eight pillars, crowned by a golden *kalasa*, which is now missing.

Historians believe that Mirza Jawan Bakht made his escape from this tower in 1784, when he fled to Lucknow. Jawan Bakht was anxious to inform the British Governor, who had recently arrived in Lucknow, of the disorderly state of affairs in Delhi. His escape was easy as the tower was not too high and thus, after secretly departing from his chamber in the palace and passing from the roof of one building to the roof of another, he reached the Nahr-i-Faiz, which crosses the Hayat Baksh garden.

For many years afterwards, the Burj served as an officers' residence but in 1902, when its conservation was taken up, the marble cascade was reconstructed and modern additions removed. The earthquake of 1904 further damaged the structure and it became necessary to raze it almost entirely and rebuild it.

Marble Pavilion

To the south of the Shah Burj is a beautiful pavilion, believed to have been built by Aurangzeb. It is an arched chamber facing the south, with five cusped arched

A drawing of the Shah Burj and the Marble Pavilion.

A view of the Shah Burj and the Marble Pavilion.

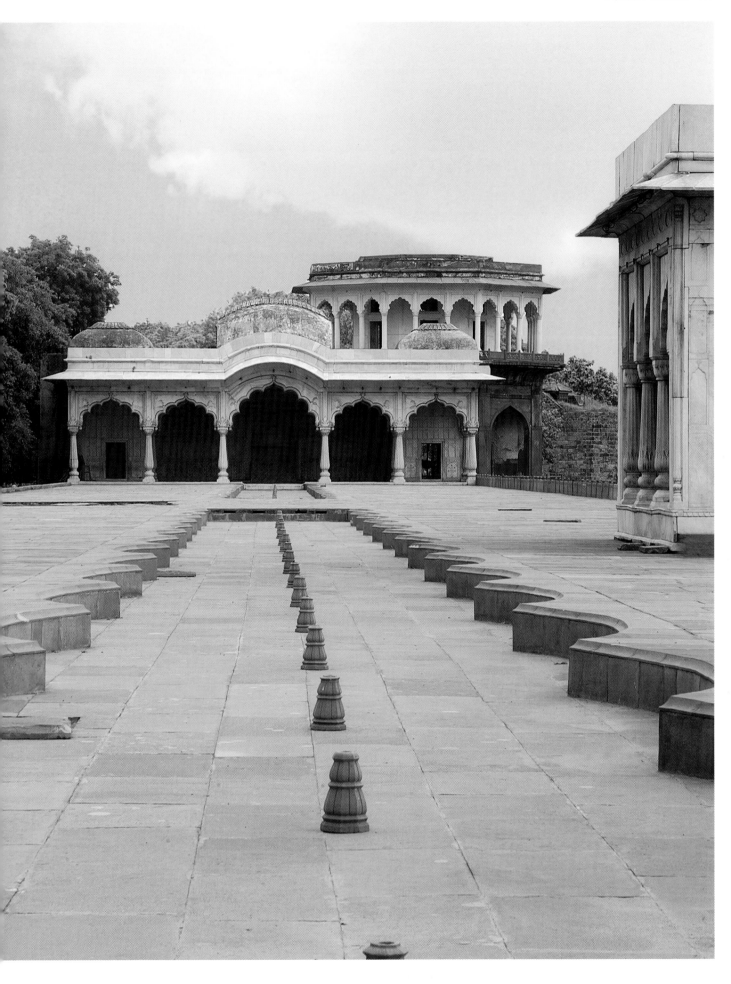

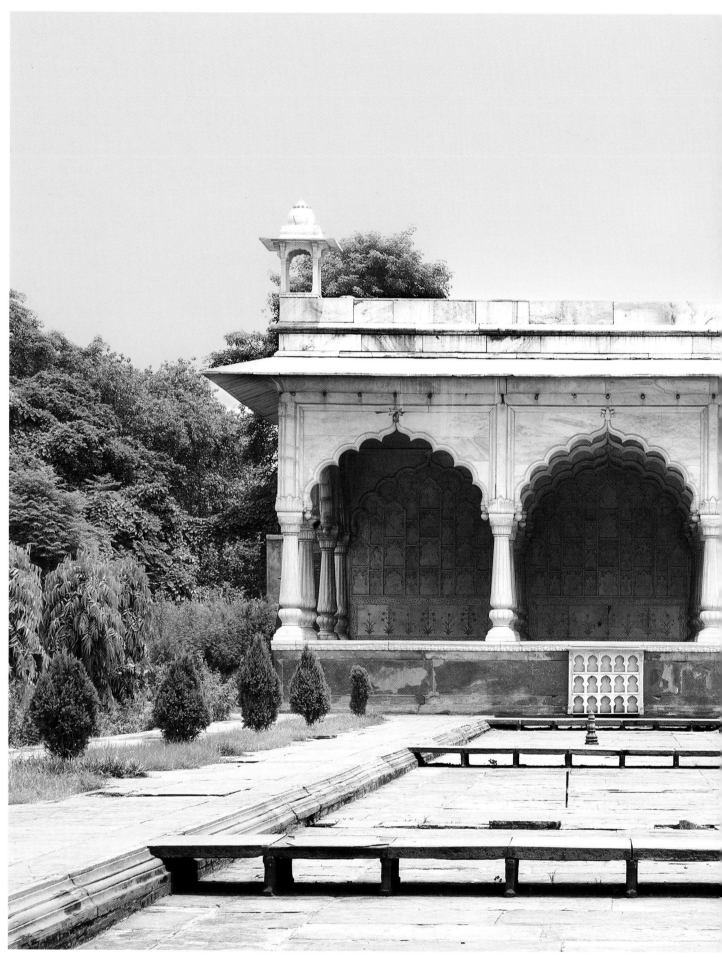

The Bhadon Pavilion with a tank.

openings, the central one being the biggest. It is shaded with a bent *chhajja* and crowned with a curved Bengali arched roof. In the centre of the northern wall is sunk a marble water cascade of pleasing design formerly inlaid with flowers delineated in cornelians of different colour. It slopes into a scalloped marble basin of light green agate surrounded by borders decorated with floral inlay work—certainly the most chaste and unique specimen of the kind now known. The water is further carried through a marble channel connected to the basin.

The Marble Pavilion measures about 19.27 metres (east to west) and 9.75 metres (north to south). It is two-aisle wide with two chambers respectively on the eastern and western ends of the inner aisle. The whole structure has been constructed in marble with cusped arches supported on cylindrical pillars with a moulded base. The grass terrace between this Pavilion and the Hammam is laid out as it existed in 1911, and the Gun Battery, formerly in its centre, has now been removed. The Nahr-i-Bahisht, the famous canal that supplied water to the many fountains and channels of the palace, also served this building and it proceeded along the entire length of the east wall. The terrace has now been paved with red sandstone and the Nahr-i-Bahisht has been renovated.

Sawan and Bhadon Pavilions

In the days of the Mughal emperors, two beautiful pavilions—Sawan and Bhadon—with their cascades of water, created an atmosphere of the rainy season. It is an enthralling sight to imagine—flower vases of gold and silver, full of golden flowers, during the day and camphor candles sparkling brilliantly at night, with thin sheets of water gently falling before them. These white wax candles appeared like stars in thin clouds when placed inside the veil of water. Their twinkling lights produced an ethereal effect. The pavilions were decorated with pictures and paintings depicting the enamelled throne of the Queen of Sheba as well as Solomon's emerald-studded throne. The Sawan Pavilion lay in the extreme north of the Hayat Baksh garden. The word *sawan* is derived from *Shravan*, a month in the Hindu calendar corresponding to the first month of the rainy season.

The Sawan Pavilion is built on a platform with a channel in the centre from where water can flow to a cascade that has candle niches. The water would then flow to a tank with fountain jets and from there it would be

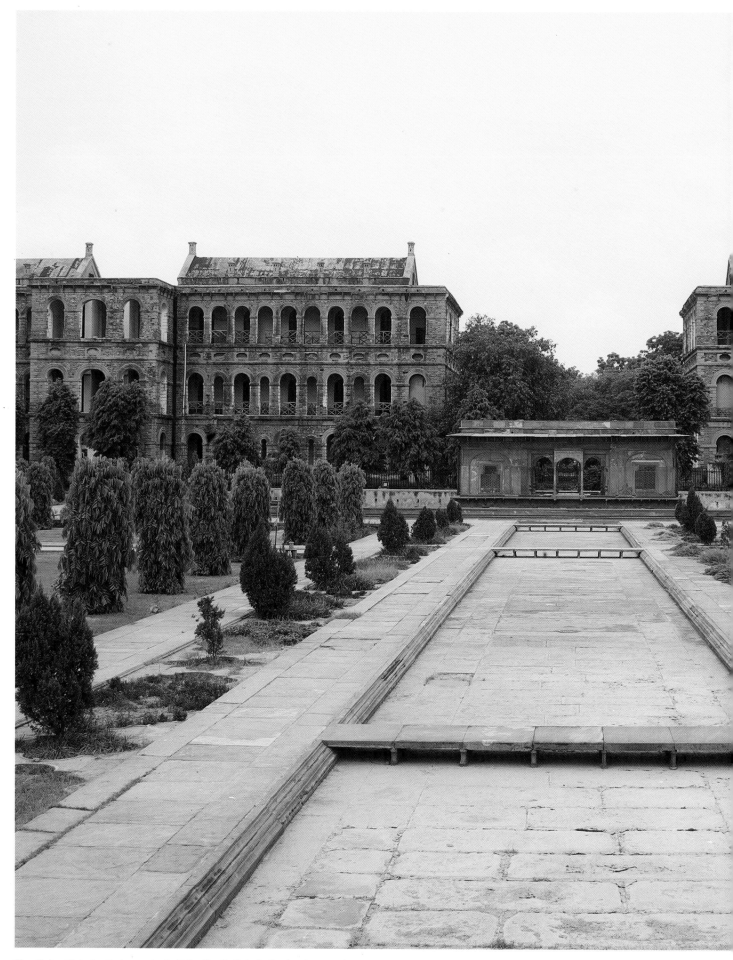

The Zafar Mahal with barracks built by the British, in the background.

A drawings of the Sawan Pavilion (left) and Bhadon Pavilion.

carried to the Hayat Baksh garden. It is a three-aisle wide pavilion with three engrailed arched openings on three sides and a wall on the northern side. It is supported on 16 highly polished cylindrical marble pillars with moulded bases that have been exquisitely designed. The arched pavilion is shaded by a marble *chhajja* and in the corner of the roof are placed beautiful domical *chhattris*.

The Bhadon Pavilion lies in the extreme south of the Hayat Baksh garden. The word *bhadon* refers to the second month of the rainy season. This pavilion is similar to the Sawan Pavilion in shape and design. It stands on a platform and consists of 16 highly polished pillars that support the archways. Here, the southern side is enclosed by a wall. A marble tank, measuring 1.22 metres by 1.22 metres and 0.45 metres deep, is sunk in the centre of this pavilion. A channel that has been diverted from the Nahr-i-Bahisht falls into the tank, leading finally to a canal in the Hayat Baksh garden. The water system of this complex is now defunct.

Zafar Mahal

There was once a large square tank in the Hayat Baksh garden; it had 49 fountains of silver; its walls had 112 silver fountains that were fed by water continuously through an underground pipe. And, around the tank was a red sandstone canal, 5.48 metres wide, with 30 silver fountains on either side. The fountains, long gone, gave way to Bahadur Shah Zafar's palace known as Zafar Mahal. This is a square pavilion built in red sandstone, with arched corridors on its sides and square chambers placed in its corners. A central courtyard lies open to the sky. Sayyid Ahmed in his account of this building noted, 'On one side a bridge for ingress and egress has been built.' This bridge has since disappeared.

8
Teardrop in Heaven

To the west of the Hammam lies a beautiful, small mosque with a chaste architectural style, called Moti Masjid (Pearl Mosque). It was built in 1659 by Aurangzeb for his personal use. Its ornamentation is stunning and it certainly surpasses all other buildings in the area.

Shah Jahan did not build any place of worship inside the Red Fort, opting instead to construct a large congregational mosque for public worship and for his own ceremonial usage. The magnificent Jama Masjid stands 500 metres from the western wall of the Red Fort, as a testimony to both, his faith and his marvellous vision.

Shah Jahan appreciated beauty and splendour in his own life as in the magnificent monuments built by him. He would visit the Jama Masjid every Friday, generally passing through the Delhi Gate of the Red Fort. The streets would be watered to settle the dust and cool the heat. Approximately 200 to 300 musketeers formed a retinue from the gate of the Fort, and as many more lined both the sides of a wide street leading directly to the mosque. Five or six horsemen were also ready at the gate of the Fort; their duty to clear the way for the emperor. These preparations completed, Shah Jahan left the Fort, sometimes on an elephant decorated with rich trappings and a canopy supported by painted and gilted pillars; sometimes on a throne gleaming with azure and gold, placed on a litter covered with scarlet or brocade, which eight chosen men, in handsome attire, carried on their shoulders. A body of *umarahs* followed the king, some on horseback, others in *palkis* (palanquins). Among the *umarahs* were a great number of *mansabdars* and bearers of silver maces. Unlike his father, the devout Aurangzeb, however, was inclined to worship at a place close to his private bed

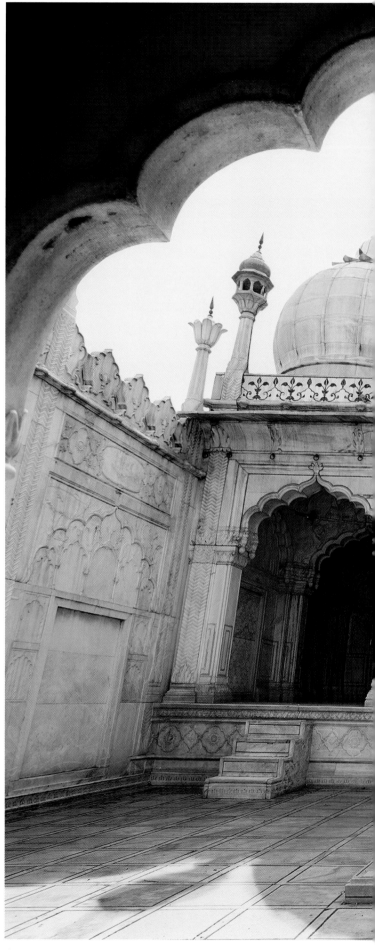

A prayer chamber of the Moti Masjid.

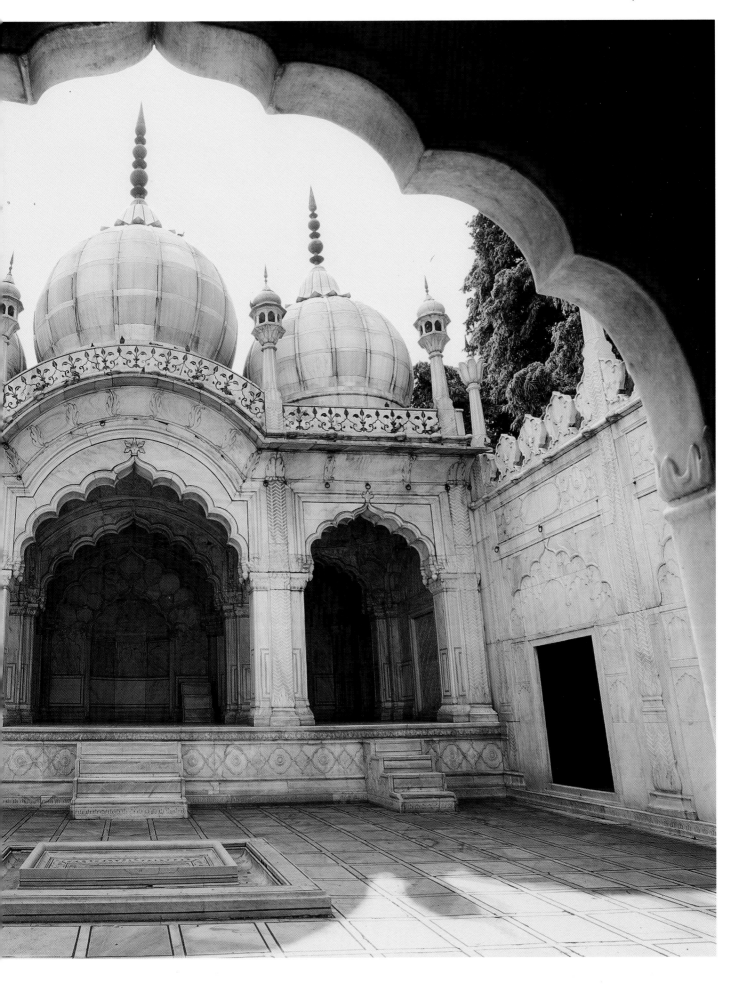

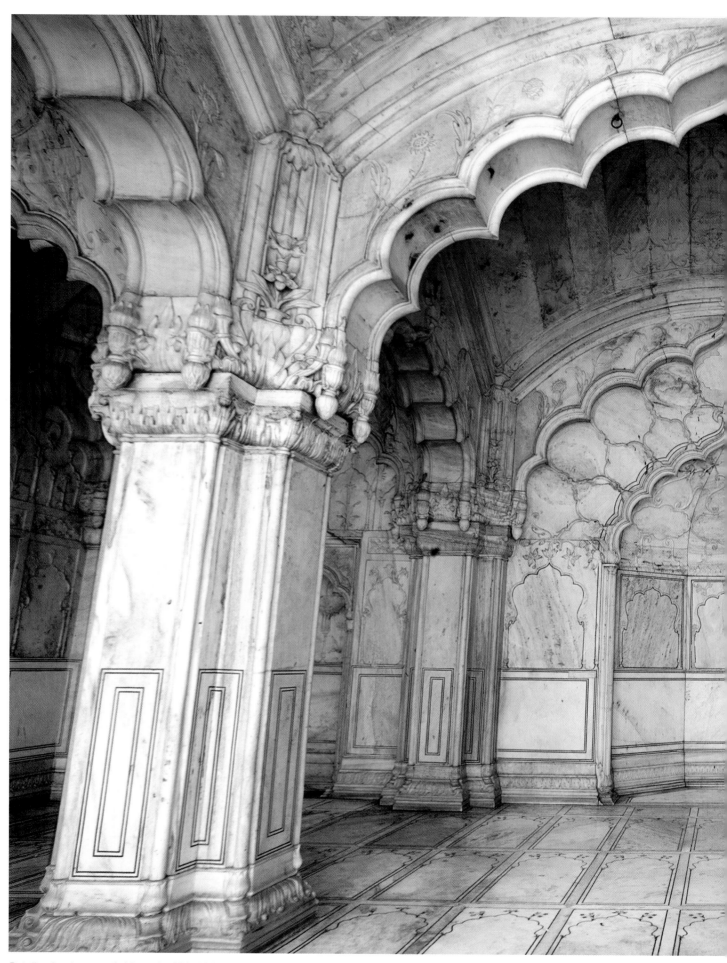

Details of a decorated side arch of Moti Masjid.

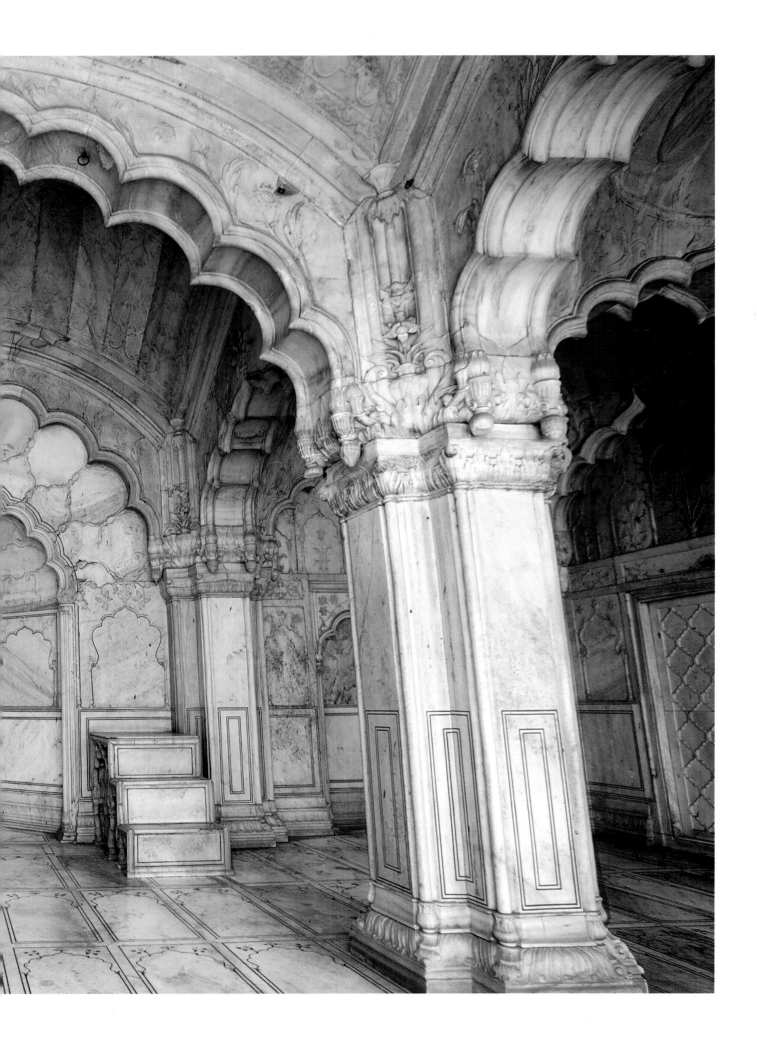

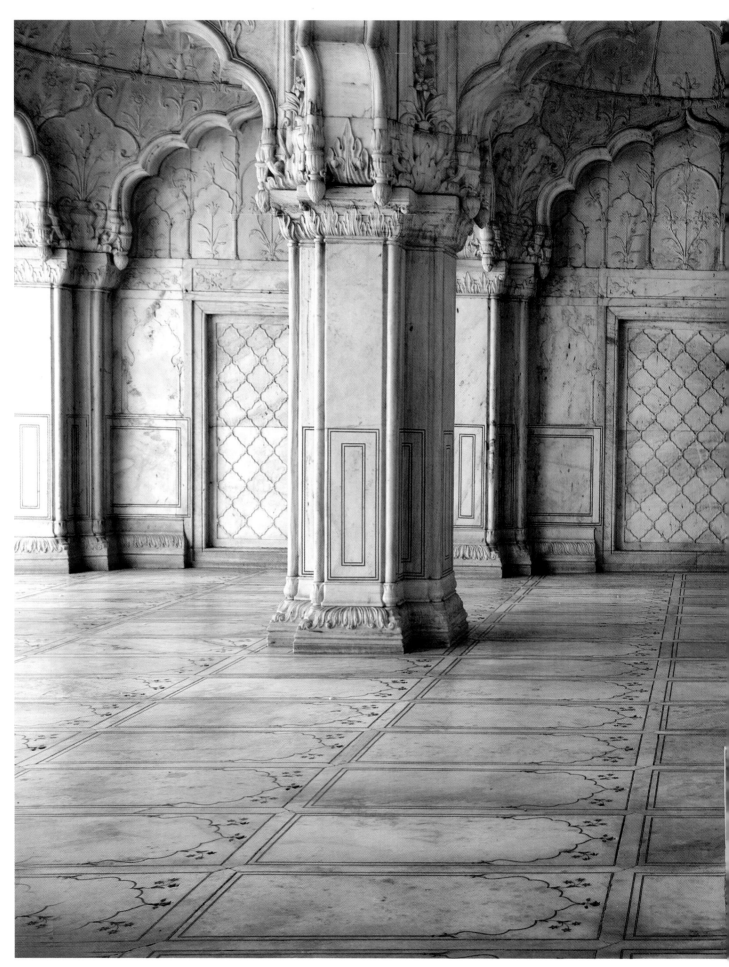

Inside view of the Moti Masjid showing the mihrab *and the pulpit.*

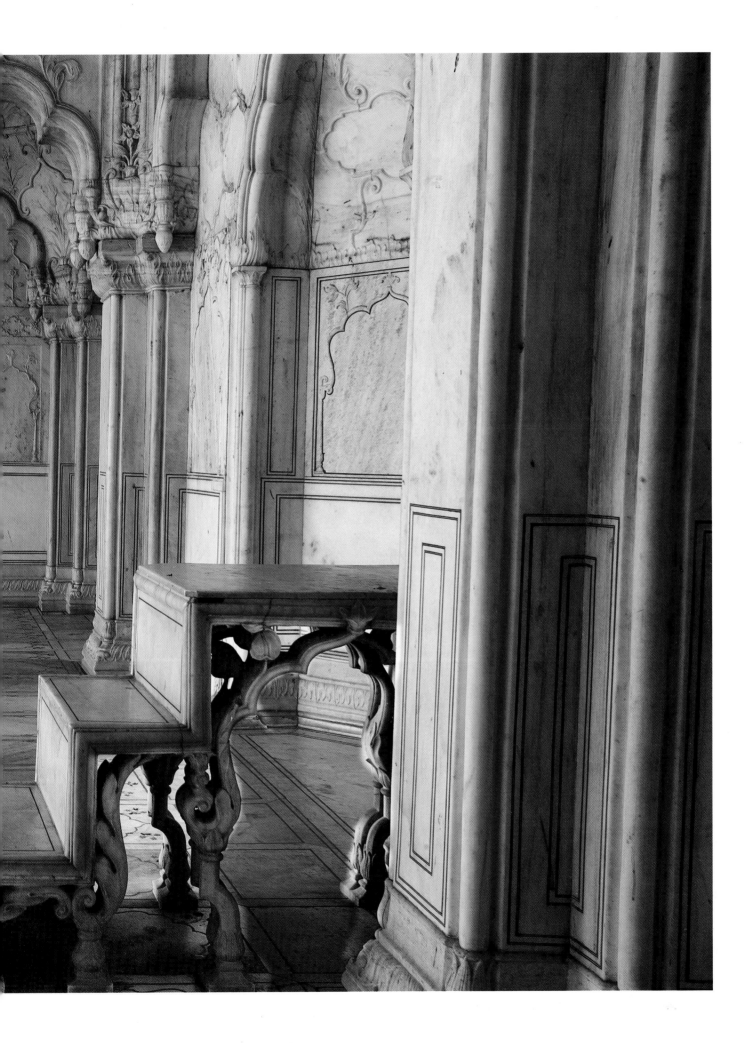

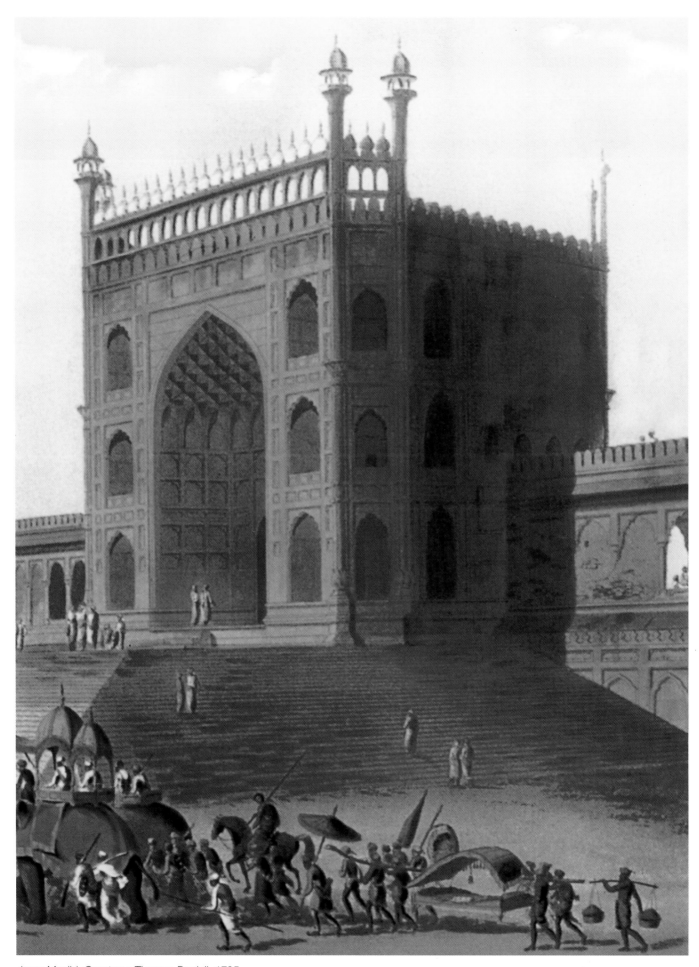

Jama Masjid. Courtesy: Thomas Daniell, 1795.

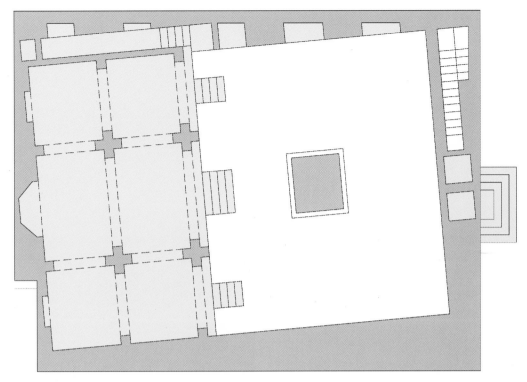

A drawing of the Moti Masjid.

chamber, so that it would take him just a short walk to reach the sacred place of worship at various times of the day or night. Hence he built the Moti Masjid in the Red Fort complex.

The date of the completion of this mosque was discovered by Aqil Khan, an able servant of the court, in the following verses of the Quran: 'Verily the places of worship are set apart unto God, wherefore invoke not any other therein, together with God.' This chronogram is believed to have been approved by the emperor and was carved in a stone slab here. The inscription is unfortunately no longer traceable.

Moti Masjid is built in white marble and measures approximately 12.19 metres by 9.14 metres and is about 7.62 metres in height. It is built over a raised plinth and can be entered through an eastern arched gateway with a copper-plated door. A stairway to the north of the eastern entrance gate leads to the terrace. The courtyard of this mosque is enclosed by high walls, decorated with an arched design and painted white; the parapet is adorned with merlons. The sidewalls have marble pinnacles embedded right up to the merlon in the parapet, with *guldastas* (bouquets) on the top. The northern wall of the courtyard is perforated. In the courtyard is a tank with a fountain used for ablution; it gets its water from the Hayat Baksh garden.

To the west is a two-aisled sanctuary built over a plinth of 1.06 metres, the façade of which consists of three engrailed archways flanked by minarets with pinnacles and miniature *chhattris*, crowned by cupolas. The main hall of the sanctuary is surmounted by three bulbous domes in marble; the central one is bigger than the other two. The flooring of the sanctuary is laid with marble and inlaid with the outline of *musallas* (a carpet design for prayer) in black marble. In the western wall are sunken *mihrabs* (niche); near the central one is a pulpit of white marble.

The mosque was damaged during 1857 and the domes that were originally copper-plated were later finished with marble work.

Chobi Masjid

To the south of the Hayat Baksh garden was another mosque, Chobi Masjid, also known as the Wooden Mosque. It was built by Emperor Ahmad Shah in 1750 and was supported by columns and arches of wood, from where it got its name. On the entrance of the mosque was the following inscription: 'This mosque was built by the King, Protector of the Faith who received help from Divine power. Whoever performs the prostrations of supplication there is sure to be guided by the light of worship ...' The Chobi Masjid was destroyed in 1857.

9
Garden of Life

Sad hazaran gul—shagutab dar-o
Sabzah bedar-o ab khuftah dar-o

(A thousand varieties of flowers blossom exuberantly in this garden, the greenery is ever fresh, and the sweet murmur of water almost appears to be a rhythm of the quietude.)

The Hayat Baksh, or life-bestowing garden was the most beautiful and well-planned garden in the entire palace area. It was laid in the Charbagh Mughal pattern with causeways and channels. It had a variety of green plants and flowers of all colours. The fresh grass, the blooming roses and the tall trees created a soothing ambience. In fact, the interlocking branches of the trees provided a shady canopy that even hid the blue sky above.

To the west of the garden was the Mehtab Bagh (Garden of Moonlight); it extended up to the line of the arcaded street that once ran northwards from the square in front of the Naubat Khana. The site of the Mehtab Bagh that was occupied by military barracks, constructed after the seizure of the Red Fort by the British Army, is now known as Barrack Square. The pavilions that existed here are no more.

The gardens, though not very large, were extremely beautiful and were full of old orange and other fruit trees and rose bushes. In the centre of the beautiful Hayat Baksh garden, a tank, 54.86 metres by 54.86 metres, used to glitter brilliantly. It was decorated with 49 shining silver jets, an additional 112 jets played round it. In all the four avenues, each of which was made of red sandstone and had a breadth of 18.28 metres, there was a large channel 5.48 metres broad, with 30 playing fountains in its centre. On the left and right of this garden were the two charming pavilions, Sawan and Bhadon.

The Hayat Baksh garden with the Shah Burj in the background.

The barracks behind the Hayat Baksh garden; the Moti Masjid is seen on the right.

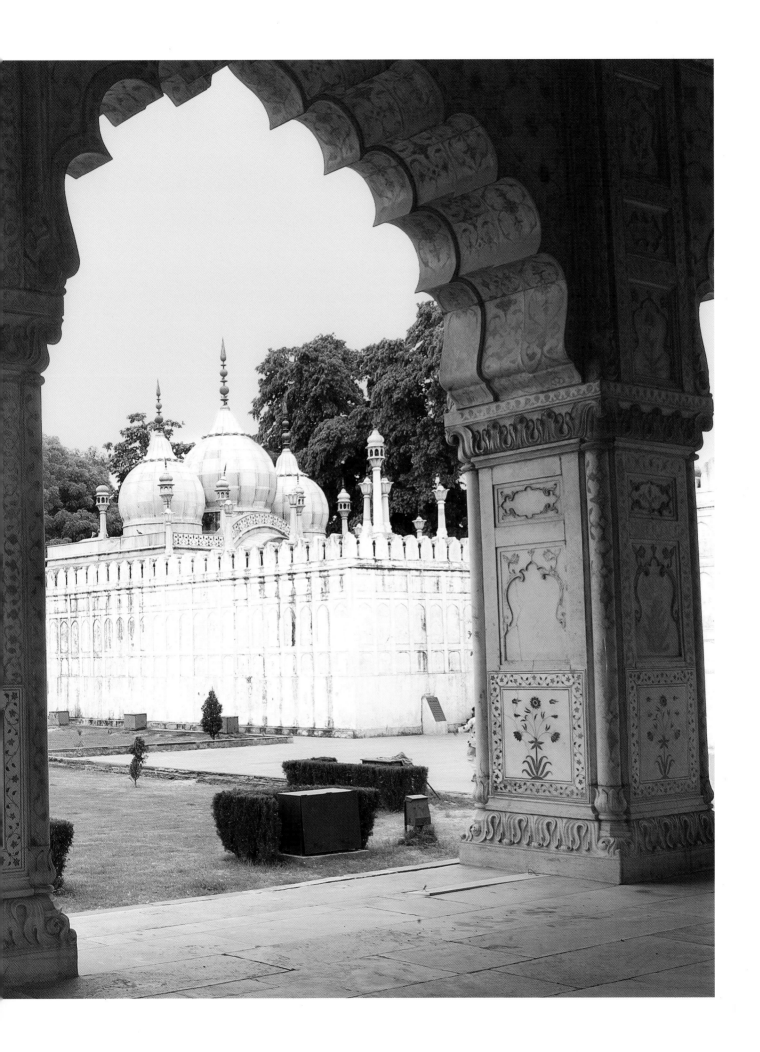

Visitors enjoying a walk in the gardens of the Red Fort.

Although this garden was once a beautiful retreat and a perfect place to rest, it remained desolate and deserted before the British Government took over. The garden was then reshaped. The old water supply system was defunct; a new water supply system to this garden was made by lifting water by motor pumps from the newly dug wells.

In 1904, excavations were carried out on a large scale in the Hayat Baksh garden, which brought to light the ancient tanks which had the Zafar Mahal as the central feature. Work was then begun on the reconstruction of the old channels. Fragments of the ornamental kerb and causeways were found between the tank and the Sawan and Bhadon pavilions, and from these, together with the old plans which showed the border, it was possible to carry out the restoration work with certainty. The large central tank, built by Shah Jahan, appears to have been deepened, probably at the same time as the Zafar Mahal was erected in its centre, and this had been done by building a parapet on the top of the ornamental border. Missing portions of the parapet have been restored so that the tank can be filled to a higher level.

The parapet round the tank was completed in 1907, while the construction of the four main causeways with their channels, pavements and ornamental beds was completed a year later. During this excavation, traces of subsidiary channels were discovered, dividing each quarter of the garden into four equal squares. Further excavations revealed a pathway on the east side of the garden, connecting the north and south pathways.

A part of this was repaired at first, the remaining portion completed when the gun battery and the military road to it on the east terrace were removed in 1913.

In the summer of 1908, a conference was held at Shimla in which the Director General of Archaeology and the relevant military authorities were present. It was decided, among other important matters, that the tank and channels of the Hayat Baksh garden would be filled and the servants' quarters within the archaeological area demolished; the Naubat Khana, the Shah Burj and the Mumtaz Mahal were included in the area.

In the years that followed, the Hayat Baksh garden was planted with trees, flowers and grass. The positions of the old buildings were indicated by masses of flowering shrubs, while a screen of conifers, backed by grevillea trees, masked the iron railings and barracks surrounding the area. With the exception of the east terrace, the garden was now complete and it was easy to see that the whole area held abundant promise of future charm. Early in January 1911 Sir John Hewett and the Durbar Committee visited the gardens and it was decided that a royal garden party would be held there at the time of the Coronation Durbar and that the rest of the area would be laid out immediately, in accordance with the scheme of the archaeological department.

The other portion of the garden that still remained to be put in order at the end of 1910 was the east terrace of the Hayat Baksh garden. This was raised some 1.52 metres above the level of the remainder of the garden. There were buildings on it and it was found that a retaining wall ran along its western face. This wall ran from the north wall of the Hammam to the Shah Burj; it was impossible, at first, to continue its alignment owing to the presence of the gun battery and the military road that gave access to it. The removal of the battery brought to light traces of the pavilion that formerly existed here—the Moti Mahal—now shown by a large rectangular clump of shrubbery.

10
Flow of Water

Water constitutes an element of life and continuity in gardens and palaces. Its sound plays an important role in the design process of water gardens. Its uses are both aesthetic and functional. There are various means that have been employed in the Red Fort to create the movement and sound of water in its palaces, courtyards and gardens.

Emperor Shah Jahan was not only a great builder, he was equally concerned with indoor water devices and the construction of *hammams* (royal bathrooms). It was during his period that the water system introduced by his great grandfather Babur reached its culmination. The white marble pavilions, basins and fountains in the Red Fort bear witness to this. The running, splashing and rippling of limpid water was once part of the grandeur and luxury of the palace.

An important amenity in the construction of the Fort was the provision of a full and continuous supply of water distributed throughout the complex. This was brought by means of a conduit called the Nahr-i-Bahisht or Canal of Paradise. It entered the Fort through a sluice under the Shah Burj that received water from the River Yamuna flowing below it. Such a constant stream enabled the chain of gardens to be ornamented with fountains, cascades, waterfalls and pools and also furnished the extensive and gorgeous Hammam adjacent to the palaces.

The water system of the Red Fort can possibly be divided into two parts—the Ali Mardan canal that fed the Chandni Chowk canal and the moat and the canal that ran north and south of the central tank in the square in front of the Naubat Khana, towards the Hayat Baksh garden, the Mehtab Bagh and the Delhi Gate. On either side of this canal were the arcaded streets

The Shah Burj, the Hira Mahal and the Nahr-i-Bahisht.

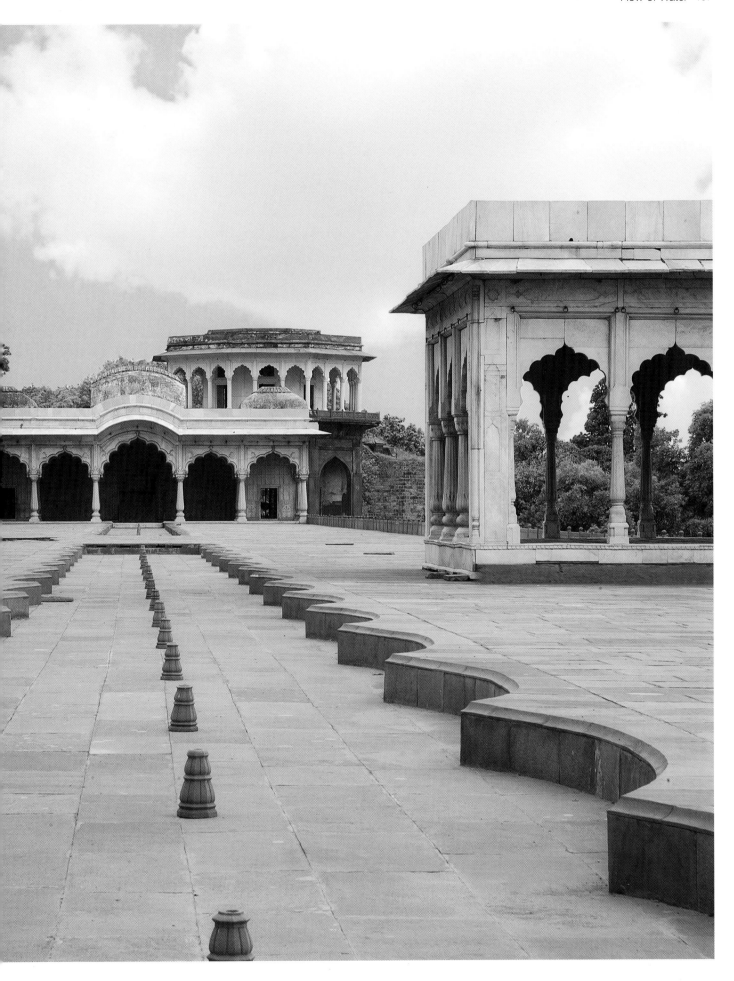

Front view of the Hammam.

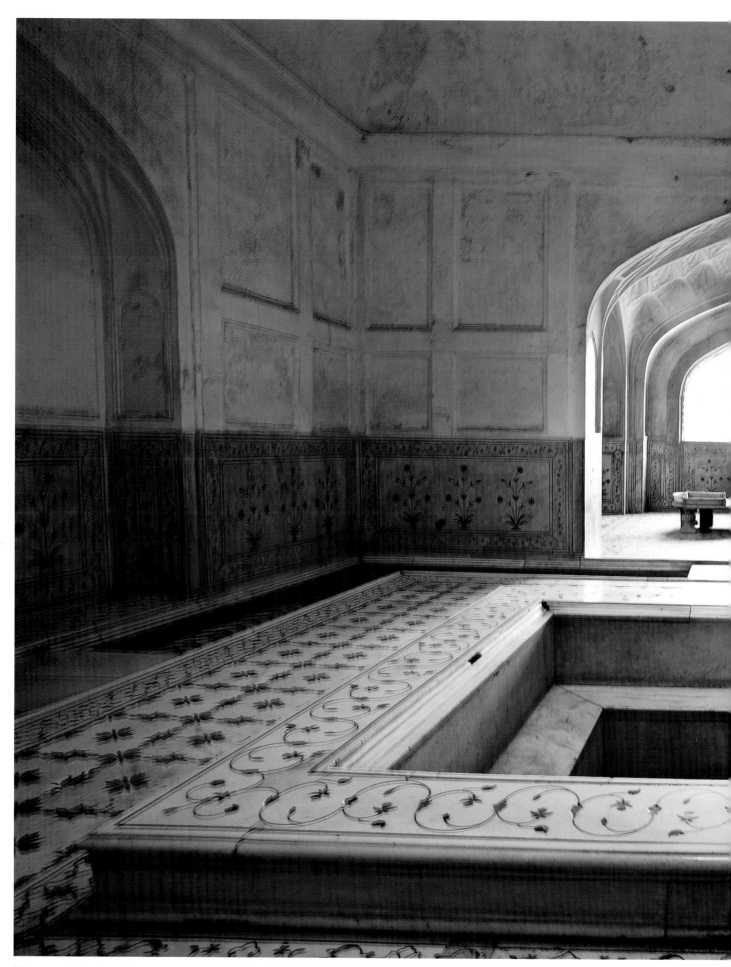

The central chamber of the Hammam with a marble basin.

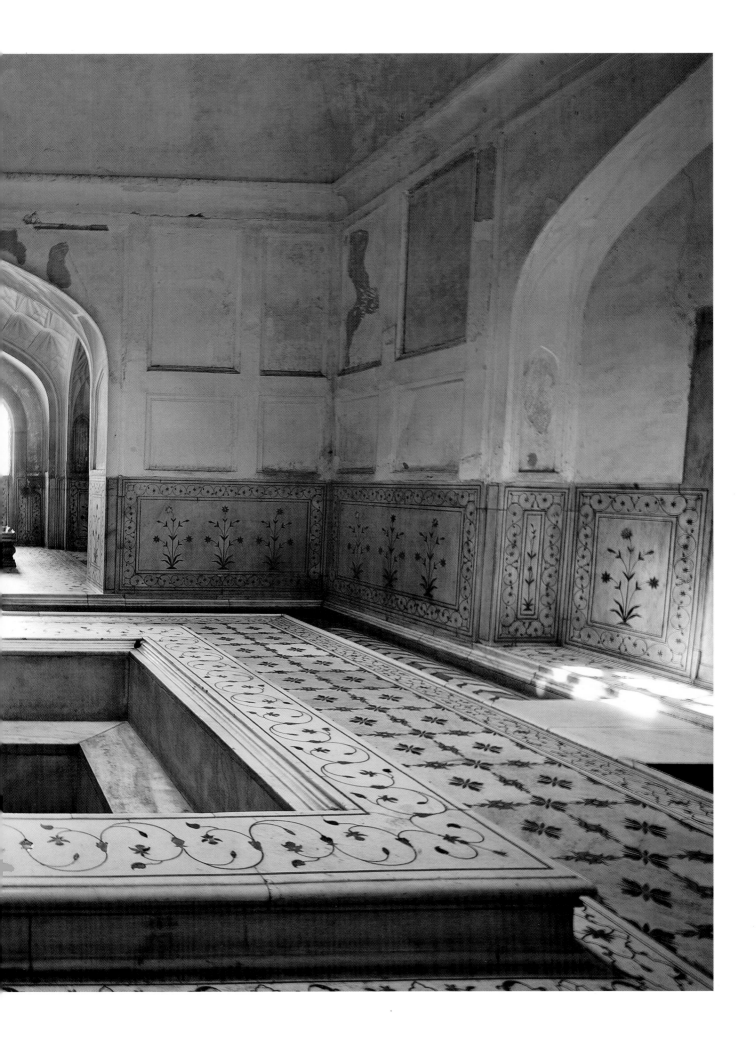

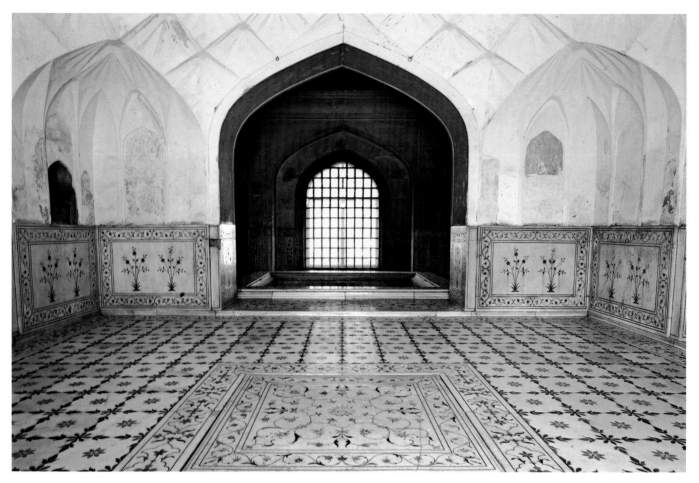

The western chamber of the Hammam with a vapour slab to emit steam.

within the Fort. The Nahr-i-Bahisht ran throughout the eastern terrace.

The outline of the Nahr-i-Bahisht—uncovered during the excavations in 1910—has since been replaced by flowerbeds. A shallow basin with a channel leading westwards was also found in front of the Hira Mahal, evidently to connect with the minor channel of the Hayat Baksh garden that runs into the path near this point. The Nahr-i-Bahisht was provided with fountains at frequent intervals and the copper pipes of several of these fountains have been found. After passing along the eastern terrace, water entered the channel in the Hammam and flowed along the outer range of buildings to the Rang Mahal.

All the gardens in the courts of the palace, including the Mehtab Bagh and the Hayat Baksh garden, were fed from the supply water from the Shah Burj, where the water was collected from the River Yamuna by the *rehant* (waterwheel) system from the well and drawn into the tanks through overhead aqueducts that have since disappeared or been destroyed. The water supply to this area is provided by raising water from two old wells, one of which is outside the area on the Barrack Square. Water is lifted by a pump and stored in the reinforced concrete overhead tank, from which it is supplied to the entire Red Fort area.

A shallow white marble tank within the upper apartment of the Shah Burj had been shaped into conventional ornamental foliations with cusped and foiled borders. Each curved point had a fountain mouth to ensure a pattern even in the spring water. Falling in a rippling cascade down the marble chute in the Shah Burj pavilion and flowing around the terrace that bordered the Hayat Baksh garden, water traversed the chain of stately edifices that lined the eastern wall of the palace—the Hammam, the Diwan-e-Khas and the Khwabgah—silently gliding beneath the Mizan-i-Adl, across a sun-bathed court into the cool of the Rang Mahal. It then passed through the little Rang Mahal, the Mumtaz Mahal and other buildings of the imperial harem, sending out shoots to feed many channels and fountains. As the historian Bernier tells us, every chamber had its reservoir of running water; there were delightful alleys, shady retreats, streams, fountains and grottoes, deep excavations that afforded shelter from

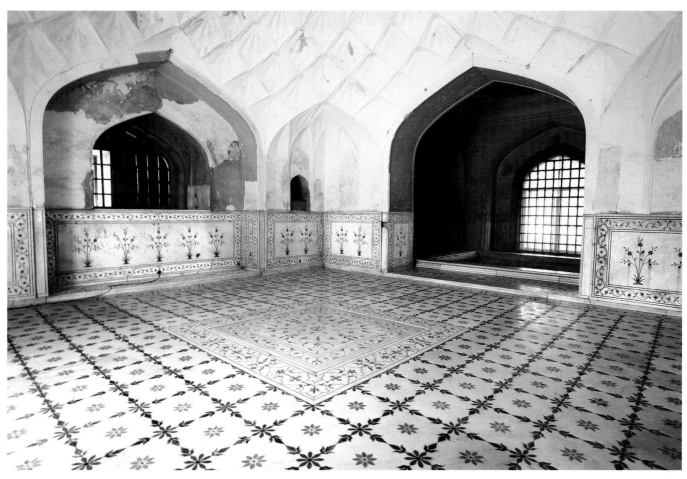

Another view of the western chamber showing a deep storage tank used for heating water.

the sun by day; lofty divans and terraces, on which to sleep cool at night.

Hammam

Though a great builder who provided marvellous indoor water devices in the palaces, Shah Jahan was equally concerned with the building of the Hammam—popularly known as Ghusal Khana. The Hammam complex to the north of the Diwan-e-Khas consists of a complicated water system with miniature tanks sunk into the wall. It has a series of copper and clay pipes embedded into the thick masonry wall and ground. These are connected with other water devices to supply hot and cold water. In fact, these served more or less as air conditioners in apartments close to the Diwan-e-Khas that were used as summer retreats. The Hammam is built on the same terrace as the Diwan-e-Khas and an entry is provided to the north and the west. The main entry is through a southern façade that faces the northern façade of the Diwan-e-Khas. On the southern side is a *dalan* (verandah) with three arched façades and two small chambers each on either side. The royal children used these for their baths. The eastern room has a bathing tank in the centre. Its

flooring is in red sandstone while the walls are decorated with inlay work. The complex further to the north consists of three compartments separated by corridors. The building is cased in marble up to the dado level. Then it is coated with shell lime plaster. The surface is inlaid with floral designs of coloured stones. The floor is laid with marble that was once decorated with inlay work in multi-coloured semi-precious stones.

The apartment towards the east, facing the river, known as the Jamakan, is the dressing room. It contains two fountain basins—the one in the centre of the main chamber was used to emit a spray of rose water. This invariably evokes a keen interest in visitors. The windows on the eastern chambers are filled with fine marble latticework and are artistically fixed with coloured glass panes. The central window has a projected balcony capped with an arch through which a pleasant scene of the riverside and greenery could be seen. The central apartment or chamber consists of a marble basin in the centre, which could be used for hot and cold water baths as it is designed with fountains in all four corners. There is a fine shallow canal of three feet width around it. This could be filled with warm and

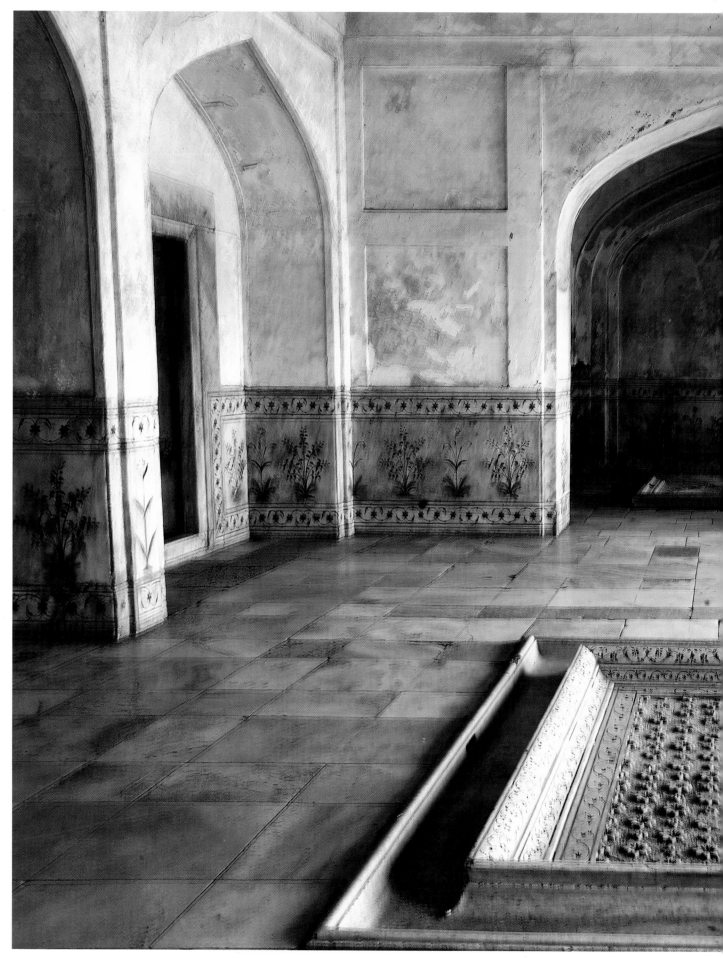

The eastern chamber with a basin in the centre used to emit rose water.

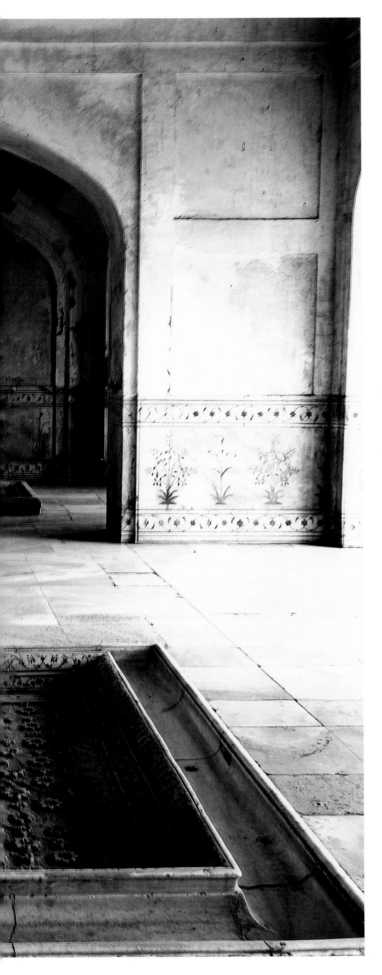

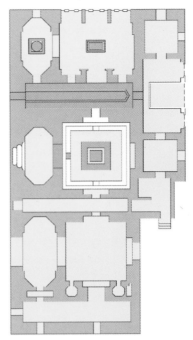

A drawing of the Hammam.

cool water. A couch built entirely of carved and inlaid marble still stands in the northern chamber. It shows the superb quality of fittings that such chambers contained. A portion of it is square and built of white marble. The western chamber is also of marble. It contains water ponds; the central one with the marble platform was used for hot water baths only. It possesses a beautiful vapour slab that emits steam. There is a deep storage tank in this wall to heat the water. Beneath are devices where firewood can be placed for heating the water. The warm water reservoir was inlaid with precious stones and the cold water one adjoining it to the north had a jet of gold at each of its four corners. Windows were provided with stained glass panes for light.

The entire complex is so skilfully and exquisitely planned that visitors to this place cannot stop admiring it. The baths are, in fact, not the invention of the Mughal emperors alone. Their origin can be traced to the reign of Sher Shah Suri from 1540-45. This Afghan ruler used such bathrooms at the council house where state business and confidential matters were discussed. The Mughal emperors, too, conducted important business in the Hammam.

It is said that hot water was not used at the Red Fort Hammam after the reign of Shah Jahan and Aurangzeb. This is because at least 125 mounds of firewood was required each time the water was to be heated and this was a luxury that the rulers who came after Aurangzeb could not afford.

11
Symbol of Sacrifice

About 1.5 kilometres north-east of the Red Fort, on the right side of the bustling Ring Road, are the remains of a small fort called Salimgarh. It was built by Salim Shah, son and successor of Sher Shah Suri, in 1546, as a defence against the approach of Mughal emperor Humayun. Strengthened by bastions provided at regular intervals, the fort has a gateway to the north with a marble slab overhead, inscribed with the information that it was built in 1852 by Bahadur Shah II, the last king of Delhi.

A sum of 4 lakh rupees was spent on the construction of Salimgarh. The Fort was still unfinished at the time of the death of Salim Shah in 1552, after which it was totally neglected. It was here, in August 1788, that the helpless Emperor Shah Alam was imprisoned after being blinded by Ghulam Qadir.

Farid Khan, an *Amir* who flourished in the reigns of Akbar and Jahangir probably received Salimgarh, with other possessions along the banks of the River Yamuna, in grant from Akbar. In 1828, these buildings were in a state of ruin, but a two-storied pavilion and a garden were preserved with care by Akbar II, who occasionally used to take a walk here, undisturbed by the public.

The East Indian Railway passes over Salimgarh, and close to it is a fine iron bridge. To the north is a boat bridge, on the road from Delhi to Meerut, across which the freedom fighters entered Delhi in May 1857.

Another railway bridge spans the space between Salimgarh and the Red Fort and is named Hanuman Bridge, as it is in the vicinity of an old Hanuman temple. To the immediate south of this bridge is an ancient gateway, now closed and embedded into the wall of the

The entrance to Salimgarh from the Red Fort.

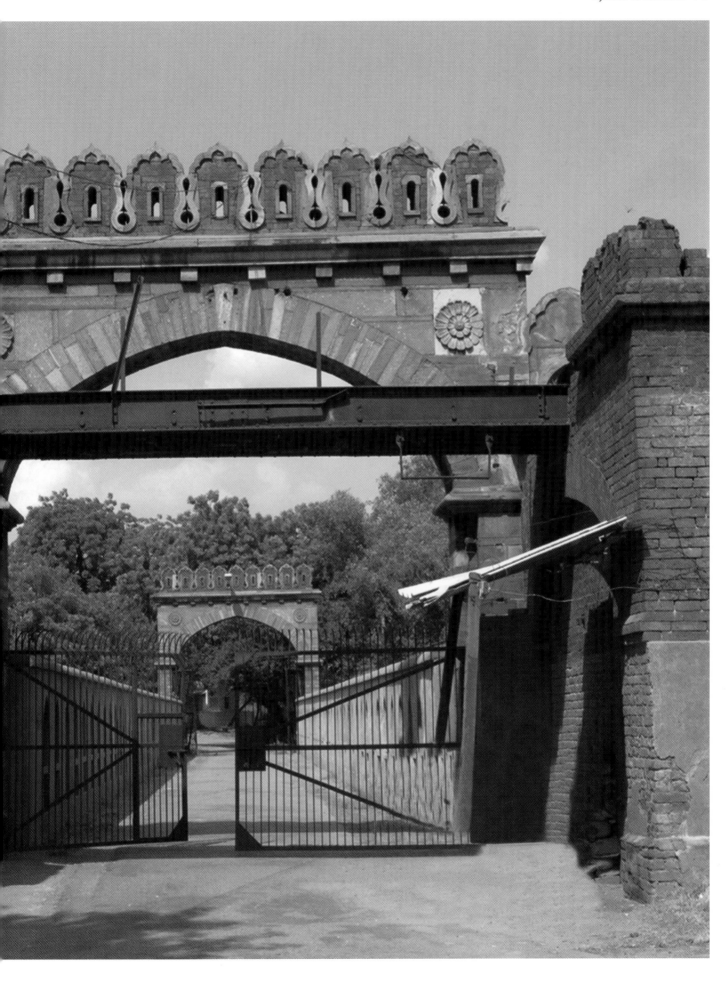

The Freedom Fighters' Memorial.

The railway track that runs through Salimgarh.

The Hanuman Bridge.

Red Fort. To the south, is the three-arched Mughal Bridge that connects the Red Fort and Salimgarh. This bridge is open for tourists who want to visit Salimgarh to see the two barracks that were used to imprison Shah Nawaz Khan, Prem Kumar Sehgal, Gurbaksh Singh Dhillon and hundreds of other soldiers of the Indian National Army as well as the other barracks that are being maintained as a symbol of the sacrifice made by them and other freedom fighters. Salimgarh has been renamed Swatantrata Senani Smarak (Freedom Fighters' Memorial) and today it stands, in close vicinity to the Red Fort, as a symbol of a lost era. Like its neighbour, the mighty Red Fort, it remains a silent spectator of history.

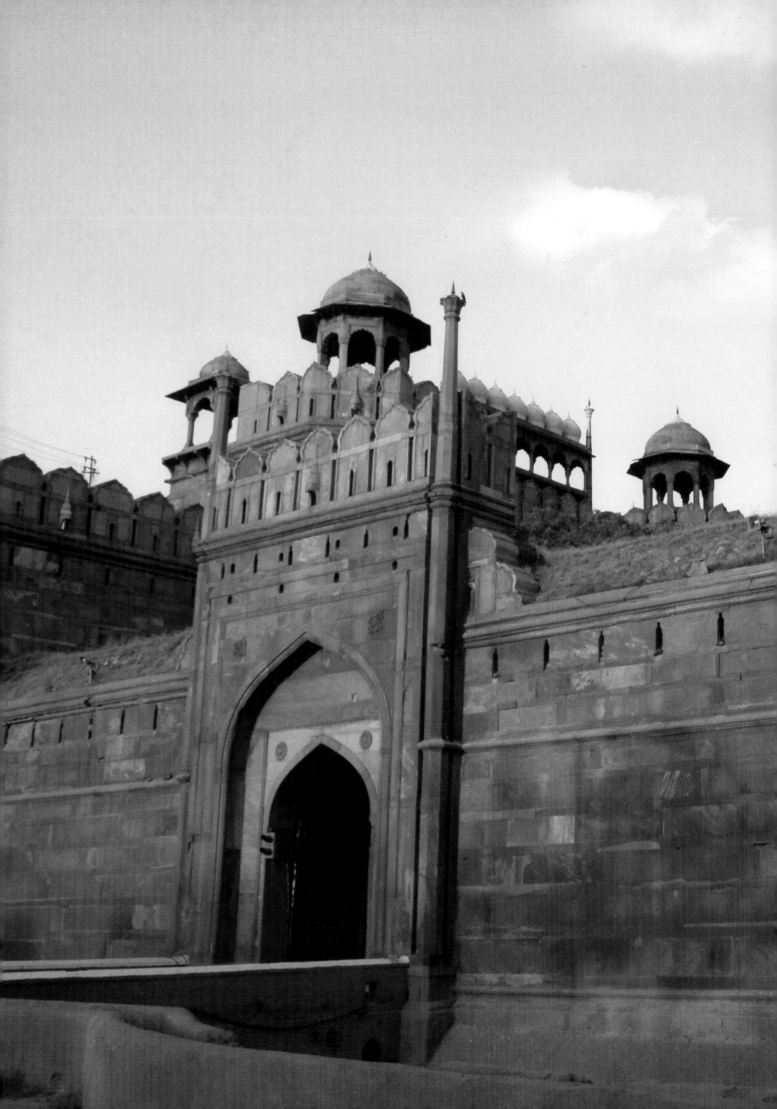

PART III

Preserving the Past

1
Changes of Time

In 1719, disaster struck the Red Fort during an earthquake, the intermittent tremors of which continued for over a month. Four decades later, the buildings around it were considerably damaged during the frequent conflicts between the Marathas and Ahmad Shah Daurani. According to a contemporary writer, Azad Bilgrami, it was Ibrahim Khan Kardi who 'fired at the Fort with three guns from the *reti* side [the sandy shore between the Fort and the river] which lies below the Fort on the east, and discharged cannon balls like rain on the Asad Burj, Musamman Burj and other royal buildings'. This resulted in great damage to the Diwan-e-Khas, the Rang Mahal, the Moti Mahal and the Shah Burj. The Red Fort, because of its great strength, remained undamaged.

The removal of the smaller buildings and courts around the Red Fort after the First War of Independence has taken away a lot of its charm. The harem courts and gardens to the west of the Rang Mahal, the Mumtaz Mahal and the Khurd Jahan have all disappeared, together with a building known as the 'Silver Palace' which stood some distance to the west of the Khurd Jahan. The royal storerooms, kitchens and chambers, which lay to the north of the Diwan-e-Am have, together with the Mehtab Bagh and the western half of the Hayat Baksh garden, given place to military barracks and the parade ground. To the north of the Hayat Baksh garden lay the houses and gardens of the royal princes. These have also disappeared.

The glory of the Red Fort had actually started vanishing even before 1857, when Bishop Heber visited Diwan-e-Khas early in the 19th century. He described the Red Fort as being 'dirty, desolate, and forlorn'. The shining roof and glittering throne had been carried off by spoilers and birds had built their nests in the recesses of the throne. Originally every red sandstone surface was shell plastered, polished and gilded like white marble and no red stone surface was visible. But the impoverished Mughal emperors after Aurangzeb could not spend much on the maintenance of such a vast complex.

The forces of nature, too, combined to erode the beauty of the citadel. The white marble stone used in the pillars, floors, domes and other places was severely affected by atmospheric pollution. The iron used as dowels for fastening the stones corroded over time and further damage was caused by the growth of vegetation in the core of the masonry.

Another cause of damage to the stones was the smoke emitted by the coal fires from power stations situated in the vicinity. The formation of sulphuric acid resulted in the deterioration of the outer surface of the stones, particularly the eastern façade. Subsequently it blistered and flaked off, causing exfoliation. The sandstone got discoloured over time and assumed a drab appearance as the pores of this stone got clogged with soot and dirt. Decay to the stones was also caused by frost and the extensive use of wrought iron as dowels.

After the siege of the Red Fort by the British in 1857, the royal buildings underwent overwhelming alterations. Almost all loose fittings, such as the sandalwood furniture and doors, were removed. A few years later, the beautiful palaces and gardens were denuded of their original splendour. It was only after 1862, when the Archaeological Survey of India was founded and Alexander Cunningham took over as the Surveyor General of India, that attempts were made to conserve and preserve the remains of this marvellous Fort. But

The barracks at the Red Fort built by the British after 1857.

he, too, could not manage as much as he would have liked to as the Red Fort was occupied by the British Army. The historical buildings at the Red Fort and its immediate surroundings remained neglected for a long period, till about the beginning of the 20th century. These glorious buildings had lost much of their originality on account of the large-scale demolition work and the construction of new buildings by the British Government. They were used as barrack rooms or stores, while the area where they originally stood was encroached upon by new roads and disfigured by military buildings. It was only when Sir John Marshal, the new Director General of the Department of Archaeology, took over that conservation work started in right earnest.

2
Restoring History

The significance of the Red Fort, its place in history and architecture, demanded that by way of restoration efforts were vital. The gardens as they now stand, together with the conservation of the buildings in the area, are the outcome of the improvements suggested by Sir John Marshal in 1902. These included the acquiring from the military authorities as much of the old area formerly occupied by the palace as was possible, so that it could be enclosed and kept in a state of orderliness and the buildings that it contained were saved from further mutilation or damage. This done, the ground was to be changed as far as was possible to its old levels, the modern buildings and roads removed, and the area laid out in lawns and shrubberies so that the buildings could be seen in better condition.

The lawns and shrubberies were to represent, respectively, the position of the former courtyards and buildings that had been removed, but whose position was traceable from the remnants of their buried foundations and old plans. In the case of the northern portion of the area—the Hayat Baksh garden—vestiges of the old water channels and causeways were abundant, but buried under three feet of earth and rubbish. The fact that the gardens would be eventually used for occasions such as the royal garden party necessitated more reconstruction work, so that the old channels and fountains could be made to perform their former functions.

Till 1908, work proceeded slowly and its completion would have taken many more years had it not been for the Coronation Durbar, which demanded that the buildings that for so many years had witnessed similar ceremonies of the Mughal emperors, should be restored to some of their former glory. The evacuation

Damaged inlay work.

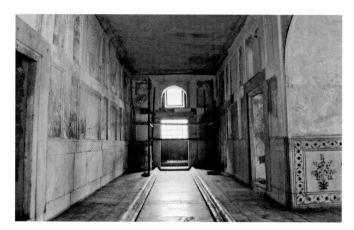

The neglected interior of the Hammam.

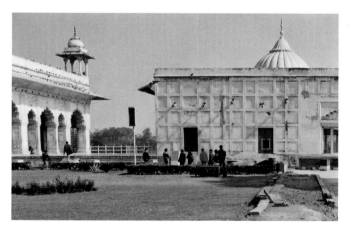

The path leading to the Khas Mahal in disrepair.

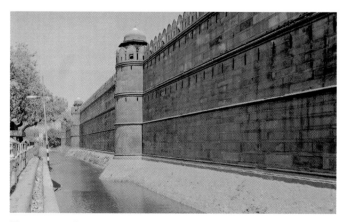

The moat wall and the moat in need of attention.

Inlay work after conservation.

The restored interior of the Hammam.

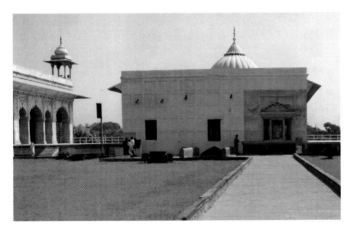

The repaired path leading to the Khas Mahal.

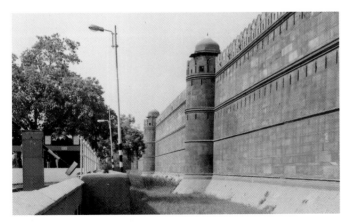

The moat wall and the moat as in olden times.

of the grounds by the military authorities, the construction of new buildings to take the place of those removed outside the area, and the difficulties of irrigation owing to the danger of mosquitoes breeding in the stagnant water of the gardens had all to be arranged for, before the scheme could be successfully implemented.

In the next couple of years substantial progress was made in the work on the gardens and the iron railings around the area were practically completed. The main entrance to the garden was fixed through the Naubat Khana, thereby reviving an old Mughal custom. For, it was at this point that all visitors to the court descended from their palanquins or elephants and approached the royal presence on foot. One private entrance was provided to the south of the Diwan-e-Am and a special military entrance near the Shah Burj, so that the battery on the east terrace could be accessed.

In the Hayat Baksh garden, the work on the minor intersecting causeways with their water channels was completed and the whole area lowered to its original level and dressed ready for grass. Work on the water supply that now irrigates the whole garden is well underway. The water is obtained from two old wells, (one of which is outside the area on the Barrack Square) into reinforced concrete tanks behind the Bhadon Pavilion, by means of two pumps.

The buildings within the area have, since 1902, all been thoroughly repaired, the work on the mosaics in the Diwan-e-Am has been carried out, while modern additions have been removed from the Naubat Khana, the Rang Mahal and the Mumtaz Mahal, and these buildings restored, as far as compatible with the precepts of archaeological conservation, to their former appearance. The Shah Burj pavilion which was, in imminent danger of falling down in 1904 has been permanently secured, while the pavilions of the Hayat Baksh garden have been thoroughly overhauled and their marble tanks and cascades uncovered.

The paths have been laid down so as to follow, as far as possible, their original demarcations. The inner and outer courts in front of the Diwan-e-Khas have been depicted by lawns and the buildings between them by shrubberies, composed of inga hedges, backed by banks of acalephan and duranta, while behind these stand taller shrubs such as murry, hamelia,

bougainvillea (the compact variety), hibiscus and tacoma. As expected, the foundations of old buildings were exposed during trenching. Grass courts have similarly been constructed in front of the Diwan-e-Am and Mumtaz Mahal. In the case of the Diwan-e-Am, the old courtyard that used to exist in front of it, and which witnessed the daily *durbar* of the emperor, was lined on both sides by colonnades. All traces of these had vanished and a military road ran between the Naubat Khana and the Diwan-e-Am.

The old colonnades are now represented by a screen of grevilleas and conifers. The line of grevilleas to the north of the central pathway occupies almost the same position as the colonnade, but that to the south is unavoidably nearer to the central pathway owing to the fact that it is virtually impossible to remove the military road that runs outside the new railing. Another shrubbery runs from the ends of the Diwan-e-Am and represents the buildings seen in old pictures and plans. These buildings screened the private precincts of the palace from the public eye.

The grass court in front of the Mumtaz Mahal has not been reduced to its original level as yet and the plinth of this building is still partially hidden. Fragments of a marble tank were found in front of it through which a water pipe had been laid. This tank, between the Rang Mahal and the Mumtaz Mahal, can possibly be exposed when this portion of the garden is dealt with. Trenching has also revealed an underground drain leading to a doorway in the outer wall of the Red Fort that had apparently been bricked up by the Mughal builders themselves.

Since 1913, the main restoration work in in the Red Fort has been concentrated on the overall improvement of the Hayat Baksh garden and the completion of the water channel and causeways. Copper-plated doors with appropriate designs of the Mughal era were affixed to the openings in the Khas Mahal so as to enable visitors visualise the interior decoration of that period.

The outline of the water channel named the Nahr-i-Bahisht, exposed during excavations in 1910, has since been represented by flowerbeds. In front of the Hira Mahal was found a shallow basin with a channel leading westwards, evidently to connect with the minor channel of the Hayat Baksh garden that runs into the path near this point; from the character of the work it appears to

The baoli *in ruins.*

The Nahr-i-Bahisht in disarray.

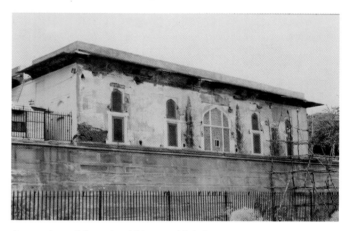

A rear view of the ruined Mumtaz Mahal.

The Hayat Baksh garden gone to seed.

The restored baoli.

The Nahr-i-Bahisht after conservation.

Mumtaz Mahal as it once was.

The Hayat Baksh garden in bloom.

belong to the late Mughal period. The Nahr-i-Bahisht was provided at frequent intervals with fountains the copper pipes of several of which have been found. After flowing along the eastern terrace, the water entered the channel in the Hammam and passed on along the outer range of the buildings to the Rang Mahal.

The new water installation, besides enabling irrigation of the garden and shrubberies, also helps fill the channels of the Hayat Baksh garden and the Zafar Mahal tank. It also sustains the working of the fountains in the Zafar Mahal tank and in the main channels running from the Sawan to the Bhadon pavilions, and for the cascades in these two pavilions as well as in the Shah Burj. The marble channel from the Hammam to the south end of the Rang Mahal can also receive water as before while a fountain jet has been fixed in the marble basin in front of the Rang Mahal.

The amount of water required to operate the fountains and cascades as well as to fill the tanks and channels is considerable with continuous pumping necessary for about two weeks. This prevents the disposal of water on the ground below the Fort and a scheme has accordingly been prepared by which water can be raised into the tanks again and hence reused. However, the removal of some of the military barracks to the immediate west of the Hayat Baksh garden has been hinted at; so it is hoped that these difficulties may eventually be overcome and that the fountains and tanks may be permanently provided with water. The additional charm that the layers of cascading water impart to the buildings and gardens cannot be overestimated.

Removing the barracks to the west of the Hayat Baksh garden would also enable its western portion to be completed, together with the Mehtab Bagh—a work which would greatly enhance the appeal of the Red Fort. The strip of ground between the Mumtaz Mahal and the Asad Burj can also be developed, so that the whole of the eastern terrace of the Fort, from north to south, may be open to visitors.

The Archaeological Survey of India has carried out considerable work at the Red Fort since India attained independence in 1947. In 1956-57 the broken red sandstone pieces of the balcony of the Rang Mahal were replaced and its asbestos ceiling repaired. The ornamental marble fountain in the centre of the hall of

the Rang Mahal was enclosed with a marble railing to protect it from being gradually eroded under the shoes of the visitors. At the Moti Masjid, the fallen and damaged portion of the plastered exterior was repaired and coloured.

The underground cells of the Rang Mahal, which were flooded during the heavy rains of 1958, were cleared of silt and floodwater in 1958-59. Temporary low retaining walls were constructed to prevent water from overflowing into the basement from the lawns; a portion of marble floor to its north was dismantled and reset. The broken and missing marble railing between the Diwan-e-Khas and the Hammam was replaced. The restoration of inlay work in the Diwan-e-Khas was carried out and the decayed lime concrete roof of the Diwan-e-Am and the Khas Mahal was dismantled and relaid with fresh lime concrete.

The exquisitely carved marble *jali* in the Diwan-e-Khas had darkened over the years. A systematic cleaning helped completely eliminate injurious and discolouring accretions and the details of the exquisite, intricate patterns were fully brought out.

In 1961-62, a brass railing was provided around the marble throne in the Diwan-e-Am. Some of the broken and worn-out stones with ornamental friezes on the northern side of the Diwan-e-Am were replaced. Work on the replacement of the ornamental red sandstone slabs in the floors and edges was also kept in progress. The exteriors of the Rang Mahal, Mumtaz Mahal, the Hammam and the Moti Masjid were colour-washed and the outer face of the rear wall of the Diwan-e-Am was provided with two coats of a dull, terracotta paint. A new path was laid along the southern edge of the Moti Masjid and two viewing platforms provided on the northern and southern sides of the Hammam. The brick parapet walls between the Mumtaz Mahal and the Rang Mahal and between the Shah Burj and the Bhadon Pavilion were also repaired.

Continuing the work of the previous couple of years, the worn-out red sandstone of the Diwan-e-Am was replaced in 1964-65. Extensive repairs to give a facelift to the monuments were also undertaken in connection with the *Son-et-Lumière* (Sound-and-Light) show. This included the realignment of the approach road, repairs to the pathways and floors and a new coat of paint to the exterior surfaces of the Hammam, the Diwan-e-Khas, the Rang Mahal, the Moti Masjid and other monuments.

A neglected chamber in front of the Asad Burj.

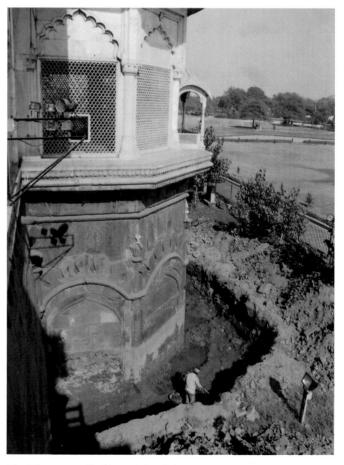

The Mussaman Burj in a state of decay.

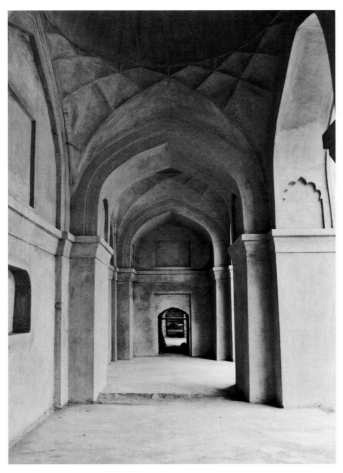

The restored chamber in front of the Asad Burj.

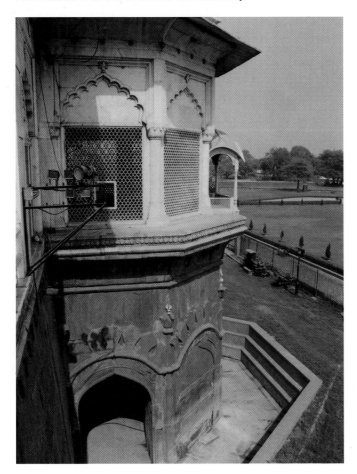

The Mussaman Burj after conservation.

For the inauguration of the *Son-et-Lumière* show, chemical treatment on the marble surface of the structures of the Diwan-e-Khas, Moti Masjid and the Bhadon Pavilion was carried out. Stains on the marble pillars were lightened with the help of alcohol, hydrogen peroxide and detergents. The growth of moss on the exterior of the structure was removed and the metal cupolas on the *chhattris* were cleaned and a gold-coloured composition was applied on them. Chemical treatment of the golden paintings on the panelled ceiling of the Diwan-e-Khas continued for some time. The black marble screen was also cleaned with the help of emulsifiers. Floral designs in gold, executed on the marble surface of some pillars and arches, were cleared of an overlaying deposit of soot and grease. Since the patterns were intricate and the gold paint was executed on very thin base, the treatment demanded much skill and patient labour.

In 1966-67, specialised repairs to the wooden ceiling of the Diwan-e-Khas, involving delicate and careful joinery, were executed. The damaged and missing marble slabs on the floor of the Diwan-e-Khas were replaced. Chemical treatment of the paintings on the walls of the Rang Mahal, involving the removal of moss, was completed soon after. The painted cloth on the ceiling of the Diwan-e-Khas, which had got separated from the wooden supports at the rear, was fixed. Accretionary deposits of insect nests, cobwebs, mud and smoke were cleaned. The repair work went on at a steady pace. Electrical fittings were provided in the Mumtaz Mahal by making a chassis in the wall. Decayed plaster was removed and a fresh coat applied. Coir matting was spread over the floor in the Rang Mahal to protect the Nahr-i-Bahisht. The cracked roof of the Naubat Khana was dismantled and a new one, matching the original, was laid. The walls were replastered as per the original, repeating the geometrical patterns and other motifs.

In the Diwan-e-Am, the decayed uneven flooring stones were replaced with new ones. The south-east part of the fortification wall was exposed to view in 1977-78. A number of fountains as well as a causeway were found while work was going on in the fountain tank between the Rang Mahal and the Diwan-e-Am. Channels were cleared for the reflow of water to the fountains in the original channels. The plinth around the Diwan-e-Am was exposed and a carpeting of dressed red sandstone was provided over it.

Dawat Khana—a teahouse converted into a restaurant.

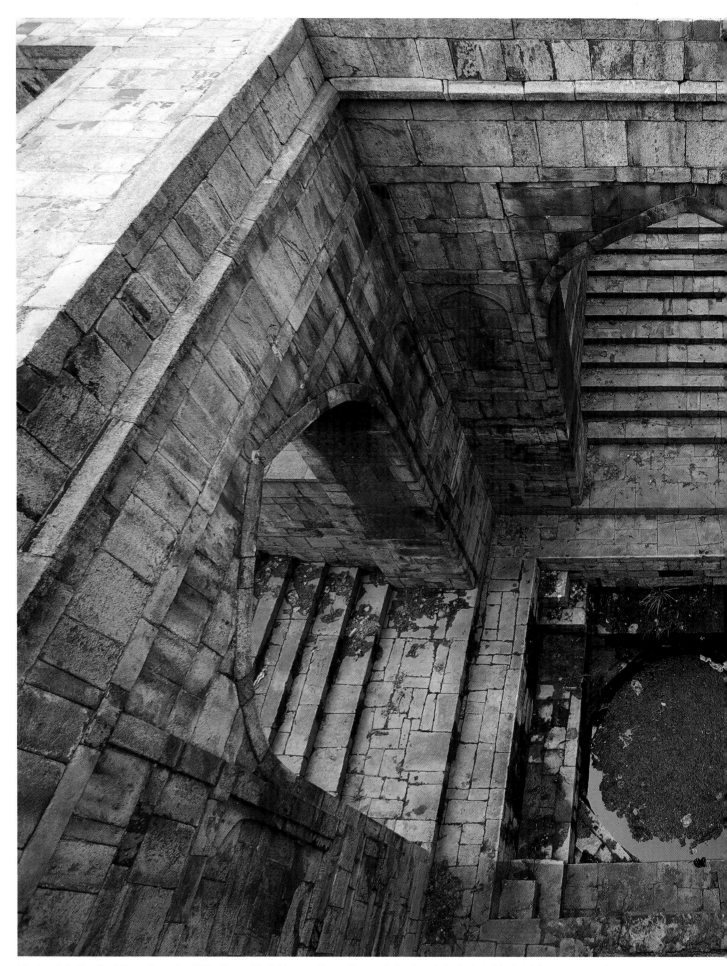

The baoli *in the Red Fort where the INA officers Shah Nawaz, Prem Kumar Sehgal and Gurbaksh Singh Dhillon were confined.*

During the early eighties, the red sandstone in the southern bastion of the Lahore Gate was cleared and the motifs secured. The bulging portion near the Lahore Gate and the fallen stones of the rampart were reset and restored. The marble veneer stones of the parapet towards the east of the Shah Burj were reset. A few *chhajja* stones were also reset along with the wall of the adjoining stairways of the Zafar Mahal. The entire peripheral wall of the Red Fort facing the Ring Road from the Asad Burj to the Salimgarh Bridge was chemically treated for removal of vegetational growth, hardened accretions and calcareous deposits.

In 1987-88, the restoration of the cut and moulded red sandstone and marble parapet panels, fixed with moulded plaster over the eastern wall, was taken up. The marble steps of the Diwan-e-Khas and the Rang Mahal were also restored and the missing ornamental brass plates on the door of the Moti Masjid were fixed as per the original design. The damaged red sandstone flooring of the Sawan Pavilion was dismantled and new flooring laid, after providing a bed of cement. Missing floral bands on the western side of the Diwan-e-Am were reproduced in consonance with the original pattern and the exterior walls of the Moti Masjid plastered, once again following the original pattern. The fountains in front of the Rang Mahal were fixed and plastered as well.

Work was also carried out on the surface of the Hammam, three sides of the rampart wall and two cupolas under the flag mast facing Chandni Chowk. In 1997-98, the golden paintings on the wooden ceiling of the Diwan-e-Khas and the upper portion of the Moti Mahal were subjected to chemical conservation. The entrance gate was also treated with sodium potassium nitrate.

Repair and restoration are an integral part of the life of any great monument. They are also an ongoing process that preserves not only the building but its environs as well. In 2003-05, the eastern side of the Red Fort was a slum. This area is now a beautiful park with causeways, fountains and flowerbeds. Its name, Dilli Chalo Park, is derived from the slogan given by Netaji Subhash Chandra Bose in 1943—'Dilli Chalo'.

The western front of the Red Fort has also been given a facelift; its entire walls spruced up and cleaned chemically. The area in front that was once uneven and

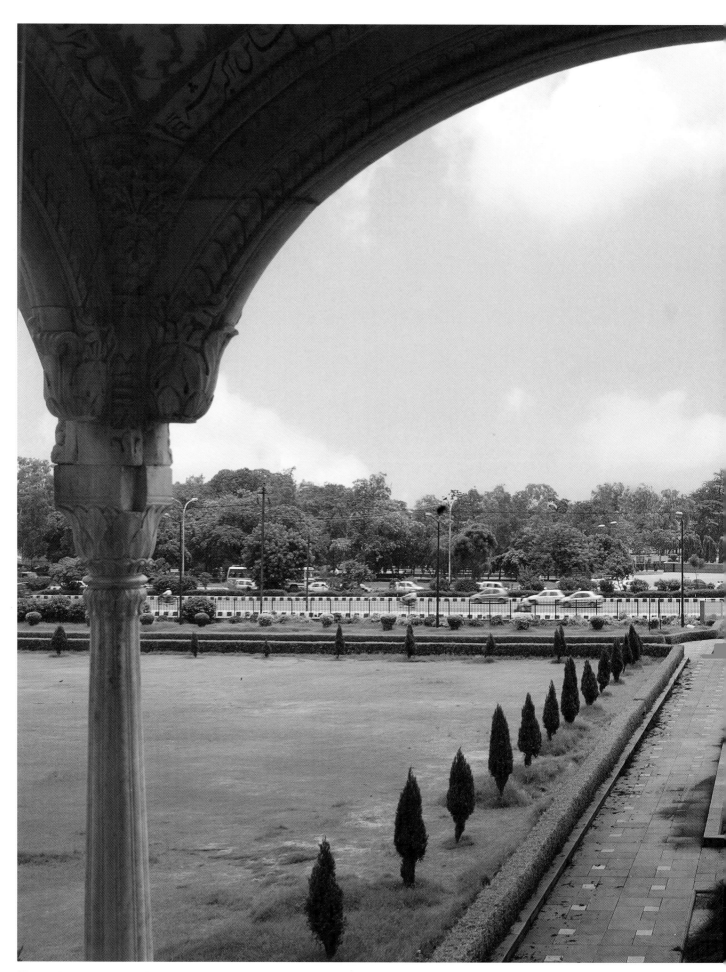

The newly developed Dilli Chalo Park on the eastern front of the Red Fort.

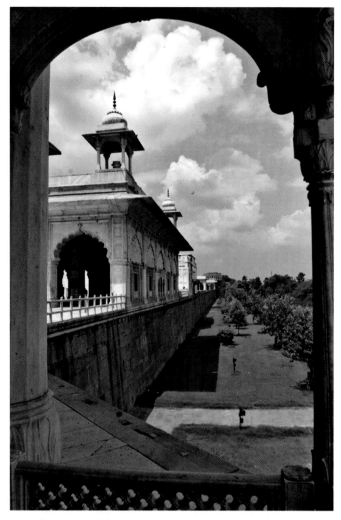

The Dilli Chalo Park which was at one time a river.

Special treatment has also been given to a virtually unknown *baoli* (step well) that reveals a small but an inspiring part of the history of the Indian freedom struggle. It had an indigenously designed bathing tank and a large courtyard, about 8.53 metres below the ground level, approachable through the stairs. During the occupation by the British Army, the *baoli* fell into disuse and a good part of the courtyard was converted into prison cells where the freedom fighters were brought for interrogation.

After 1945, however, the *baoli* and the cells were closed. A lot of junk, garbage and building material got dumped here. It was only much later that the *baoli* was cleaned. Hundreds of truckloads of garbage was removed and the prison cells and the *baoli* exposed to view. A museum with an appropriate display of historic documents is being set up here.

There are many other changes in the citadel area. Some have been dictated by the need of the hour, others are quaint and historic and reflect the ambience of the surroundings. A new underground ticket house has been constructed and the Sound-and-Light show upgraded. Lawns in the old style have been developed in the area that was vacated by the Army.

An old dilapidated structure that was once used as a stable by the Mughals and converted subsequently to a teahouse by the British troops was lying almost like a garbage bin. It has now been rebuilt as an elegant restaurant—Dawat Khana—displaying various crafts and handicrafts. A Documentation-cum-Information and Interpretation Centre is being set up.

Besides information about the Red Fort, the Centre will provide a panoramic view of the journey of Indian civilisation from the ancient times to the present day. It will also have a reproduction of all the speeches delivered from the ramparts of the Red Fort by the Prime Ministers of India.

A fresh life has thus been injected into the mighty Red Fort and a new dimension imparted to both its present and future. Few would dispute that the inspiring picture that has emerged in and around the Red Fort is highly instructive and is an excellent example of creative and constructive management. As the then Prime Minister Atal Bihari Vajpayee said to Indians across the entire country on 15 August 2003, while referring to the

uncared for has been developed into a beautiful garden by the Central Public Works Department with the efforts of the ASI. It has been named August 15 Park. The entire area facing the Jama Masjid and Chandni Chowk now glitter because of an elegantly designed system of lighting. The 1.7 kilometre-long moat where massive slush had accumulated over the years has been cleared. About 2,200 square metres of pathways have been relaid with new stones.

The shell plaster on the walls of the Mumtaz Mahal, the Rang Mahal and the Hammam has been refixed. All the 23 red stone *jali* windows that were broken have been remade. The Diwan-e-Khas, the Khas Mahal, the Naubat Khana and a *tehkhana* (basement chamber), too, have been restored to their old glory; the Hayat Baksh garden, with its fountains, channels and cascades, has also been repaired. The old underground passage to the River Yamuna, under the Musamman Burj, has been cleared and opened on the Ring Road side. The restoration of the Nahr-i-Bahisht, which seemed almost impossible, has been carried out.

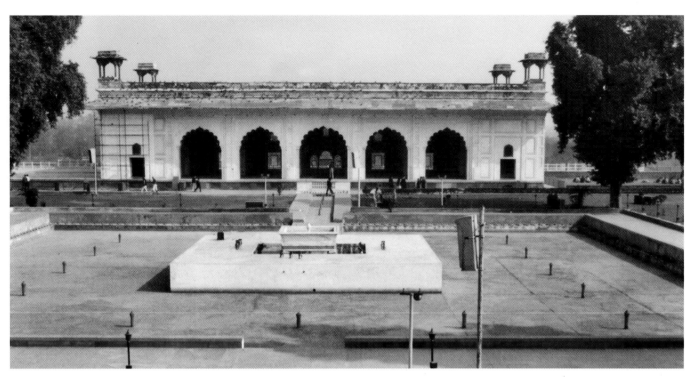

The restored fountain and tank in front of the Rang Mahal.

comprehensive restoration of the Red Fort, 'I would like you to emulate this example by undertaking such a beautiful project for the conservation of heritage in your own village or town.'

Since the Army has now moved out, the ASI plans to take up the restoration work of the Fort on a larger scale. A comprehensive conservation and management plan has been outlined and expert conservationists are studying various proposals. This plan will be implemented in consultation with the Supreme Court's appointed Expert Committee on the Red Fort. Hydrologists will study the waterlogging problem that afflicts several parts of the Fort. Similarly, chemical experts will decide how best to restore the paintings and other art works; conservationists will find out what type of intervention is required so that the Fort is not divested of its original character.

To facilitate restoration work, the Red Fort area has been divided into three categories—Mughal and later Mughal, structures built by the British Army and those built by the Indian Army after 1947.

The magnificent Red Fort attracts visitors from all over the world and is indeed a mighty tribute to India's rich heritage. It represents much more than past eras—it occupies a special place in the annals of India's history as well as in the hearts of all its people.

An ornate fountain in front of the Rang Mahal.

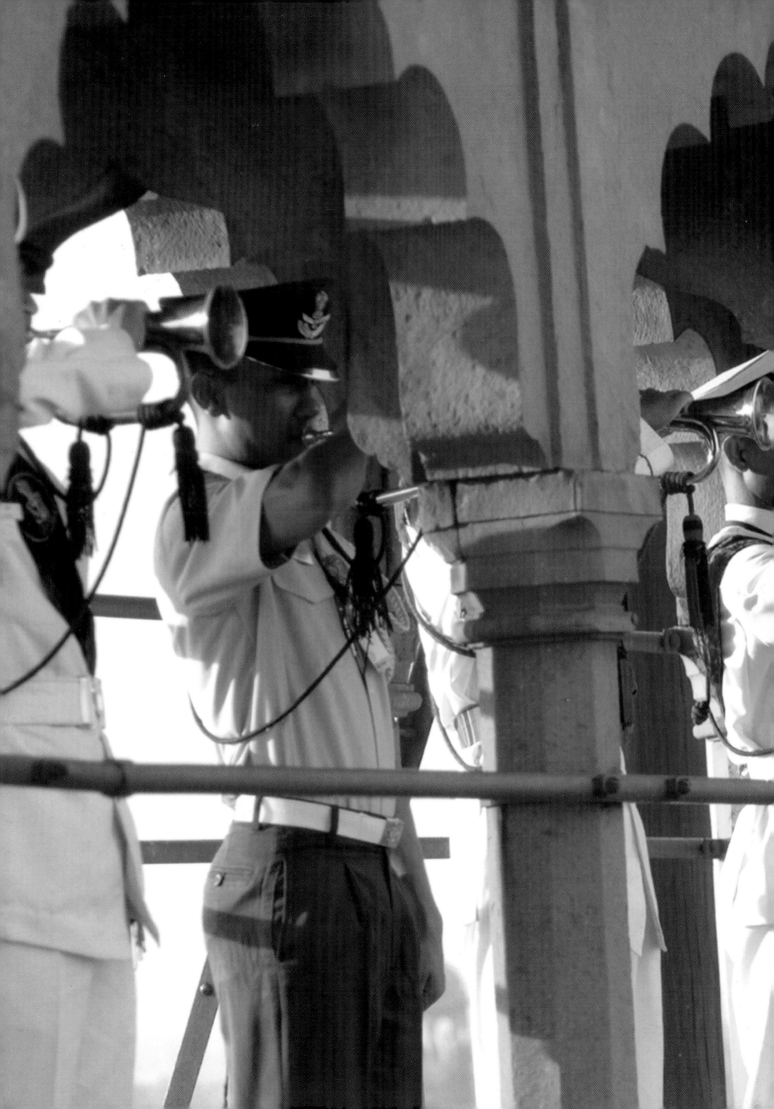

PART IV

Celebrating History

1
Moments of Joy

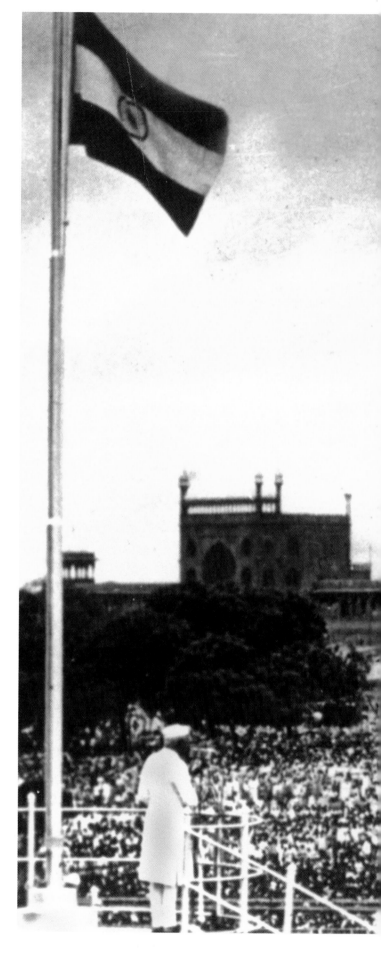

Victory and joy—moments always celebrated at the majestic Red Fort with gay abandon by the emperors, their nobles, begums and women of the harem. On such occasions fancy bazaars were set up where the emperors would spend large amounts of money. A historian of those times, who witnessed one such event, described the scene as a grand one with the emperor dressed in the most magnificent attire: 'The turban, of gold cloth, had an aigrette whose base was composed of diamonds of an extraordinary size and value, besides an oriental topaz, which may be pronounced unparalleled, exhibiting a lustre like the sun. A necklace of immense pearls, suspended from his neck, reached to the stomach, in the same manner as many of the Indians wear their strings of beads. The throne was supported by six massive feet, said to be of solid gold, sprinkled over with rubies, emeralds and diamonds.'

During the festivities the pillars of the two assembly halls were covered with brocades of gold. Flowered satin canopies were raised over the expanse of the apartment, fastened with red silken cords from which were suspended large tassels of silk and gold. The floor was covered with carpets of the richest silk. A tent, called the aspic, was pitched outside, larger than the hall, to which it was joined at the top. It spread over half the court and was completely enclosed by a great balustrade, covered with plates of silver. Pillars overlaid with silver supported it. The outside of this magnificent tent was red and the inside lined with elegant chintz. The emperor and after him, the *umarahs*, were weighed against solid gold.

Another way of celebration for the emperors and the ladies of the royal harem was to watch elephant fights. The low ground to the east of the Red Fort, between

The first Prime Minister of independent India, Pandit Jawaharlal Nehru, addressing the country on its first Independence Day from the Red Fort. Courtesy: Nehru Memorial Museum and Library.

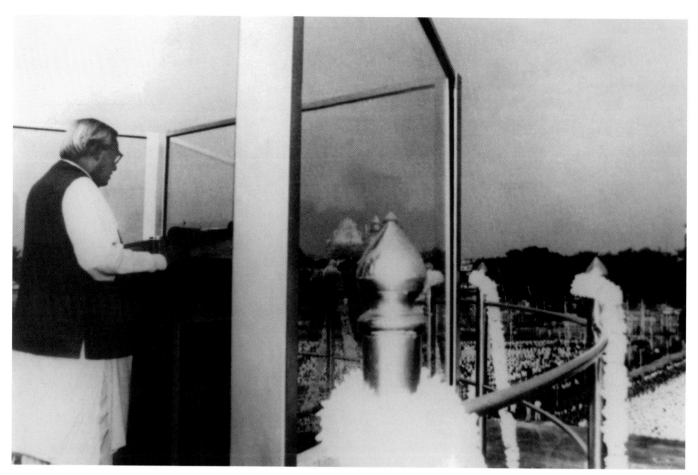

Former Prime Minister Shri Atal Behari Vajpayee addressing the nation from the Red Fort on Independence Day.

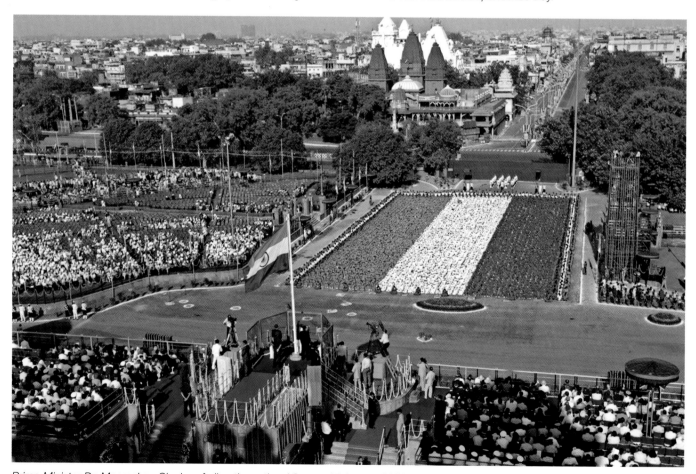

Prime Minister Dr. Manmohan Singh unfurling the national flag on 15 August 2006 at the Red Fort.

the citadel and the river, was used for these fights and the *umarahs* would have to review them before the emperor could witness the spectacle from the palace. The ladies of the court and *umarahs* would watch such events from different apartments of the Fort facing the river. A wall of earth was raised and the two ponderous beasts would meet one another face to face, on opposite sides. Each had a couple of riders to guide the elephant with a large iron hook. The riders would animate the elephants either by soothing words, or by goading them as cowards, and urge them on with their heels, until the poor creatures approached the wall and were forced to attack. There were frequent pauses during the fight; it was suspended and renewed and the mud wall often thrown down. The animals could be separated only by fireworks, for they were naturally timid and had a particular dread of fire. It often happened that the spectators were trampled upon by the elephants or by the crowd.

The most spectacular scenes were witnessed at the Red Fort during the marriage ceremonies of the Mughal princes. The entire area and its surroundings glittered with a variety of lights.

Such activities have today disappeared from the Red Fort, giving way to new festivities, celebrations and sports. Dussehra, Muharram, Eid, Guru Purab, Gandhi Mela, Army Day, Independence Day, Republic Day and many more special occasions are celebrated here and the area is still transformed into virtually a mela. Kite flying as well as horse racing are all-time favourites.

During Dussehra as many as three Ram Lilas take place in the vicinity of the Red Fort. It requires months of preparations to set up the three main effigies of Ravana, Meghnath and Kumbhakarna. There is an elaborate scheme of fireworks for burning these effigies that symbolises the victory of good over evil.

Sikhs also hold their festivities in this area. Usually it is the birthdays of the Sikh gurus, known as Guru Purab, that are celebrated here. On these occasions, the Guru Granth Sahib is carried in a procession on a float, decorated with flowers, and taken through the city. Five armed guards head the procession carrying the *Nishan Sahib* (the Sikh flag). Local bands playing religious music form a special part of the procession which generally ends at Gurudwara Tegh Bahadur in Chandni Chowk, near the Red Fort.

On Independence Day, cultural programmes are organised where noted poets recite poems and *qawals* enchant the gathering with *qawalis* (devotional songs) and *mushairas* (poetry sessions). The towers are then illuminated, the lawns are spruced up and the Fort is given a facelift.

Patang bazi (kite flying) is another way the people here express their joy on this occasion. The mood is exuberant as the sky is covered with colourful kites of all shapes. Women flaunt their tri-coloured bangles and children wear tri-colour caps. There is plenty of merry-making as people eat and drink together. On Republic Day, tableaus from different states that participate in the procession are parked in the ground just outside the Red Fort. Thousands of people throng this area to catch a glimpse of these colourful tableaus. Inside the Fort, an extravagant hour-long Sound-and-Light show takes place every evening. The changing lights are synchronised with the sound to make it a particularly popular show with tourists as it recreates the magic of the events that made history at the Red Fort. Once again, the Red Fort then stands resplendent in all its glory, providing an ideal backdrop for events that have shaped the destiny of the nation.

Glossary

The meanings given here refer to the contextual framework of the book and merely help in understanding the text.

A

Aiwan	Colonnade
Alamgir	World compeller
Amlaka	Tamarind

B

Badshah Ghazi	King and Champion of Faith
Baithak	Sitting place for conversation
Baoli	Step well
Begum Sahiba	Queen
Bhadon	A month as per the Hindu calendar
Burj	Tower

C

Chhajja	Sloping cornice
Chhattri	Turret
Chobi Masjid	Wooden Mosque
Chhoti Baithak	Small sitting place
Chowk	Crossing

D

Dalan	Verandah
Dariya	River
Durbar	Court
Darwaza	Gateway
Dhilhijjah	A.H.1048 9th Moharram of A.H.1049
Divan	Raised platform
Diwan-e-Am	Hall of Public Audience
Diwan-e-Khas	Hall of Private Audience

F

Farman	Edict, a written command bearing the royal seal

G

Ghusal Khana	Bathroom
Guldasta	Bouquet

H

Hammam	Royal bathroom

Hayat Baksh — Life Bestowing

Hayat Baksh	Life Bestowing

I

Imtiaz Mahal	Palace of Distinction
INA	Indian National Army or Azad Hind Fauj was the army which fought along with the Japanese Army during the Japanese campaign in Burma
Inquilab Zindabad	Long live the revolution

J

Jali	Tracery work
Jihad	Religious war

K

Kalasa	Vessel
Kanjura	Merlon or stepped battlement
Khas Mahal	Emperor's Palace
Khirki	Wicket gate
Khurd Jahan	Little World
Khwabgah	Place to rest/sleep
Koh-i-noor	Great diamond (Mountain of Light)
Kucha	Enclosed residential complex
Kurta	Long shirt

M

Mahouts	Elephant riders or attendants
Mansabdars	Junior lords
Masand	Pillow to rest on
Mehtab Bagh	Moonlit Garden
Meri-i-Imarat	Supervisor of Buildings
Mihrab	Niche in the Qibla wall of a mosque oriented towards the Ka'ba
Mirza Jawan Bakht	Son of Bahadur Shah Zafar
Mizan-i-Insaf	Scales of Justice
Mohalla	Locality
Moti Masjid	Pearl Mosque
Muhajjar	Cenotaph
Mumtaz Mahal	Elect of the Palace
Musalla	Carpet design for prayer
Musamman Burj	Golden Tower
Mushaira	Gathering where poetry is recited

N

Nadri	Jewelled dagger
Nahr-i-Bahisht	Canal of Paradise
Nasheman	Canopied seat
Nashiman-i-Zill-illahi	Seat of the Shadow of God
Naskh	Common cursive Arabic script
Naubat or Naqqarkhana	Ceremonial Drum House
Naubat	Beat of drum announcing royalty or the hour of prayer
Nazar	Present
Nazir	Superintendent of the Household
Nishan Sahib	Sikh flag

P

Pagri	Headgear
Palki	Palanquin
Panj Hazari	Five thousand horses/foot
Patang Bazi	Kite flying

Q

Qawali	Devotional song
Qila	Fort

R

Rang Mahal	Palace of Colour
Rehant	Waterwheel

S

Sardar	Leader
Sawan	Month as per Hindu calendar
Sayyid	Lineal descendant of the Prophet Mohammad
Shah Burj	Royal Tower
Shamiana	Marquee
Sheesh Mahal	Palace of Mirrors
Shehnai	Musical instrument
Shibqiran-i-Sani	Second Lord of Happy Conjunction
Swaraj	Independence

T

Taj	Crown
Tehkhana	Basement Hall
Tasbih Khana	Place used for praying by telling of beads
Takht-i-taus	Peacock Throne
Toshkhana	Place where people meet to sit and talk

U

Umarah	Lord
Ustad	Master

V

Vande Mataram	India's signature song, composed by Bankim Chandra Chatterjee in a mix of Bengali and Sanskrit

Bibliography

Bernier, F, *Travels in the Mogul Empire, 1656-1688,* Constable & Co., London,1901

Carr, S, *Archaeology of Delhi,* Civil and Military Gazette and Station Press, Simla,1876

————, *Archaeology of Delhi,* Thacker Spinks & Co., Calcutta, 1876

Cole,HH, Reports, *I, II and III of the Curator of Ancient Monuments in India, 1881-82,1882-83 and 1883-84,* Government Press, Calcutta and Simla

Cunningham, A, *Archaeological Survey of India, Reports I, II, III, V, VIII, IX, XIV, XV, XVI, XVIII and XXII,* Government Press, Calcutta

Duncan, EA, *Keen's Handbook of Visitors to Delhi,* Thacker Spinks & Co., Calcutta, 1906

Fanshwe, HC, *Shahjahan's Delhi-Past and Present,* John Murray, London, 1902

Fergusson, J, *History of Eastern and Indian Architecture,* John Murray, London, 1910

Flatcher, B, *A History of Architecture,* Bats Ford, London, 1905

Gabrielle F, *When Kings Rode to Delhi,* William Blackwood, 1912

Havell, EB, *Indian Architecture,* John Murray, London, 1913

Hearn, GR, *Seven Cities of Delhi,* Thacker Spinks & Co., London, 1906

Kaye MM, *Golden Calm—An English Lady's Life in Mughal Delhi*

Marshal J, Sir, *Archaeological Survey of India Annual Reports,* 1883-1936

Sandreson, G, *List of Muhammadan and Hindu monuments,* Government Press, Calcutta, 1914

Sayyid AK, *Asaru-s-Sanadid,* Delhi Edition, 1847 and Kanpur Edition 1904

Spear, TGP, *Delhi: Its Monuments and History,* Oxford University Press, 1943

Tavernir, J-B, *Travels in India,* Macmillan & Co., London, 1889

Zaheer, H, *Monuments of Delhi, Lasting Splendour of the Great Mughals and Others* (Reprint, New Delhi, 1977)

Suggested reading:

Proceedings of the Trial of Muhammad Bahadur Shah, 27th January, 1858

Government Press, Calcutta,1895

Reports of the Curator of Ancient Monuments in India, Vols. I, II and III

Size of Delhi, Handbook, Allahabad, Pioneer Press, 1907

Index

Photo Credits

Amit Pasricha

Archaeological Survey of India

Ashok Dilwali

Debatosh Sengupta

Indian Council of Historical Research

Jawaharlal Memorial Museum and Library

National Museum, New Delhi

Photo Division, Ministry of Information and Broadcasting, Government of India

The Royal Collection © 2007 Her Majesty Queen Elizabeth II